Ansel Adams

At the water's edge

Without water, the earth would be sharp and naked as the moon.

— Nancy Newhall

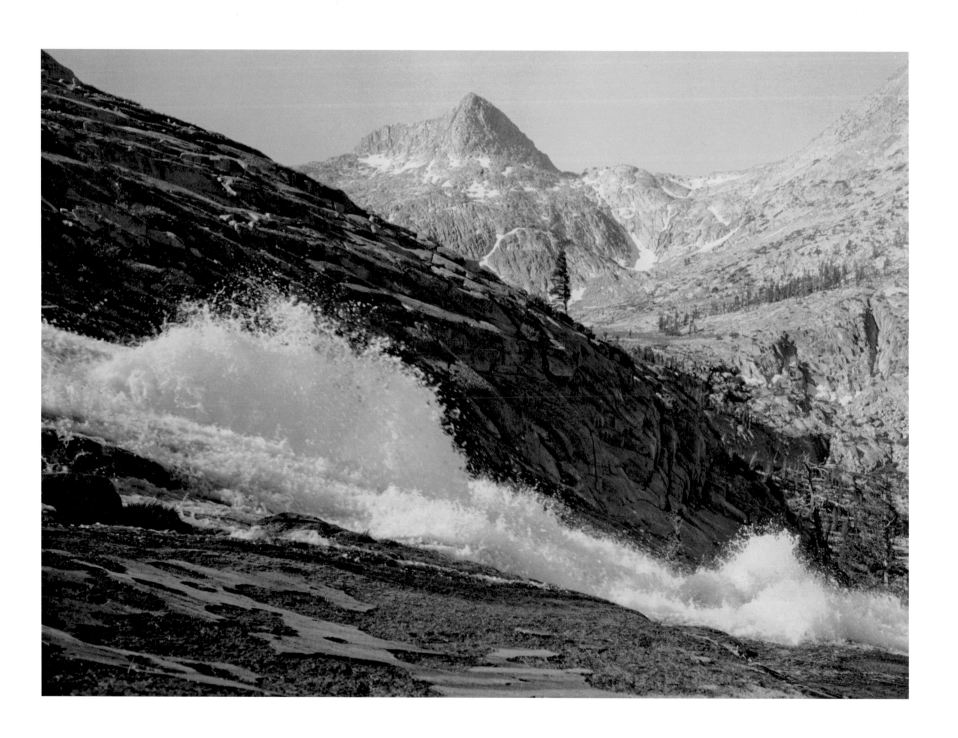

Evolution Creek, 1933

Ansel Adams

At the water's edge

Phillip Prodger

Preface by Rebecca A. Senf

Peabody Essex Museum

Ansel Adams: At the Water's Edge is organized by the Peabody Essex Museum, Salem, Massachusetts.

Support for the exhibition was provided by David H. Arrington, the Center for Creative Photography, University of Arizona, and the East India Marine Associates (EIMA) of the Peabody Essex Museum.

Published by the Peabody Essex Museum

Peabody Essex Museum
East India Square
Salem, Massachusetts 01970
www.pem.org

Library of Congress Control Number: 2012932336

ISBN 978-0-875772-25-7

Produced by Vern Associates, Inc., Newburyport, Massachusetts
www.vernassoc.com
Designed by Peter M. Blaiwas
Production by Susan McNally
Printed and bound by Capital Offset Company, Concord, New Hampshire

Front cover: Ansel Adams, *Nevada Fall, Profile, Yosemite Valley*, about 1946 (plate 76)
Back cover: Ansel Adams, *Upper Yosemite Fall, Yosemite Valley*, about 1946 (plate 75)

First printing, May 2012
Second printing, December 2012

Contents

Foreword

Let the most absent-minded of men be plunged into the deepest reveries. . . and he will infallibly lead you to water, if water there be in that region. . . . Meditation and water are wedded forever.
— Herman Melville

Ansel Adams—arguably America's most famous photographer, admired internationally for his powerful images of nature and place.

Water—contained in almost everything, one of our oldest sources of fascination.

Ansel Adams and water—a coupling that dominated the photographer's career, yet has seldom if ever been recognized, discussed, or celebrated.

Whether fleeting or lasting, fame implies being in the spotlight, illuminating someone's significance. Many visual artists owe their fame to a signature innovation, style, medium, or type of imagery. This becomes their passport to the hallowed realm of the iconic, yet sometimes also skews toward an inadvertent path to being taken for granted, since fame can also blind us to considering other, even obvious elements of an artist's work. Given the considerable degree to which Adams' works have entered our visual public domain, one could well ask, What fresh ideas and eyes can be brought to his body of photographs? In 2012, the one hundred tenth anniversary of Adams' birth, the answer resides in two key aspects tackled in this exhibition and publication: the undeniable, enduring significance of water as a subject and source of inspiration and experimentation for Adams, and the artist's deliberative and energetic engagement with modernism as an agent for innovation.

"The best hydro-citizens are water watchers," according to water conservation scientist Peter Warshall.[1] Living by the water almost all of his life, Adams was indeed a hydro-citizen, well known as an advocate for protecting and preserving America's natural resources. He was also a water watcher extraordinaire, captivated by and capturing water in so many places—from Hawaii to Massachusetts— and states of being, from fresh to salt, calm to turbulent, liquid to gas to solid; from deep to trickling.

Environmental advocacy, however, was not his sole or even initial impetus for focusing on water. Rightfully, Adams' photographs have been lauded for the role they played in moving photography from a late-nineteenth-century fixation on the impressionistic to an assertion of the camera's possibilities as a modern machine. The intensely sharp focus and absolute resolution of his images can be construed as a kind of site specificity akin to the documentary, an approach that again has little to do with why Adams engaged so profoundly with water. Instead, its "siren song," as exhibition curator Phillip Prodger describes it, was the lure of capturing as an artist, as a photographer, the very idea of fluidity as metaphor, symbol, form, and subject. And as if that were not challenge enough, Adams closely associated water with his desire to create visual narrative through careful image framing, in large measure because he considered the flow of water and narrative to be equivalent.

How did he express this equivalency? Some artists develop a one-note orientation; others work with a loosely related succession of styles and themes or pursue different directions and media more randomly. Still others take a cyclical or serial approach, culling and weaving permutations of materials, forms, or concepts from an expanding central vocabulary that affords opportunities to modify, refine, and extend. Adams gravitated to the latter, demonstrating a compositional flair and an orchestration of repetition, variation, and seriality that suited his desire to plumb the depths of possibilities represented by motifs such as water. Often, artists who return to subjects again and again engage in repetition as acceptance of the challenge to reach resolution, even perfection, because repetition provides a context and boundaries for experimentation and exploration.

Variation for artists like Adams is also an experimental process, challenging the harmonic concept of finish because it means creating works as installments in a larger, continuous narrative composed of elements that recur and change. The duality of harmony and tension that can evolve from the interplay of repetition and variation is a tribute to an artist's ability to pace and combine. In Adams' case, working in series was a logical extension of the value he placed on

this interplay. If we take a moment to consider how many words we have for water and its many states and places, it is not surprising that an artist's meditations on its environments, sites, moods, and atmosphere could assume the proportions they did for Adams. Seriality also implies something that occurs over time, including lapses and rushes of time, a characteristic that could not have been lost on Adams as a version of the physical flow and passage of time that he sought to capture.

This exhibition and its companion publication are the brainchild of Phillip Prodger, the Museum's Curator of Photography. We congratulate him for the clarity and depth of insight with which he offers a compelling perspective on Adams and his work as well as provides another vista onto the realms of the marine and maritime, an arena with particular resonance for this museum. We join Phillip in praising the Museum's staff for the array of talents and dedication they marshaled to realize this project's many facets. Similarly, we express our gratitude to the Ansel Adams Publishing Rights Trust; the several public and private collections that generously granted loans, especially the show's principal lender, the Center for Creative Photography at the University of Arizona, Tucson; and the National Maritime Museum, Greenwich, England, for its gracious partnership as a venue.

We greatly appreciate the philanthropic support of David H. Arrington, a most discerning collector of Adams' works, and PEM's East India Marine Associates. We would also like to recognize our media partner, WBUR, Boston's NPR station, for its sponsorship of a year of photography comprising this and two other exhibitions and related radio programming at the Museum in 2012.

Adams' studies of water are intimate and contemplative revelations of one man's ability to personalize something so universal. They are also muscular and dynamic manifestations of the modern artist as witness, observer, interpreter, and advocate—roles that in this instance invite us to consider how we frame and understand our own capacity as water watchers.

Dan L. Monroe
The Rose-Marie and Eijk van Otterloo Director and CEO
and
Lynda Roscoe Hartigan
The James B. and Mary Lou Hawkes Chief Curator

1 Peter Warshall, " Watershed Governance: Checklists to Encourage Respect for Waterflows and People." In David Rothenberg and Marta Ulvaeus, *Writing on Water*. Cambridge, MA: The MIT Press, 2001, 56.

Acknowledgments

In organizing At the Water's Edge I had the privilege to work with some of those who knew Adams best—the director of the Ansel Adams Publishing Rights Trust, William A. Turnage, Adams' son, Michael, daughter-in-law Jeanne, and grandson Matthew. It is no exaggeration to say that this project could not have happened without their support. We are enormously grateful to William for encouraging and advocating for the project and for his priceless insight and advice. We also thank Tish Rosales, business manager at the Trust, for her invaluable assistance. Jeanne and Michael Adams quickly welcomed me into their extended family, and their kindness in sharing their knowledge of Ansel and his work has been remarkable. Experiencing the roaring waterfalls of Yosemite Valley together with them during the annual spring thaw was one of the unforgettable experiences of my career.

Two extraordinary collectors with distinctive backgrounds shared their holdings, as well as their perspectives and passion for Adams' work. PEM Overseer Saundra Lane, whose photography collection is among the finest in private hands, lent numerous works. Saundra and her late husband, William, knew Adams personally and their holdings reflect their long-term association and impeccable taste. David H. Arrington, of Midland, Texas, has built one of the outstanding private collections of Ansel Adams' photography. We are thankful to David and his family for their hospitality and kindness in Midland and for their generosity in lending their prized possessions to our project. David's enthusiasm for Adams and sensitivity to his work are contagious. David is aided by Andrew Smith of Andrew Smith Gallery in Santa Fe, New Mexico, for whom no problem was insurmountable. We greatly appreciate all Andrew has done to help realize this project.

My colleagues and I extend our sincere thanks to the staff of the Center for Creative Photography at the University of Arizona, Tucson, for their many contributions in making this book and the accompanying exhibition possible. We are deeply grateful for the enthusiasm and advice of directors Britt Salvesen and Katharine Martinez, registrar Trinity Parker, archivists Leslie Squyres and James Uhrig, rights and reproductions specialists Tammy Carter, Denise Gose, and Sue Spence, and preparators Tim Mosman and Alan Lavery. We also thank curator Rebecca Senf for her passion for Adams' work and willingness to share it and for the enlightening preface included in this volume. The range and importance of the CCP's collections are surpassed only by the generosity and expertise of its staff.

At the Peabody Essex Museum, I warmly thank Director Dan Monroe and Deputy Director Josh Basseches for their guidance and support. It was also my great fortune to work on this, and all other PEM exhibitions, with Chief Curator Lynda Hartigan, and Head of Exhibition Planning Priscilla Danforth. Research and Publications Director Kathy Fredrickson skillfully managed the production of this volume. Curator for Exhibitions and Research Paula Richter was my close associate during the project and spent countless hours ensuring this publication's successful production. Former Assistant Curator George Schwartz and research assistant Cerys Wilson also provided invaluable help with research and organization. Chief Marketing Officer Jay Finney, himself a long-time Adams aficionado, provided assistance at key moments. I thank, too, interpretive liaison Michelle Moon, Exhibit Projects Coordinator Gwendolyn Smith, Major Gifts Officer Rebecca Ehrhardt, Head of Collection Management Eric Wolin, and exhibition designers Karen Moreau Ceballos and Dave Seibert. Other PEM staff who assisted are too numerous to list, but the contributions of their departments—Education, Registration, Development, Marketing, Retail, and Security—are no less genuinely appreciated.

I am also grateful to Peter Blaiwas and Brian Hotchkiss, of Vern Associates, for the design and production of this handsome volume. In addition, I thank Jay Stewart of Capital Offset, Susan McNally, and Pam Ozaroff for their production and editing expertise. Claudia Sorsby helped to edit early drafts of the text. Stephen Wirtz provided valuable information about George Fiske, and Mack Lee assisted with the William Dassonville estate. Rachel Sailor, Assistant Professor at the University of Wyoming, graciously organized a session of the annual Western History Association conference exploring new directions in Ansel Adams scholarship. Barbara Hitchcock and Jennifer Urhane provided access to the Polaroid collection, and Denise Bethel helped at Sotheby's.

I would also like to thank the Museum of Modern Art, New York, and the Museum of Fine Arts, Boston, for lending to the exhibition, and our venue partners at the National Maritime Museum, Royal Museums Greenwich, including Kevin Sumption and Philippa Simpson.

My heartfelt thanks, as ever to April Swieconek, on whose support, ideas, and counsel I rely.

Phillip Prodger, Curator of Photography

It was my farewell to the Valley and its waters—this hour in front of the great Upper Yosemite—the mighty cataract, a third of a mile high, which is perhaps the most beautiful of all. It seemed like some young Greek god, some athletic nude Achilles, standing there so slim and straight and tall, with his head in the sun and his feet on the clouds . . . this fine lithe spirit, springing from the mountain, poised on the rock, alive with a thousand leaping pulses, chanting a song of a thousand echoes. In that long hour the splendid living thing became companionable and divinely kind. My little human life grew to its stature, throbbed with its force, sang with its music. For an hour I shared in the triumph with a pagan joy, sitting there in the sun on a ledge and watching the eternal rush and rest. Those glorious waters washed the whole world clean; I looked down and saw its sins dashed away over the rocks, I looked up and saw its perplexities float off in those climbing mists. And below me, as I swung my feet over the precipice, the Valley lay fresh and pure, its silver ribbon of a river sparkling in the sun.

— Harriet Monroe (1860–1936), "Camping above the Yosemite—a Summer Outing with the Sierra Club."
Sierra Club Bulletin VII:2 (June 1909): pp. 92–93.

Preface

Rebecca A. Senf

Ansel Adams' best-known images are of the unpeopled landscape—mostly in the western United States and very often in protected national parks. Modern viewers frequently assume that Adams' connection to these wild environments was spiritual (which it was) and solitary (which it was not). For Adams, an incredibly extroverted and gregarious person, the camaraderie of his hiking and photographic trips was a key element of enjoying the outdoors. He chronicled the American wilderness on trips with anywhere from a single companion to two hundred Sierra Club outing members. These sojourns were often social occasions that allowed him to make work that conveyed his deeply held ideas about the land.

Adams greatly valued his explorations of the high reaches of the Sierra Nevada, and he made a vast number of mountain views during his mid-20s and early 30s. He often went on extended camping trips with mentors he met through the Sierra Club or in Yosemite Valley, like Francis Holman (1856–1944), a retired geologist. Adams described "Frank" as a kind and intelligent man of few words, a Puritan who was reverent toward all living things. He was 46 years older than Adams—old enough to be the young photographer's grandfather. Holman excelled at bird-watching, fishing, and hiking; these activities required patience and keen observation, as did Adams' photography.[1] One imagines that Holman, motivated by bird-watching, would have practiced a deliberate, learned, and technical approach to the great outdoors and may well have introduced Adams to a methodical way of moving through the wilderness.

Another mentor was Joseph N. LeConte (1870–1950); an engineering professor at the University of California, Berkeley,[2] he was also a charter member of the Sierra Club and an avid mountaineer. In 1925, when Adams was 23, he joined the LeConte family on a nearly two-month camping trip to King's River Canyon. As the junior member of the excursion, Adams worked hard, building campfires, cooking, and leading the pack animals, which were an essential part of the trip—especially for Adams himself, thanks to the sheer weight and volume of his photography equipment. Cameras then were large and heavy, requiring durable and heavy protective cases, a tripod, and bulky film or plate holders for each negative. LeConte's son, Joseph Jr., later remembered that one of the three burros that summer carried

Adams' cameras and negatives: "We had about fifty or sixty pounds of glass plates, which had to be very carefully packed. . . . [Adams] could carry his little camera, but all his big cameras had to go on the pack. He couldn't possibly carry all that."[3]

Despite his practical duties, Adams found time to make good use of his photographic gear. On July 6, when the younger members of the party took a day trip to Kearsarge, "Ansel stayed on . . . to get proper lighting effects,"[4] to make a view called *Kearsarge Pinnacles* [plate 9].

Kearsarge Pinnacles is a sophisticated study in texture, tone, and shape. Adams created a layered composition that plays the dark, bristly trees off the ridge of mountains behind them. It is clear why proper lighting effects were essential, as Adams waited until the top of the craggy mountains are in shadow, creating a visual division between the solid peaks above and the eroded and crumbling rock sliding toward the lake below. The light further heightens the range of textures within the print, raking across rocks and rippled water, enhancing the details of each. Adams fits the elements of the picture together like pieces of a puzzle—the small tree at center just touches the top of the distant shore; the tree to the right falls within the silhouette of the Kearsarge range, allowing the ridgeline to dominate; and the tree to the left extends into the sky, mimicking the shape of the peak on the right. The longer one considers this mountainscape, the more Adams' care and deliberation are evident, and the clearer his success becomes.

In 1927 Adams created *Parmelian Prints of the High Sierras,* a portfolio that brought together 18 photographs from the previous six years. Most of the portfolio's pictures were made in the high country of the Sierra Nevada, during extended treks like his visit with the LeContes. The photographs Adams included in the portfolio were hiker's views—pictures of distant mountain peaks, shots made along the trail, and scenes of possible campsite locations or hike destinations, such as *Marion Lake,* about 1925 [plate 8].

Marion Lake was a place of special significance to Adams and of even greater significance to his friend Joseph LeConte. In 1902 LeConte had named the glassy mountain lake for his wife, Helen Marion Gompertz LeConte, herself an avid hiker and climber.[5] In the summer of 1925, one year after his wife's death, LeConte wrote this diary entry for July 25, at Marion Lake:

Got up late, and after a good breakfast, I went around on the west side of the lake and found a beautiful white granite rock bedded in the meadow grass near the shore of the lake. At the foot of this Helen [LeConte's daughter], Joseph [his son], and I buried the box containing the ashes of my beloved wife. I then drilled the rock and started work on the placing of the bronze tablet. In the afternoon I finished the erection of the tablet, and with Ansel's help placed a flat boulder over the grave.[6]

Adams must have felt honored that the family included him on such a meaningful trip, as he was able to help LeConte create a sanctuary in the mountains for his wife's remains.

When LeConte first saw Marion Lake in 1902, he described it as "fringed with tiny meadows on one side, and guarded on the other by fine cliffs of white granite, which could be traced far down beneath the clear waters till lost in their blue depths."[7] By framing his photograph with an imposing granite wall to the left and a rising mountain to the right, Adams suggests the protected nature of the lake. The vantage he selected, however, would not serve well in real life for extensive contemplation. One looks out across the lake, but the ground below pitches steeply downward, and the crumbly rock surface of the trail looks as if securing a foothold would be a challenge. This spot above Marion Lake is not for resting or relaxing; Adams stopped to record the shot and then proceeded along the trail once he had captured the scene, forever preserving the view of a personally significant and remote location.

Another plate from the *Parmelian Prints of the High Sierras* portfolio was *Roaring River Falls*, 1925 [figure 1]. The view up a cascading section of the river readily engages the senses. What we look at is purely visual—frothing water between craggy hillsides becomes areas of bright highlights punctuated by dark rocks, and mist creates patches of lighter grey where the detail and definition of rocky banks is obscured. Yet it evokes the tactile experience of cold mountain water rushing past, spraying icy droplets onto exposed skin. The print awakens a sense of the audible as well, with the crashing rush of the water.

In his late teens, Adams began to explore the pictorialist style, experimenting with soft-focus lenses, matte-surface papers, and layered paper mounts.[8] A prime example is the tender view of Lake Washburn, in Yosemite, that Adams made when he was about 16 [plate 10]. The influence of asymmetrical Japanese prints can be seen, as he heavily weights the bottom and left sides of the picture with dark rocks and trees. *Lake Washburn,* like all of his best prints from this period, reflects Adams' considerable advances in compositional sophistication, his technical mastery in making prints that retain detail and texture in both highlight and shadow areas, and his engagement with the current style of art photography.

Adams cites 1930 as the time when he had a change of heart, rejected pictorialism, and embraced photography's inherently mechanical nature. He credits seeing Paul Strand's sharp-focus negatives as a revelation that, with continued consideration, led him to a "straight photography" aesthetic.[9] Later in life, Adams downplayed his own short-lived experience as a soft-focus pictorialist, emphasizing instead his long-lived association with sharp-focus straight photography.[10]

Even by age 18, Adams had begun to feel that photography might offer him expressive potential that transcended what he was achieving with his pictorial works. In his *Autobiography* (published the year after his death), Adams wrote about one early water picture that captured this nascent desire.[11] In a June 8, 1920, letter to his father, with which he enclosed a small print of *Diamond Cascade, Yosemite National Park* [plate 15], Adams explained how he had thought for several days about how to make the photograph before actually going into the field.[12] He contrasted a "cold material representation" with what he hoped to achieve: "an impressionistic vision" and a portrayal of "the character and spirit of [the] little cascade."[13] Adams explained to his father that the same tools—line and tone, detail and texture—are available to all photographers, but that he wanted his picture "in some way [to] interpret the power of falling water, the light and airy manner of the spray particles and the glimmer of sunlit water."[14]

In his letter Adams describes a goal of creating a picture that achieves a higher, less literal, layer of meaning. Yet it would be 10

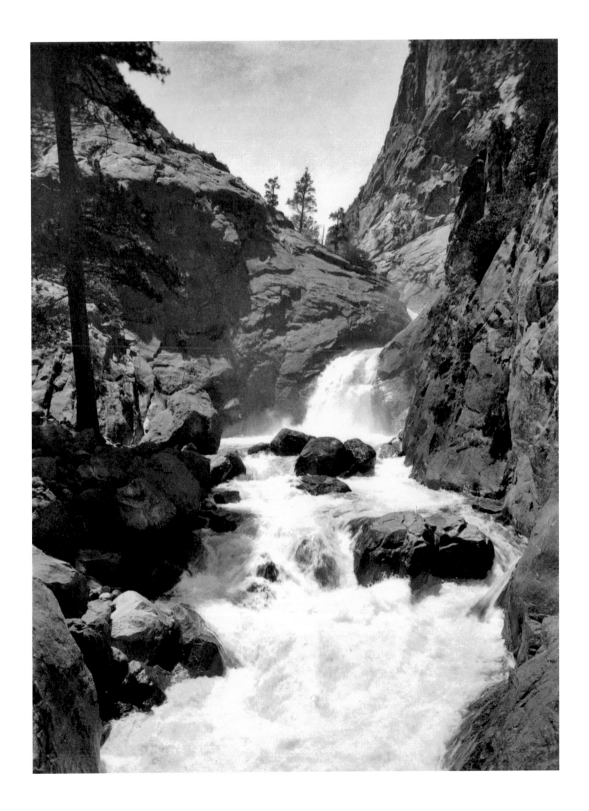

Figure 1
Ansel Adams
Roaring River Falls, Kings Canyon National Park,
California, 1925

years before he would meet modernist photographers like Strand and Alfred Stieglitz, who espoused the goal of making photographs that, through their use of line and tone, detail and texture, could express the artist's inner state.[15] In his 1979 book *Yosemite and the Range of Light,* Adams singled out these two photographers when talking about his transformation from a snapshot photographer into an artist:

> I knew little of these basic problems when I first made snapshots in and around Yosemite. I was casually making a *visual diary*—recording where I had been and what I had seen—and becoming intimate with the spirit of wild places. Gradually my photographs began to mean something in themselves; they became records of experiences as well as of places. . . . My relatively incoherent and romantic philosophy was clarified and strengthened by meeting Paul Strand in Taos in 1930 and Alfred Stieglitz in New York in 1933.[16]

Although this little print of a waterfall may not yet have achieved the power of Adams' later work, we see how Adams was beginning to imagine the photograph as a vehicle for telling a deeper, richer story. And again, his own sociability comes into play, as his meeting and talking with Strand and Stieglitz helped advance his work.

Adams continued to photograph the Yosemite wilderness in his mid-20s and early 30s, often going on the annual Sierra Club summer outings. Adams loved these four-week hiking trips. As many as two hundred people traveled together, with mules to carry the gear and massive stoves; a cook to prepare meals; and evening campfires replete with musical, educational, and literary entertainment. In 1928 Adams became the trip's official photographer, allowing his friends in the club's administration to help cover his expenses so that he could afford the trips. His financial compensation consisted of the waiving of the $212 outing fees (roughly $2,800 in 2011 dollars). In return, Adams produced a comprehensive album of trip photographs, from which outing members could purchase prints. Much like the treks with his early mountain mentors, these larger outings combined a wonderful social environment with photographic opportunities.

From one of these Sierra Club trips emerged a picture that was markedly different from Adams' previous work. As the photographer became more mature and experienced, and engaged more with a straight approach to photography, he became more daring—and his experiments became more successful. One such success story is the stunning *Ice and Cliffs, Kaweah Gap,* 1932 [plate 104].

This close-cropped view became one of Adams' signature images, one that he included in exhibitions and books and continued to print throughout his career. In this view of a frozen lake's surface abutting a vertical rock wall, where the meeting point collects sifted snow, Adams moves toward abstraction with a decisive forward stride.[17] By cropping out contextual details that would have helped the viewer interpret the three-dimensional orientation of vertical cliff and horizontal lake, Adams is able to fill his frame with layers of pattern that appear flat and parallel to the picture plane.[18] With references to real space diminished, the photograph's focus becomes the relationships among the different patterned swaths. The whole is made beautiful by the subtle variations of tone and the way Adams conveys the different textures.

In a later book, Adams wrote, "Many speak of this image as abstract, but I was not conscious of any such definition at the time. I prefer the term *extract* over *abstract,* since I cannot change optical realities, but only manage them in relation to themselves and the format."[19] Either way, *Ice and Cliffs, Kaweah Gap,* represents one of Adams' earliest successful nonrepresentational images. Adams created a photograph that does not rely on its reference to the real world for relevance or meaning.

As the years passed, Adams made fewer extended treks through the high mountains, but he kept working. He consistently found views from which he could make compelling and persuasive photographs that demonstrated the nourishing potential of our unpeopled wilderness. Sometimes those spots were surprisingly near at hand.

Adams' *Clearing Winter Storm, Yosemite National Park,* made around 1937 [plate 105], seems impossibly pristine: Surely such a dramatic view is available only to those who hike vast distances over challenging terrain. Yet Adams set up his tripod at a spot sometimes euphemistically referred to as the Wawona Tunnel Esplanade, but

more typically known as the parking lot just east of the Wawona Tunnel. Adams was likely staying in the valley at the time, just a short drive away.

As he had many times before, Adams framed the scene to include El Capitan on the left, Bridal Veil Falls on the right, the tree-filled valley in the foreground, and the sky above. Adams used the moody clouds to reveal and conceal details of the granite cliffs, as the already spectacular Yosemite took on snow. He further sculpted the scene when he printed the photograph, using the darkroom techniques of dodging and burning.[20] The storm moving through the valley added an element of drama, underscored by the title *Clearing Winter Storm*.

Adams made this photograph to share the vision of his experience with us, viewers who would one day see the resulting print. He invites us to join him in a moment of appreciation, as he memorializes his experience of watching a storm transform Yosemite into a glittering jewel box of trees laced with snow. We become Adams' companions, standing at his side across distance and time.

1 Ansel Adams, *An Autobiography* (Boston: Little, Brown, 1985), p. 56. Other companions included Admiral Charles Fremont and his daughter Elizabeth (Bessie) Keith Pond, Harold Saville, and Mr. and Mrs. Lee Stopple. Keith-McHenry-Pond Family Papers, 1841–1961, Bancroft Library, University of California, Berkeley; H. D. Saville to Charles Adams, May 17, 1920, unpublished letter, in the Ansel Adams Archive (AAA) at the Center for Creative Photography (CCP), University of Arizona; and Ansel Adams to Charles Adams, June 8, 1920, unpublished letter, AAA in the CCP.

2 Adams, *Autobiography*, p. 56. Joseph N. LeConte also served as the second president of the Sierra Club, after John Muir.

3 Joseph LeConte, Jr., oral history interview by Anne Van Tyne, November 10, 1983, Colby Library, San Francisco, p. 5.

4 Ibid.

5 Francis P. Farquhar, "Place Names of the High Sierra," *Sierra Club Bulletin* 12, no. 1 (1924): p. 56. For more on Helen Marion Gompertz LeConte, see her obituary by J. S. Hutchinson, "Helen Marion Gompertz LeConte, April 11, 1865 to August 26, 1924," *Sierra Club Bulletin* 12, no. 2 (1925): pp. 148–55.

6 Joseph N. LeConte 1925 Diary, LeConte Family papers, Joseph Nisbet LeConte, C-B 452, Carton 1, Kings River Region Folder–1925–1930, Bancroft Library, University of California, Berkeley.

7 Joseph N. LeConte, *Sierra Club Bulletin* 4, no. 4 (1903): p. 259, quoted in Farquhar, "Place Names," p. 56.

8 Ansel Adams, *Examples: The Making of 40 Photographs* (Boston: Little, Brown, 1983), p. 49. Adams discusses his experimentation with pictorialism in reference to *Lodgepole Pines, Lyell Fork of the Merced River, Yosemite National Park*, his most reprinted pictorialist image.

9 Adams, *Autobiography*, pp. 87–88.

10 Mary Street Alinder, *Ansel Adams: A Biography* (New York: Henry Holt, 1996), pp. 37–39, 59, 62; Adams, *Autobiography*, p. 88. Although Alinder discusses Adams' engagement with pictorialism, in his autobiography Adams himself makes almost no mention of his pictorialist work (though he does criticize the style's shortcomings).

11 Adams, *Autobiography*, pp. 71–72.

12 Ansel Adams, *Letters and Images, 1916–1984*, ed. Mary Street Alinder and Andrea Gray Stillman (Boston: Little, Brown, 1988; Boston: Bulfinch Press, 1990), pp. 6–8 (page references for 1990 edition).

13 Adams, *Autobiography*, p. 71.

14 Adams, *Autobiography*, pp. 71–72.

15 Ansel Adams, *Ansel Adams: Yosemite and the Range of Light* (Boston: New York Graphic Society: 1979), p. 12.

16 Ibid.

17 Adams, *Examples*, p. 11.

18 Karen E. Haas and Rebecca A. Senf, *Ansel Adams in the Lane Collection* (Boston: MFA Publications, 2005), pp. 120–21.

19 Adams, *Examples*, p. 11.

20 Most traditional photographic prints are created by exposing light-sensitive paper to the pattern of tones in the negative. Usually a color or gelatin silver print (the most common type of black-and-white photograph) is created with a film negative and printed in the darkroom, using basic techniques. If the photographer wants a particular area to be lighter or darker in relation to the overall print, allowing additional light to shine on that area of the paper creates a darker area (burning), while blocking some of the light creates a lighter area (dodging).

The *f*/64 Manifesto (1932)

The name of this Group is derived from a diaphragm number of the photographic lens. It signifies to a large extent the qualities of clearness and definition of the photographic image which is an important element in the work of members of this Group. . . .

Group *f*/64 limits its members and invitational names to those workers who are striving to define photography as an art form by simple and direct presentation through purely photographic methods.

The Group will show no work at any time that does not conform to its standards of pure photography. Pure photography is defined as possessing no qualities of technique, composition or idea, derivative of any other art form. . . .

The members of Group *f*/64 believe that photography, as an art form, must develop along lines defined by the actualities and limitations of the photographic medium, and must always remain independent of ideological conventions of art and aesthetics that are reminiscent of a period and culture antedating the growth of the medium itself.

— In Therese Thau Heyman, ed., *Seeing Straight: The f.64 Revolution in Photography* (Seattle: University of Washington Press, 1992), pp. 20–24.

Sharp as a Tack, Mysterious as the Universe
Ansel Adams Photographs Water

Phillip Prodger

"Mid-afternoon," Ansel Adams recollected. "A brisk wind breathed silver on the willows bordering the Tuolomne, and hustled some scattered clouds beyond Kuna Crest."[1] It was 1931, and Adams had been given the job of describing the Sierra Club's annual outing in Yosemite National Park for the club's official *Bulletin*. As soon as the trip began, the assembled group was eager for adventure. "A little tired and dusty," he admitted, but "already aware that contact with fundamental earthy things gave a startling perspective on the high-spun unrealities of modern life."[2] The trail wound down through Tuolomne Canyon in western Yosemite, through Muir Gorge, and past Waterwheel Falls. "There was much regret over the unprecedented low water," he wrote. The falls "were only suggested by feeble jets from glassy cups of granite."[3] Adams was philosophical. "It is a typical modern conceit to demand the maximum dimension and maximum power in any aspect of the world—whether of men or mountains. It is better to accept the continuous beauty of things as they are, and forget comparisons of effects utterly beyond our control. An Oriental aesthete would never question the exquisite charm of those pale threads of water patterned on shining stone."[4]

By the time he wrote this account, the 29-year-old Adams had already been photographing in Yosemite for 15 years. So magnetic was its pull that it existed in his imagination before he viewed it in life; his first encounter had been in the pages of J. M. Hutchings's *In the Heart of the Sierras* (1886), which he first read in April 1916 while convalescing from a cold.[5] Based on its florid descriptions, Adams convinced his parents to take him to Yosemite for vacation that summer. The place made an immediate impression on the 14-year-old boy. "The splendor of Yosemite burst upon us and it *was* glorious," he remembered. "The river was mostly quiet and greenish-deep; Sentinel Falls and Yosemite Falls were booming in early summer flood, and many small shining cascades threaded the cliffs. There was light everywhere!"[6]

Adams' parents gave him a Kodak Box Brownie on the second day of the trip, and he immediately began to take pictures. In one well-known incident, he climbed to the top of a rotting tree stump to get a good vantage for viewing Half Dome; the shutter fired inadvertently as his perch gave way, and he tumbled headfirst into a bed of pine needles.[7] When he took the film to Pillsbury Pictures

in Yosemite Village to be developed, it was no less than legendary photographer Arthur Pillsbury (1870–1946) who gave him back the uncut negatives, asking how it was that a single frame had come to be upside down in relation to the others.[8] The elder photographer received the boy's tale with skepticism, but the image became one of Adams' favorites.

Judging from photographs of the trip preserved in the Ansel Adams Archive at the University of Arizona, Tucson, certain elements of Adams' vision endured throughout his career. His passion for landscape took fire from the start, so that on his arrival in Yosemite, he recorded virtually everything around him, from majestic mountains and sheer rock cliffs to luxuriant forests and meadows. However, favorite subjects quickly emerged.

The Adams Archive includes two albums of photographs made by Adams after early trips to Yosemite. One, reliably dated to 1916, is widely accepted as a compilation of Adams' own photographs. The other, sometimes dated to 1915 on the basis of earlier photographs it contains, also includes numerous pictures of Yosemite in the same format. Although Adams' role in assembling the second album is undisputed, the attribution of the photographs within is sometimes questioned, given stylistic differences between the first and second albums. Nevertheless, the overwhelming similarities in subject matter between the two albums and the lack of a plausible alternative point to Adams as the most likely candidate to have made them. Regardless of who took them, the photographs in the second album clearly demonstrate Adams' early interest in water in the landscape. For example, Adams dedicated an eight-page section of the second album to photographs of waterfalls and rapids, arranged three across and two deep [figure 2]. These early depictions of water include rapids on the Merced River (especially the whitewater stretch known as Happy Isles), and Yosemite, Vernal, Nevada, and Bridal Veil Falls. The quantity of aquatic sites Adams recorded in those early days is remarkable. Water, and the seemingly endless possibilities for interpretation it afforded, had him hooked.

Even at this early date, Adams was experimenting with different ways of depicting water, shooting from close range and far away, and trying out different angles. Distant views might show a waterfall

Figure 2
Attributed to Ansel Adams
Views of Yosemite National Park, about 1916
From Ansel Adams, International Exposition Album, begun 1915

as a small white smudge on a remote ridge or as a thin ribbon descending a rocky outcrop. Close-ups showed roiling masses of water, overwhelming in their complexity and crowned with licks of foam. The album concluded with a photograph clearly not from Adams' own camera: a mysterious image of a gigantic wave crashing over the side of a ship at sea, a hapless sailor clinging to the rigging for survival [figure 3]. It appears in the album without explanation. Perhaps Adams intended this image to symbolize the tidal wave of excitement that marked his first forays into Yosemite, or his youthful thirst for adventure. Or possibly he included it simply for inspiration. The picture was a marvel. How, Adams might have wondered, did the photographer choose the right moment to capture the intense, thunderous urgency of a colossal crashing wave? Could he himself do something similar?

The previous year, on the grounds of the San Francisco World's Fair, Adams had made what are believed to be his first photographs. The Panama-Pacific International Exposition of 1915, as the fair

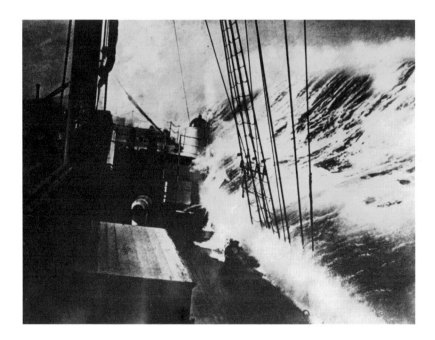

Figure 3
Maker unknown
From Ansel Adams, International Exposition Album, begun 1915

was known, was held in the Presidio district, just a few miles from his family's home on Bakers Beach. In the classroom, Adams was a maladjusted student, prone to bouts of hyperactivity, weeping, and hysterical laughter. He would later describe his father, Charles, as "unorthodox" for taking him out of school, but given his son's erratic behavior and the family's limited financial resources, he probably had few good alternatives. He gave his son a season ticket to the fair instead of formal schooling; strolling the grounds was to be his education.[9] The young Adams, who gravitated toward both music and the visual arts, attended the noon organ recital daily and explored the art exhibits.[10] The most conspicuous displays were housed in architect Bernard Maybeck's (1862–1957) Palace of Fine Arts, which became the subject of one of the first photographs Adams ever made [plate 1].[11] Foreshadowing his later interest in water, the young artist devoted nearly half the composition to the pool in front of the Palace's central pavilion, with water cascading from the fountain in the lower left and concentric ripples emanating from its base.

The balance, sensitivity, and pictorial charm of the photograph belie a more penetrating message. During the Panama-Pacific Exposition, art was shown in numerous buildings. The Palace of Fine Arts featured historical displays and one-room treatments of masters from previous generations. Modernism and other styles of contemporary art also had a strong presence there. Examples were shown in other buildings, too, including the San Francisco Pavilion.[12] At least one reviewer heartily approved: "Call it optical music, emotional mathematics, or by whatever term you choose, the production of Picasso, Picabia, Léger, Gleizes, and their colleagues cannot be dismissed as mere impertinent pleasantry. Something of that passionate self-absorption which characterized the great seers of the past finds reflection in the aims and activities of these men."[13]

The organizers of the Panama-Pacific Exposition, unlike those of previous American world's fairs, did not shy away from controversial developments in art and included avant-garde works by younger artists.[14] Selections were even brought in from the New York Armory Show of 1913, including, notoriously, Marcel Duchamp's *Nude Descending a Staircase,* 1912.[15] As a result, visitors could survey one of the most extraordinary upheavals in the history of art in digest form,

or as one commentator put it, "Sargent evolving into Matisse, Whistler fading out in Signac, Bouguereau metamorphosing into Picasso."[16] Aiming his camera at the façade of the Palace of Fine Arts and naming his photograph *Portals of the Past,* the precocious 13-year-old Adams noted the transition from old to new.[17]

There was no mistaking where Adams' sympathies lay. He made a pest of himself in the Dada and cubism displays, at first professing not to understand them but eventually debating their virtues with one of the curators. Adams was particularly critical of the modernist reduction of form to successions of straight lines: "There are really no straight lines in nature," he told a curator attending the galleries. A crowd began to gather, and Adams argued the point for ten minutes or more. "I know there are some straight lines in crystals, and fracture planes," he conceded, "but 99.9% of nature is a fluid thing, which isn't the least bit concerned with a straight line." Adams relished the role of *agent provocateur,* and as the conversation proceeded, he refused to back down. "There isn't a straight line on the body," he argued.[18] Nor, indeed, were there straight lines in the undulating ripples portrayed in *Portals of the Past.*

Sinuous and transitory, water provided an ideal point of departure for Adams to explore new directions in modern art. In ripples and pools, cascades and rapids, he saw an antidote to what he perceived as the superficial tendencies of some of his contemporaries and their willingness to settle for a static view of a world that in reality was constantly in motion—to make "straight lines" out of curves.

Water was his siren song. Consistently, repeatedly, Adams visited the theme of water throughout his career, from his first pictures in 1915 until his death in 1984.[19] Water was to be found in his beloved Yosemite Valley; in waterfalls, streams, and rivers; and in clouds, ice, and snow. Adams also found water on the coast—near his childhood home at Bakers Beach, in the shipwrecks he discovered on Pacific headlands, and in crashing waves and seascapes. And it was evident in quiet moments: in ponds, basins and spillways, eroded rocks, barnacles, and tide pools. Water, for Adams, was an insistent and abiding passion that he carried with him wherever he went, from the islands of Hawaii to the rocky shores of New England.

A New Modernism

In a 2002 interview broadcast on public television in the United States, the distinguished American curator John Szarkowski (1925–2007) repeated an observation he often made about Adams, on whose work he was an authority. In an Edward Weston landscape, he would say, geology takes pride of place, but with Ansel Adams, attention shifts to the weather. Weston (1886–1958) was one of Adams' closest friends and confidants, a cofounder of the influential Group *f*/64, who photographed many of the same locales. Yet the two artists' works are generally easy to tell apart. With rare exceptions, most notably in his late views of Point Lobos, California, Weston featured solidity and permanence in the landscape, whereas Adams was drawn to the transitory nature of things. "In Ansel's best photographs," Szarkowski explained, "you have the sense you could identify the temperature, the relative humidity, the hour of the day, and the day of the month, because that's what they're about. He's not doing this for nothing; he's not doing this to show off. That's the nature of his subject matter, . . . [which] requires that he be able to describe the quality of the air."[20]

Urgent, elusive, and ephemeral, Adams' photographs of water have few parallels in Weston's photography. In *Nevada Fall, Profile* [plate 76], the Merced River shoots over a cliff as if propelled by a rocket, spray scattering in all directions like so many watery fireworks. In *Sentinel Falls* [plate 79], a thin rivulet snakes delicately down a verdant hillside like a Chinese brush painting. Enveloping and alarming, the waves in *Surf, Point Lobos State Reserve,* and *Wave, Pebble Beach* [plates 16, 17] pound the shore in frenzied disintegration, shaking the ground with their violent force. Rivers ebb and flow, quiet ponds shimmer and reflect, and gentle ripples lap the sand. Whatever its mood, water is often the ingredient that distinguishes an Adams photograph. If Weston was geology, as Szarkowski had it, Adams was not merely weather. He was the riotous instability of our natural surroundings.

Adams is now so highly regarded, and his work so enduringly popular, that it is hard to comprehend a time when he represented the radical fringe of contemporary art. Yet he was one of the most vocal advocates for a new type of photography based on a machine aesthetic. When Adams came of age in the 1920s, photography was in the midst of a fundamental transformation. In the late nineteenth

century, pictorial photographers dominated exhibitions and salons. Their soft-focus, narrative style was designed to resemble traditional prints and drawings. In their day, pictorialists were themselves groundbreaking, arguing that a photographer could do anything a painter or printmaker could. Yet with the onset of the First World War, what once looked ingenious began to seem nostalgic and dated. A new generation of photographers wanted to reinvent art based on the unique characteristics of camera and lens. This new breed was hard-edged and uncompromising, their subjects laid bare by the camera.

In Germany and the rest of continental Europe, this style became known as the *Neue Sachlichkeit,* or "New Objectivity," movement, a loosely associated group of literary, musical, and visual artists that included the photographers Albert Renger-Patzsch (1897–1966) and August Sander (1876–1954). In New York an analogous circle coalesced around the American photographer and gallery owner Alfred Stieglitz (1864–1946), including Paul Strand (1890–1976), Edward Steichen (1879–1973), and Gertrude Käsebier (1852–1934). Living on the American West Coast was both a blessing and a curse for a photographer. Californians like Adams were largely immunized from the furious debates raging to their east, but their physical distance also left them somewhat outside the mainstream of critical discourse.

Nevertheless, the issues raised in European and American capitals were acutely felt in the American West, where pictorialism continued to hold sway well into the 1920s. Adams joked about these antique holdovers, blaming them for his recurring bad back: "I am of the opinion that such afflictions relate to a life of sin—this life or an older one; I might have been a Pictorialist in a previous existence!"[21] The truth was that many of those who ultimately came to exemplify the austere modern look began their careers as pictorialists. Vestiges of the approach are even evident in some of Adams' early photographs—the tender light of the setting sun in *China Beach* [plate 2], for example, or the impressionistic blur of *Rainbow Falls* [plate 12]. In more generous moments, Adams conceded that pictorialism was not so much inferior as it was simply of its time. He likened transformations in art history to the moods of water: "One can never assert the superiority of the vast decorations of the Sistine Chapel over some pure experience in line by

Picasso," he wrote, "or of torrents swollen by the floods of spring against the quiescent scintillations of an autumn stream."[22]

In his photographs of Yosemite in the 1920s, Adams can be seen wrestling with cutting-edge developments in photography, which he would have gleaned largely from magazines and exhibitions. In *Marion Lake* and *Kearsarge Pinnacles* [plates 8, 9], water elements are reduced to graphic planes, with an altered sense of perspective recalling Japanese woodblock prints. In *Mount Clarence King* [plate 6], a pool takes on the shape of the mountain it reflects, the checkerboard pattern of clouds, trees, and rock forms creating a dazzling array of partially repeating shapes. And in *Fall in Upper Tenaya Canyon* [plate 14], a cascade appears like a gash in the rock, a sizzling lightning bolt of white against a jumbled, rocky outcrop.

San Francisco was not without its own modern pioneers, who challenged the stubborn hold of pictorial salons and photo clubs. Foremost among these pioneers was William Dassonville (1879–1985), whose work neatly bridged older and newer styles. Adams knew Dassonville well. "He was very kind to me," Adams recalled, "and he helped me a great deal."[23] Dassonville was both a photographer and a photographic paper manufacturer. Adams used Dassonville paper extensively before 1933, when he switched to other brands with smooth, glossy surfaces.[24] For example, he used a textured "charcoal black" Dassonville paper to print certain prints from his 1927 folio *Parmelian Prints of the High Sierras,*[25] and worked with Dassonville to develop a specially coated paper for the letterpress pages in his book *Taos Pueblo* of 1930.[26] In 1940, when Adams was asked to serve as curator of the photography section for the Golden Gate Exhibition on Treasure Island, Dassonville was among the artists Adams chose for the display.

Dassonville made many of his photographs in and around San Francisco Bay and was praised particularly for his pictures of water and ships. He often photographed incongruous juxtapositions of natural forces and urban life, hinting at the tenuous nature of civilization. In his *San Francisco Great Beach* [figure 4], for example, a whitecap crests offshore, while an ordinary street scene transpires on land. People stroll absently along a cliff walk, past parked cars and a gas lamp, while a solitary figure sits on a boulder, looking off to the left. They pay no attention as the wave rolls by in the distance,

untamed. The "split screen" effect of the people going about their business while nature marches on in the background was typical of Dassonville's work, which conveyed the irony of living in close proximity to unbridled forces of nature. These were the same forces that Adams would strive to record in his own photography.

Despite the advances made by Dassonville and others, throughout the 1920s the modern photographic community failed to coalesce in Northern California the way it had in New York and other cultural capitals. Seeking to fill the vacuum, Adams and a group of like-minded individuals formed Group f/64 in 1932. In addition to Adams and Edward Weston, the group included photographers Imogen Cunningham (1883–1976), John Paul Edwards (1884–1968), Sonya Noskowiak (1900–1975), Henry Swift (1891–1962), and Willard Van Dyke (1906–1986). Although Group f/64 did not last long—it had effectively disbanded by 1935—its influence was to be considerable.

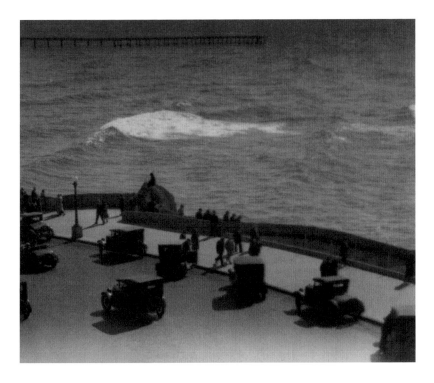

Figure 4
William Dassonville (1879–1957)
San Francisco Great Beach, 1920s

The group took its name from the smallest aperture commonly obtainable on lenses of the time: "f-stop" 64. Most commercial lenses have a diaphragm inside them that controls the amount of light that can pass through the lens to expose the picture. The aperture is a hole in the center of the diaphragm that can be opened or closed to admit more or less light. Under dim conditions, the aperture is usually opened wide to allow as much light to enter as possible; conversely, under bright conditions, the aperture is stopped down. On most lenses, f/64 represents a tiny window through which light can pass. The group took f/64 as its namesake because photographs made at this aperture are exceedingly sharp and have the maximal range of focus from foreground to background (also called *depth of field*). In other words, everything seen in an ordinary photograph shot at f/64 is clear.

The idea behind Group f/64 was to make pictures the way the camera sees, not the way the human eye does. Only a machine can render every detail of a scene in sharp focus, members reasoned, so for photographers to make the most of the medium, they had to exploit its unique capabilities. According to the group's manifesto, members strived to make pictures that were purely photographic in nature and not derived from any other art form. This doctrine was a direct challenge to the pictorialists, who sought to make photographs that looked like drawings or paintings. "We were fighting the idea of photographs imitating the feeling or the looks, the appearance of other media," Adams recollected. "The straight photograph was sneered at. There was no possibility of it being art, so earlier photographers were always trying to add something to simulate art."[27]

Before modernism, photographers were encouraged to control areas of relative sharpness and blurriness, highlighting passages of interest and guiding the eye through the picture. In the late nineteenth century, controlling differential focus was considered a photographer's duty; to abrogate this responsibility was to promote visual chaos. Applying consistent sharpness throughout the picture plane, as f/64 artists advocated, was considered vulgar.

It is a testament to the movement's success that viewers no longer notice the studied use of focus in Ansel Adams' photographs. Long after f/64 ceased to exist, Adams continued to make pictures in which foreground, middle ground, and background are equally sharp. With

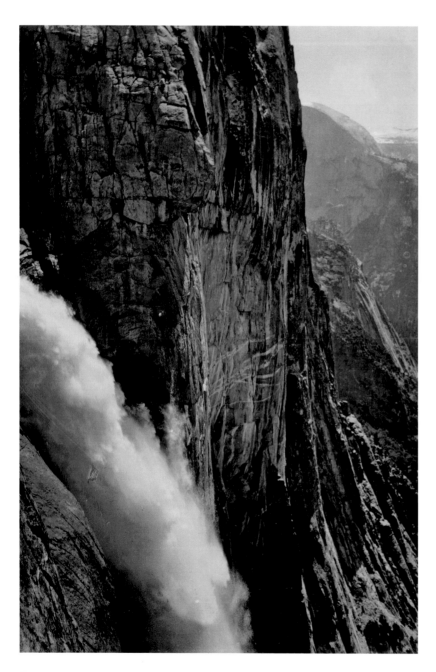

Figure 5
Joseph N. LeConte (1823–1901)
The Lip of the Upper Yosemite Fall, May 31, 1896

rare exceptions, nearly all Adams photographs follow this simple rule. Adams and his cohorts made such pictures seem normal, but in the 1920s and '30s, there was little precedent for fine art photography made this way.

Produced during *f*/64's heyday, the 1933 photograph *Evolution Creek* [frontispiece] is an excellent example of how the sharp-focus technique could be applied to an aquatic subject. Adams took the image partway up the trail to the rim above Evolution Basin in King's Canyon, California, aiming his camera down and back into the ridgeline. The granite escarpment in the foreground seems to begin just under the photographer's feet, giving the picture a feeling of intimacy. In the middle foreground, a turbulent jet of water cascades from an unseen source, thrusting upwards where it hits a rock or a dip in the stone. In the far distance looms the angular form of Mount Huxley, sharply focused and bathed in sunlight. The shape of the water jet closely mimics the mountain, creating a visual connection between the two. The mountain—barren, stolid, and motionless—contrasts with the water—vibrant, complex, and energetic. Separated by miles, they are nonetheless equally in focus, the space collapsed between them.

By positioning his camera so that mountain and water jet appear almost the same size, Adams gave the picture another level of meaning. Water is both the vitality of the mountains and the force that erodes them; the life it brings to bare stone is also the entropy that wears it down. Symbolically, mountain and water are intertwined. Given that Evolution Creek and the surrounding mountains are all named after concepts and leaders in the study of evolution, Adams could scarcely resist the irony apparent in such a conspicuous geologic struggle.

By applying his sharp-focus technique to a subject as complicated and unpredictable as moving water, Adams heightened the drama of his pictures. Sharp focus is the irresistible force to water's immovable object, the permanent record of something so intricate it is practically impossible to see. This tension is what makes so many of Adams' photographs of water so exhilarating. Turbulent water is made up of countless channels of water pushing in all directions, splashing and swirling within themselves, and sending up drops of spray.

Photographed in sharp focus, the elaborate contours of rushing water are seen in a way that is difficult to appreciate with the naked eye. In photographs such as *Cascade, Yosemite National Park* [plate 71], immersion in the otherworldly textures of rushing water is so complete that at first it is hard to recognize what the image depicts.

Stylistically, Adams' mature style has more in common with mid-nineteenth-century topographical photography than with his pictorial antecedents. Adams made no secret of his admiration for Victorian-era geological survey photographers, collaborating with Museum of Modern Art, New York (MoMA), curator Beaumont Newhall (1908–1993) on the exhibition *Mathew Brady and the American Frontier* in 1942, and jokingly signing his name "Matthew Brady" in their correspondence.[28] Adams befriended the elderly William Henry Jackson (1843–1942), who was living in New York at the time, and escorted him to the show's opening as guest of honor.[29] Writing in the journal *Camera Craft* during the run-up to the Brady exhibition, Adams commented on the similarities and differences between the work of Group *f*/64 members and that of photographers such as Jackson and Brady. There were superficial points of convergence, he acknowledged, but there were also key differences. "The style of the early days is one thing, and the aesthetic intentions (or lack of them) of the early photographers, another."[30]

Not that photography had to be high-minded to be worthwhile. Adams was a close friend and admirer of the mountaineer, professor, and amateur photographer Joseph N. LeConte (1870–1950), whose negatives Adams printed around 1970 and deposited at the Bancroft Library at the University of California, Berkeley.[31] Adams considered LeConte "a marvelous man, a very intelligent man, a very important person in Sierra history" and embarked on the printing project with enthusiasm.[32] The best of LeConte's photographs, such as *The Lip of the Upper Yosemite Fall* [figure 5], convey LeConte's genuine sense of wonder in the presence of natural beauty. However, as Adams' project evolved, he came to doubt the work's artistic merit. "Looking at them today, I wonder why I took so much interest in them as photographs,"[33] he shrugged, concluding that they are "completely uninspired but perfectly honest photographs." He explained, "Other people couldn't

tell the difference between his approach and my approach, but he was sensitive enough to realize that I was trying to add something. I thought that was a very generous thing, because I definitely was adding a point of view, where he was interested in the scientific and the factual."[34]

By contrast, Adams held the work of Timothy O'Sullivan (1840–1882) in particularly high regard and donated his *Black Canyon, Colorado River from Camp 8* [figure 6] to MoMA's permanent collection. With the wet-plate collodion technology of O'Sullivan's day, which was insensitive to long wavelengths of light, sources of ultraviolet light had a tendency to overexpose the negative. O'Sullivan's genius lay partially in his ability to anticipate the effects this overexposure would produce and to use that knowledge to create graphic elements in his compositions. In *Camp 8,* the sky was so overexposed that it printed as a jagged mass of white. The river registered as a mix of dark and light hues according to

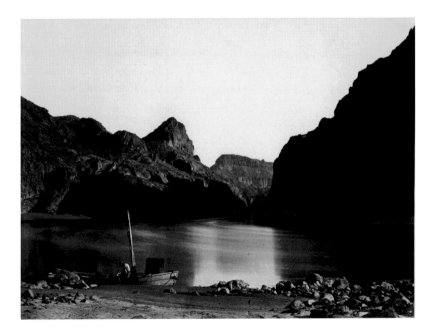

Figure 6
Timothy O'Sullivan (1840–1882)
Black Canyon, Colorado River from Camp 8, Looking above, 1871

the different wavelengths of light reflected off its surface. To Adams, the fact that O'Sullivan previsualized these elements indicated control of his materials with the aim of interpreting, not just recording, what he saw. "O'Sullivan had that extra dimension of feeling," Adams said. "You sense it, you see it."[35]

Experience and Equivalency

Adams held dear the ability to express personal experience through photography. It is a concept Alfred Stieglitz had forged with his multiple *Equivalents* [such as figure 7], the series of horizonless cloud photographs that he produced from 1923 to 1934. Initially, Stieglitz called these photographs *Songs of the Sky,* a title the accomplished pianist Adams would no doubt have appreciated. Adams greatly admired Stieglitz, whom he met in 1933; Stieglitz gave Adams one of his first important exhibitions at his American Place Gallery in New York in 1936. The show proved to be pivotal. Not only did it bring his work to an eastern audience for the first time, but it also provided Adams with a welcome injection of money and morale, as eight pictures sold to the prominent collector David Hunter McAlpin. "This I know positively," Adams wrote to Stieglitz. "The Place, and all that goes on within it, is like coming across a deep pool of water in the desert. This would be a trite statement if I were referring to an ordinary sentimental pool in an ordinary desert, but it is the only metaphor I can lean on now. Whoever drinks from this pool will never be thirsty."[36]

Adams credited his encounters with Stieglitz and Paul Strand in the early 1930s with molding his artistic philosophy. In retrospect, Adams believed that his approach had been incoherent and needlessly romantic before he met these two modern masters. "Stieglitz's doctrine of the Equivalent as an explanation of creative photography opened the world for me," Adams elaborated. "In showing a photograph, [Stieglitz] implied, 'here is the equivalent of what I saw and felt.' That is all I can ever say in words about my photographs; they must stand or fall, as objects of beauty and communication, on the silent evidence of their equivalence."[37]

Adams revered Stieglitz's notion of equivalency. To Adams, this meant that the photograph and what it depicted were to be equated with the artist's emotional state. This, he believed, was the core of

Stieglitz's idea. Adams interpreted Stieglitz to be saying: "When I see something I react to it and I state it, and that's the equivalent of what I felt. So, therefore I call my print 'equivalent,' and I give it you as a spectator, and you get it or you don't get it, you see, but there's nothing on the back of the print that tells you what you should get."[38]

Stieglitz himself left open the question of what, exactly, was being equated with what. Equivalency might mean equating one photograph with another—that each photograph is, in some sense, the same. Or it might mean that one subject is as consequential as the next—that a depiction of a cloud can be as meaningful as one of a waterfall, for example. Alternatively, it might be understood to mean that the visual character of a photograph is equivalent to the thing it depicts, the memory of making it, and the way it resonates in the mind. Stieglitz undoubtedly meant it to encompass all these things. It was a theoretical portal through which all manner of concepts could be brought together.

Adams referred to equivalency in lectures and interviews throughout his career, and he particularly appreciated when audiences took the subject seriously. Speaking before the Century Club of California in 1949, for example, he reported: "Showed the Portfolio [*Portfolio One,* 1948] and talked a bit about my concept of the Equivalent. Got nine intelligent questions on the subject."[39] Adams' 1959 photograph *Clouds and Sun, San Francisco* [plate 92] so closely resembles Stieglitz's *Equivalents,* made decades before, that it is almost certainly an affectionate pastiche. But Adams did not have to emulate Stieglitz directly to convey his own emotional state. In keeping with Stieglitz's vision, any subject could provide grounds for exploration. Clear, malleable, and reflective by nature, water served as an ideal blank slate for artistic expression. Arguably, oceans, rivers, and waves were to Adams what clouds had been for Stieglitz.

The photographs Adams made of the Hawaiian coast in 1948, and his subsequent pictures of waterfalls, lakes, and glaciers the following year, present a unique window on his thinking about photography and emotional states. In April 1948, armed with a Guggenheim Fellowship and a desire to explore new territory, Adams set sail for Hawaii on the cruise ship SS *Matsonia.* He found the voyage a chore, with little to do and not much in common with his

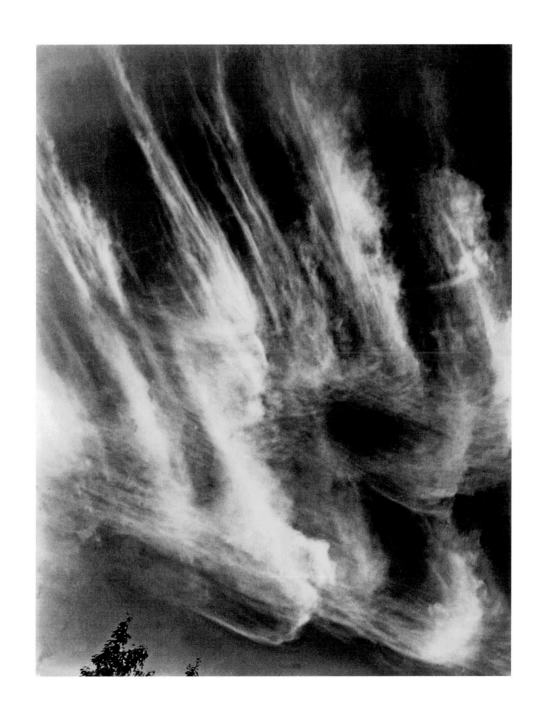

Figure 7
Alfred Stieglitz (1864–1946)
Equivalent, 1930

fellow passengers. With time on his hands, 375 miles outside of San Francisco, his thoughts turned to his frustrations with the art world. He explained: "[It] has become for me a thoroughly distasteful thing. The shallow striving for new means of expression when there is nothing to express; the stupid reiteration of posturings, of esoteric standards; of departure from visual and tactile nature; I confess I am stumped, confused, and discouraged by it all."[40] If such is the nature of art, he continued, he would rather be a coal miner. "There is something honest about coal. Coal burns. But contemporary art does not."[41]

His mind filled with such pessimism, Adams arrived in Hawaii a few days later. At first, the islands left him cold. The land was unfamiliar to him, and he was not sure how to photograph it. "The ocean is perfectly beautiful,"[42] he declared, but the air was too humid, and the sea did not smell right. "More like a bathtub," he grumbled.[43] Still, he tried to make the best of it. "Think I will try surf-board riding, just for the hell of it," he ventured.[44] But it was an idle threat. He had trouble enough trying to figure out what to do on dry land.

To make matters worse, colonial society troubled him, and he was constantly being introduced to the worst kind of poseurs. "The whole attitude is that the lords of the manors (plantations) are the vortex of all activity and the very lives of the people. Few can escape. . . . What Honolulu needs is a real good volcanic eruption—with time for the natives to take to their boats."[45] The trip resulted in a few good pictures, but not what Adams had hoped for. "My mind (the real mind) is way off somewhere else and I am here going through the actions of making pitchurs [sic]," he confided.[46]

Nearly ten years later, at the invitation of the Bishop National Bank, Adams would return to Hawaii and make a stunning group of photographs, including *Makapu Point, Oahu* [plate 36]. These new pictures became the basis for the book *Islands of Hawaii* (1958).[47] But that was for the future. For now, California beckoned him home. "Hawaii looks a little better now that I have seen the best parts. But I still yearn for pine needles, hard granite, clear water, and DRY air!"[48]

Sailing back on the SS *Lurline* (coincidentally, the same vessel on which Georgia O'Keeffe had sailed to Honolulu in 1939), Adams was so eager to return to California that catching sight of land, he nearly jumped out of the boat to swim home, coming to his senses only when he realized that the boat could make the distance more quickly.

No sooner had he returned than he was planning a trip to Yosemite. The hike would take him through territory Adams knew well—the same track he had taken with the Sierra Club outing in 1931, commemorated in his article in the club *Bulletin*. A few weeks later, the trek complete, he wrote breathlessly to his friends Beaumont and Nancy Newhall: "The return within the last 2 hours from the glorious Tuolomne Canyon and the Waterwheel Falls! A two day trip fraught with 40 pounds of knapsack, 18 miles of hiking, and rain in the AM (rain-soaked bacon and eggs, coffee so strong it etched the cup), but yesterday Oy!! such an incredible display of water going fast down-hill!"[49] Unlike in 1931, when Waterwheel Falls had been reduced to "feeble jets" in "glassy cups," in June 1948 it was in its full glory.

The spring thaw had been abundant, and the falls swelled with water flowing from high ground. The photograph Adams took that day, *Waterwheel Falls* [plate 74] shows the cascade at full force: a thunderous, pulsating torrent, with crosscurrents erupting in fountains of spray. Adams' photograph is ecstatic—a joyous outpouring of emotion, a celebration of life itself. He was so enthusiastic that he did not wait for the negative to be developed, instead sketching the cascade in blue ink in the margin of his letter to the Newhalls, illustrating rolling waves of water descending the full 1,200-foot height of the falls [figure 8]. "Celebrated with beer and stronger, shower, more drinks and longer," he reported.[50] He was on home ground at last.

Yosemite reinvigorated Adams. *Waterwheel Falls* marked the release of the pent-up anxiety of the previous months: frustrations with the art world, disappointment in Hawaii, seemingly interminable travel, and longing for home. The photograph's exuberant energy reflected his physical and mental resuscitation. Adams was unfailingly professional, yet he was never fully able to separate his personal feelings about a subject from his art. Nor, for the most part, did he try to do so. His individualistic brand of modernism sought to convey the artist's experience in the presence of the subject. Accordingly, the picture embodied what he was feeling on the day he made it.

June 20th 1948

To B ∝ N :

What a wonderful letter. Yep! Not much to say except cheers and again cheers and all the best
things in the world for you two - who so richly deserve them.

Another feather in the cap for EK if they get Beaumont! I had a hunch things were simmering;
B. made a deep impression on everybody.

If this is not coherant, the reasons are: 1st, the letter from you.

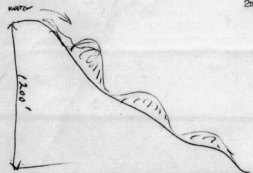

2nd, the return within the last 2 hours from the
glorious Tuolumne Canyon and the Waterwheel
Falls! A two-day trip frought with 40 pounds
of knapsack, 18 miles of hiking, and rain in
the AM (rain-soaked bacon and eggs, coffee so
strong it etched the cup), but yesterday Oy!!
such an incredable display of water going fast
down-hill! Al Gay, John Salathe', and the little
darkroom gal accompanied Adams. Al Gay getting a
good perspective on the Natural Scene! Arrival
home from Tuolumne Meadows celebrated with beer
and stronger, shower, more drinks and longer; &
thy letter and this answer;plus eight letters,
2 packages prepared and shipped, and a telephone
call to S.F. SO!

At any event, while reasonably sober, here is my schedule:

a. leave here June 23rd for S.F.
b. leave S.F. for Seattle June 25th
c. leave Seattle (with Mike) on June 30th for Skagway and points north.
 address: c/o Alaska Transportation Company, Pier 58, Seattle 1, Washington.
 mark" passenger on ss George Washington,sailing June 30th)
d. arrive points north about July 5th or 6th. address: c/o Superintendent, Mount McKinley
 National Park, Alaska. write airmail!
e. arrive Sitka Alaska, about July 25th. Address - c/o Grant Pearson, Sitka National Monume
 leave Sitka about Aug.5th SITKA, Alaska ment
f. arrive Seattle, August 8th. address Alaska Transportation Company,mark, please hold for
 arrival Attn: Mr. K.Katz GPA.
g. proceed to Yellowstone National Park to arrive there August 13th. details on this later.
h. return to Yosemite about Sept. 5th. work on Portfolio
i. East by train early in Oct. work in Eastern Parks. see note
j. return Yosemite in November. finish Portfolio
k. take breath. see second note.

NOTE 1. The idea of driving west (through the Everglades perhaps) very exciting) Much to be
 done here, too. enclose today's letter from Edward.

NOTE 2. Beaumont, on return from Europe, should visit me (professionally) in Yosemite for the
 Christmas celebrations, etc.

On second page you will find various suggestions, etc. pertaining to my personal opinions of the
Newhalls and their destiny/
 Must be taken in the spirit in which they are given; just ideas that
ooze from the subconscious. They may be of value and they may not. At any event- here they are:-

Figure 8
Letter from Ansel Adams to Beaumont
and Nancy Newhall, June 20, 1948

When Adams was particularly fond of a place, it showed. In 1949, for example, Adams flew through southern Alaska in a Grumman Amphibian airplane, accompanying a mission that was dropping relief supplies to advance bases on the Juneau Ice Field. His animated account of that flight reflected his excitement about the place: "We crossed and recrossed 600 sqm of glaciers and ice fields, and encircled the most incredible crags and spires I ever imagined. . . . Pictures will not describe it! The rear door was open to permit dumping loads by parachute. I am full of fresh air, spray on the take-off, noise, but simply unbelievable scenery. I am afraid Alaska is the Place for me! I am NUTS about it."[51]

Not surprisingly, Adams made several of his most evocative aquatic photographs in Alaska: a poignant treatment of Glacier Bay in dim evening light with a boat plying the waters in the distance [plate 38], probably made during the Grumman trip; the shimmering, interwoven flow of the Teklanika River passing through gravel banks [plate 54]; and the celebrated *Mount McKinley and Wonder Lake* [plate

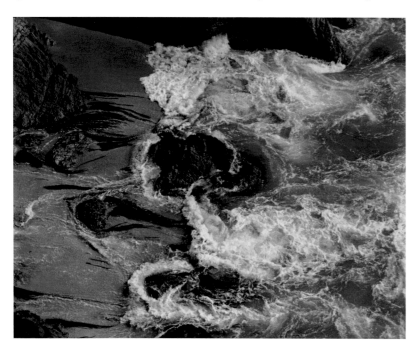

Figure 9
Edward Weston (1886–1958)
Surf, China Cove, Point Lobos, 1938

63]. In this last photograph, snow covers the mountain, creating subtle modulations of gray on its surface, while the lake beneath the mountain glows with the reflection of the frozen crags—a metaphorical window to another realm. Knowing and understated, it was not the sort of photograph Adams would likely have made on his first Hawaiian trip.

A measure of self-doubt is common even among the most celebrated artists, and Adams, only human, was susceptible to feeling down at times. But on his departure for Hawaii in 1948, it had not been just a general malaise that had possessed him; it had been a particular frustration with the culture of making art. Writing to Beaumont and Nancy Newhall, he had explained his strange mood. "I can only describe [it] as fundamental; I suddenly am aware of a deep weakness in art and its relation to humanity. . . . I am convinced now that I am heartily sick of Art for Art's sake. It seems to lead nowhere but to anaesthesia."[52] This was a period in which Adams was wrestling with deep questions about the purpose of art and his role in the art world.

One answer, he believed, lay in the differences between his work and Weston's. "[He] is sculpting nature," Adams explained, whereas "I try to reveal by penetration and enlargement of experience."[53] Adams' words foreshadowed Szarkowski's comparison of Weston and Adams as the "geology and weather" of modernist photography. But the analogy could only stretch so far. The acutely observed and frequently affecting photographs Weston made on Point Lobos in the 1930s and '40s matched Adams's work in penetration and experiential weight—as water, ironically, became one of Weston's subjects [figure 9]. It stood to reason: Adams once described Weston as an "ocean surge" of a man.[54]

Adams maintained a special affection for the landscape of California, focusing much of his attention within a roughly two hundred–mile radius of his birthplace on the shores of the Golden Gate in San Francisco. North of the city, he photographed in Marin, Sonoma, and Mendocino Counties, in locations such as Dillon Beach, Bolinas, Elk, and Bodega Bay [plates 18, 26, 37, 41]. To the south, he photographed the coastlines of Monterey, San Mateo, and Carmel [plates 23, 27–31, 33–35, 94]. Like Weston, Adams found inspiration at Point Lobos, a headland just south of the city of Carmel. When Adams

moved to Carmel in 1962, photographing in the vicinity became more convenient. He made the sensational *Surf, Point Lobos State Reserve,* 1963 [plate 16], for example, shortly after his relocation and *Wave, Pebble Beach,* 1968 [plate 17], five years after that.

Adams was an expert mountaineer, and his photographs are imbued with a naturalist's understanding of the land. However, it is one of the paradoxes of his art that while the places Adams photographed may look wild, in reality they were often within easy access of well-known roads and pullouts. Yosemite and Bridal Veil Falls in Yosemite Valley, for example, are just a few minutes' walk on level trails from heavily trafficked parking lots. Similarly, many of the coastal vistas that feature in Adams' California seascapes can be seen from Route 1, the Pacific Coast Highway that hugs the shoreline from Los Angeles in the south to Humboldt County, more than 500 miles to the north.

Given the abundance of scenic views visible from roads and parking lots, Adams may have felt no need to venture farther to make his photographs. Yet there is another factor at play in his choice of locations. In the increasingly car-oriented culture of America in the 1940s and '50s, the places he photographed were the same ones that any middle-class person could see, given time and inclination. The connection between Adams and automotive culture was sometimes quite direct, as when in 1947 and 1948 he produced a series of pictures called *See Your West* to promote driving for the Esso oil company, or when in the same decade he produced photographs for *Arizona Highways* magazine.[55] Although he did sometimes photograph remote locations, the majority of Adams' photographs feature places other people could visit without difficulty. As a result, his pictures served as a kind of idealized guide for travelers and as points of comparison for recreational photographers. Adams was innately inclusive and encouraging of amateurs. Choosing to photograph conveniently accessible places, he ensured that others could visit them. Believing that nature is a shared inheritance, Adams wanted others to be able to see what he had seen. He had little appetite for elitism in art.

Outside of California, New England was the only coastal location that Adams photographed persistently. Over the course of decades, he explored the coast from Connecticut to Maine—especially Massachusetts, making repeated trips to Cape Cod and Boston's North Shore, where he photographed in the communities of Gloucester, Lynn, Saugus, and Marblehead. Curiously, his pictures of these towns tend to feature houses and local landmarks to the exclusion of water views. In Marblehead, for example, he photographed historic slate gravestones at Old Burial Hill but does not appear to have photographed the town's famous harbor. "In the morning we drove Ansel to Marblehead," Beaumont Newhall later recounted, "where we explored the burying ground. There he photographed in a series of details the wonderful gravestone with the skeleton of Father Time inside the endless serpent."[56] Adams photographed the Marblehead gravestone on Thanksgiving Day, spending the night in the neighboring town of Swampscott, where Beaumont Newhall's aunt lived.[57] Nancy Newhall had an aunt and uncle living in neighboring Lynn.[58] Newhall recorded no explanation for his friend's choice of subject matter, but Adams may have felt that the waters of the North Shore were too placid to make the kinds of photographs he wanted.

Adams developed a significant and lasting professional association with Edwin Land, founder of the Polaroid Corporation, and from 1949 served as a paid consultant to the company.[59] Land and Adams were kindred spirits. Like Adams, Land discontinued formal schooling to embark directly on a career, and both held an enduring fascination with photography's technical side. Adams received a hundred dollars a month for his services to Polaroid.[60] In return, he tested the company's materials in the field and made suggestions for new products. In addition, he lent his name to Polaroid advertising and helped the company develop a collection of photographs by contemporary artists (including himself) for its engineers to study. In the 1960s and '70s, he also produced a number of oversized mural prints to decorate Polaroid's corporate offices.

Adams was utilitarian in his choice of equipment, employing a variety of materials to produce his photographs. For landscape work, he favored large-format sheet film (or plates, according to the technology of the day) and view cameras, while for certain commercial projects he employed 35 mm and 120 mm roll film. No technique was off-limits, and he occasionally produced final prints with Polaroid

direct positive print technologies, as he did with *Ocean Spray*, about 1960; *Bakers Beach, San Francisco*, 1954; *Rock and Sand, Bakers Beach*, 1961; and *Clouds and Sun, San Francisco*, 1959 [plates 20, 32, 43, 92]. Adams worked with the Polaroid Corporation for so many years that he had access to most of the materials the company manufactured, including some that were never released to the public.

One of the processes Adams liked best, Polaroid Type 55, resulted in the simultaneous creation of a print and a corresponding negative. From a single Type 55 exposure, the artist received both a positive, which could be kept or discarded as a proof, and a negative, which could be brought back to the darkroom to produce more conventional looking enlargements. Because pictures enlarged from Type 55 negatives are not always easy to distinguish from those made with ordinary negative film, it is not always clear when Adams used it. He might have been able to get similar results with conventional film, but he liked the instant feedback the positive layer provided. "I've always considered the Polaroid process as an intensely creative one," Adams explained, "not only because of the inherent beauty of the material, which has, if you want to speak photo-scientifically, a linear scale and cannot be duplicated by any ordinary print. But it also has the element of immediacy. You see exactly what you're getting. When you're making a picture under static conditions, you can make an immediate correction. Or if you're working in fast situations, once you have one picture you know what the others are going to be. There is a new aesthetics involved in this immediacy, and that's what I think is so important."[61] The directness of Polaroid materials was particularly helpful when Adams was photographing something as ephemeral as water. After making an exposure, he could see quickly if the picture had registered as he had hoped.

With Polaroid's headquarters in Cambridge, Massachusetts, bordering the city of Boston, it was natural that Adams would visit New England frequently. However, his interest in the region predated his Polaroid connection by more than a decade. As early as 1936, Adams photographed *Old Wreck, Cape Cod* [plate 48], carrying over an interest in shipwrecks that he had indulged on the Pacific coast. His *Shipwreck, Helmet Rock* [plate 3], for example, from

about 1919, is one of his earliest seascapes, while the oft-neglected *Shipwreck Series* of 1931 to 1934 [plates 49–52] marked one of his first significant forays into sequential photography. It was not until the photographs of barnacles and seemingly deserted structures in Chatham and Truro, Massachusetts, in the late 1930s and early '40s [plates 45–47] that Adams' photographs of New England came into their own. In these pictures, pastoral beauty blends with quiet desolation, conveying a sense of history and the passage of time. The coast here is different from that in the West. Gone are the raw, elemental forces of the Pacific. In their place is the quiet accumulation of change over generations.

Adams was acutely aware of historical depictions of the New England coast. On arriving at Acadia National Park in Maine, for example, he described the land as "More Winslow Homer than Homer," voicing the irony that the famous rocky seashore was named after the mythical Greek paradise of Arcadia and not the celebrated marine painter.[62] Adams was aware of the seascapes Edward Hopper (1882–1967) had made at the artist colonies in Ogunquit and Monhegan Island, Maine, and he ranked Hopper among the great American artists.[63] Adams also had a special affection for the watercolors of John Marin (1870–1953), who was one of Alfred Stieglitz's favorite artists and whom Adams first met in Taos, New Mexico, in 1930.[64] Marin began painting the Maine coast in 1914 and regularly returned to the state for the rest of his life. Just before visiting Acadia National Park in November 1949, Adams and the Newhalls had visited the aging artist at his home in Cliffside, New Jersey. "We were deeply moved by his magnificent paintings," Adams recalled in his autobiography.[65] "John Marin was a tremendous artist."[66] With his boldly expressionistic layering of color, Marin was not just a modern master of seascape art. His paintings were themselves formed by liquid—pigment suspended in water, applied in waves to the paper's surface.

Adams' visit to Acadia with the Newhalls lasted from November 18 to 23, 1949. It was cold, and wind blew a thin crust of snow across the road as they drove. Adams checked in with the park superintendent on the first day, "a salty New Englander much

impressed by Ansel and his work," Beaumont Newhall noted.[67] The sky was overcast, and the three friends despaired of taking good pictures. On November 20 they found a spot by the shore where each of them could photograph the water. Newhall chronicled:

A rainy, dull and miserable morning. We didn't get out until after ten, and then we headed straight for a place which we discovered yesterday: Thunder Hole, a rock formation on the Ocean Drive. Although it was raining, both Ansel and Nancy worked away. I shot some footage with the 16mm movie camera. I was not wholly satisfied with what I photographed, largely, I think, because photographing with a movie camera is quite different from making stills. I wanted surf breaking up over the rock. Again and again I would set up and start the camera rolling. Although surf had been breaking madly before I set up, it seemed an eternity before any appeared in the finder.[68]

Disappointed, they drove farther toward Corea, a fishing village where they knew Paul Strand had photographed years before.[69] When they got as far as Winter Harbor, they stopped.

[We] pulled our respective cameras out and ran down the rocks to the sea. For here at last was what we wanted: surf pounding on rocks. . . . I shot over 50 feet of the surf. As the light waned it became more dramatic, and I made an attempt to photograph in the dull light. I don't know what Ansel or Nancy got because I was too busy racing around the slippery rocks with the movie camera. We all agreed that Schoodic Point was the best spot which we have reached in our trip and we have decided to stay another day in hopes that we can return there in good light.[70]

The next day they returned to the site, where Adams "worked like mad," making 36 exposures in the morning.[71] By the afternoon they finally made it to Strand's Corea, where they traced the photographer's footsteps, photographing old shacks and making portraits of local lobstermen. By two o'clock Adams was eager to return to Schoodic Point to make more photographs of the surf. They hurried back, and he worked until nightfall.

Only one of the pictures Adams made during these sessions became well known, *The Atlantic, Schoodic Point, Acadia National Park* [plate 39]. It appeared in his *Portfolio Two,* dedicated to images of national parks and monuments. The photograph is unique in Adams' output in that it shows surf crashing at twilight. The composition is also unusual because it depicts water draining off a stone ledge toward the viewer, creating a turbulent pool in the foreground as currents cross and the direction of flow becomes confused. Photographed in fading light, the water blurs from the long exposure needed to record it. Chaotic, melancholy, and complex, the picture reflects Adams' exhaustive investigation of water and his determination to find a novel approach to an otherwise familiar subject. "All in all," Adams sighed, "results better than I should have hoped for under the weather conditions."[72]

Time as Subject

In his frequent explorations of water, Adams was the inheritor of a robust tradition that had its roots in the origins of photography. The medium as he knew it was technically advanced: Speedy panchromatic plates and film were commercially available, cameras and lenses were quick and efficient, and a variety of reliable photographic chemicals were readily available. However, when photography was invented in the 1830s, the situation was decidedly different. Photography then demanded considerable specialist knowledge and skill, as materials had to be made from scratch. The technical capabilities of early photography also fell well short of the medium that Adams knew. Emulsions were slow, exposure times were long, and photographers struggled to capture any subject that contained motion, without the results looking unintentionally blurry.

This frustrating state of affairs gave rise to a grassroots uprising in the 1850s, '60s, and '70s known as the instantaneous photography movement.[73] Instantaneous photographers strived to make pictures

of rapidly occurring action. At first, seemingly modest activities such as the rustling of leaves in a tree or the flapping of a flag on a windy day posed insurmountable obstacles to practitioners. Gradually, however, as technology improved and increasing numbers of photographers tackled the problem, more ambitious kinds of movements could be captured. In the late 1850s and '60s, the subject that most preoccupied instantaneous photographers was moving water. Capturing the curl of a single wave, as Gustave Le Gray (1820–1884) did in 1857 in his *Great Wave, Sète* [figure 10], attracted international praise. Le Gray was followed by many other "instantaneous" photographers, both famous and lesser known, who submitted their views to competitions and salons. Prizes were often given for the most compelling examples, and photographs were habitually sold with the word *instantaneous* printed on the mount. Indeed, *instantaneous* became one of the dominant marketing buzzwords of nineteenth-century photography.

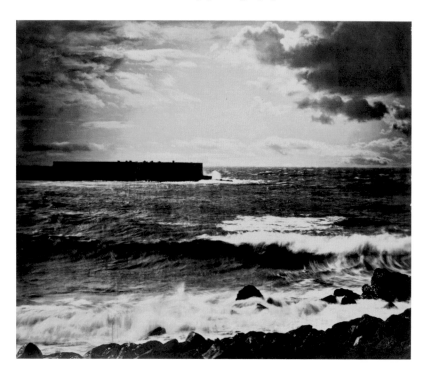

Figure 10
Gustave Le Gray (1820–1884)
The Great Wave, Sète, 1857

This milestone in the history of photography occurred several generations before Adams came on the scene, and it would have been no more than a quaint fact of history to him, except that as a teenager Adams had met one of the illustrious practitioners of the instantaneous photography movement, the Yosemite photographer George Fiske (1835–1918), shortly before Fiske died. The meeting itself was an extraordinary coincidence, since many years earlier Fiske had provided the illustrations for J. M. Hutchings' *In the Heart of the Sierras*—the very book that had inspired Adams to persuade his parents to take him to Yosemite in the first place. By the time Adams met him around 1917, however, Fiske was in his 80s and despondent. He had "no business sense," Adams remembered, "so he had an awful time financially. . . . he had a very small business and felt very discouraged."[74] Sadly, Adams' evaluation anticipated Fiske's demise. After a lifetime spent photographing Yosemite and the Pacific coast, in 1904 three-quarters of Fiske's inventory of negatives had been destroyed in a fire, along with most of his equipment and a large number of prints. Selling prints from his negatives had been his main source of income, so at age 69 Fiske had little choice but to begin all over again, returning to rephotograph locations he had shot previously. The work drained him, and the financial rewards were meager. By 1918 Fiske had suffered enough, and he took his own life.

After Fiske's death, Adams was given the job of printing the surviving negatives for the Yosemite Company, and when he married Virginia Best, of Best's Studio in Yosemite Village (now known as the Ansel Adams Gallery), numerous original prints came into the couple's possession. Adams believed them to be among the finest photographs of their time. According to him, Fiske was "a top photographer, a top interpretive photographer. I really can't get excited at [Carleton] Watkins and Muybridge—I do get excited at Fiske. I think he had the better eye. He was like O'Sullivan."[75]

Adams and Fiske were attracted to similar subjects, such as the tumult of water racing down a slope before tumbling over Vernal Falls or the seemingly inexhaustible energy of Lower Yosemite Fall spilling down the mountainside [figures 11, 12]. Adams certainly knew these images, as they were among three hundred examples Virginia and he donated to the Center for Creative Photography, Tucson, in 1979.

Figure 11
George Fiske (1835–1918)
The Race, above Vernal Falls, 1880s

Adams may have professed no special admiration for Eadweard Muybridge (1830–1904), but he was nevertheless indirectly indebted to the famous photographer. Muybridge, like Fiske, had photographed the landscape of Yosemite, although unlike Fiske, Muybridge never took up permanent residence there. Muybridge is best known for the sequential photographs he made of horses and other animals, including humans, beginning in the 1870s. These photographs represented a climax for the instantaneous photography movement, when for the first time the camera was able to record things happening faster than the naked eye could perceive. Muybridge, like Fiske, initially worked in California, where bright sunlight helped make rapid exposures practical.

Adams' magnificent *Surf Sequence* [plates 27–31] was produced long after Muybridge had perfected sequential imagery, but the legacy of his work is apparent nevertheless. Stieglitz's *Equivalents* of clouds was perhaps the most obvious inspiration for Adams' series, as the shifting forms of the surf wax and wane in symphonic rhythm. Yet its constituent frames also read as slices of time—individual moments selected from an infinite number of possibilities, each providing its own wry commentary on time's passing. Adams was possibly the first well-known photographer since Muybridge to attempt to use photography

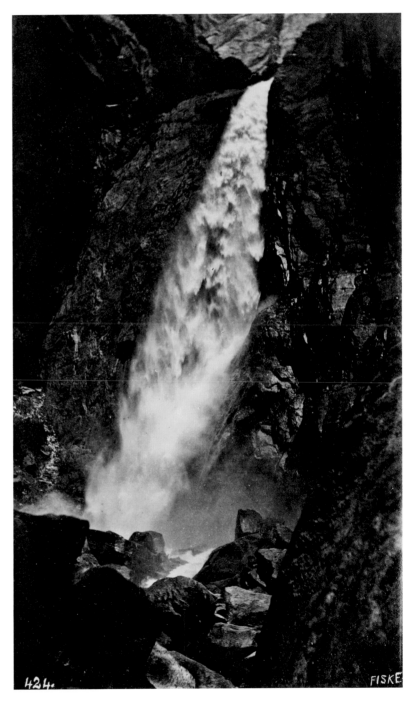

Figure 12
George Fiske (1835–1918)
Lower Yosemite Fall, 500 Feet, about 1878–1884

in this way, employing seriality and sequence to create a cohesive narrative. Yet as exceptional as the *Surf Sequence* is, the ingredients of its manufacture were actually handed down from the previous century. Instantaneity: to freeze time. Seriality and sequence: to thaw it.

Among American modern photographers, Adams was unrivaled in his investigation of sequential imagery. While he worked at deliberate speeds and attempted to plan his compositions when possible, he also cultivated spontaneity in his pictures. With a subject such as moving water, it was not enough simply to set up the camera and fire the shutter; he had to become attuned to his subject and react to its variations. This dimension of his work put him in the company of European modernists such as Henri Cartier-Bresson (1908–2004), Jacques Henri Lartigue (1894–1986), and other photographers of "the decisive moment," more than that of his *f*/64 associates. Adams often shot a scene twice or more in succession and printed each result: the before and after photographs of a wave crashing over a log in *Wave and Log, Dry Lagoon* and *Ocean Spray* [plates 19, 20], for example, or the sequence of crashing waves in *Untitled* and *Storm Surf, Timber Cove* [plates 21, 22].

The stunning photographs Adams made in 1942 of Old Faithful Geyser in Yellowstone National Park, Wyoming [plates 82–85], are his version of Monet's *Haystacks*. With these photographs, made around the same time as the *Surf Sequence,* he took the notion of time's passage one step further, seeking out different light and wind conditions and physically repositioning his camera around the geyser's base with each exposure. Dazzling in their variety and bursting with energy, these pictures are superficially celebratory yet melancholy in the repetitive activity they chronicle, as the geyser erupts every 35 to 120 minutes without end. Adams returned to photograph Old Faithful again seven years later but was unable to continue the series. Park rangers had put a fence around the geyser, an early-season storm had left four inches of snow on the rocks, and he backed his car into a ditch, breaking the rear axel.[76]

Print and Performance

Adams famously likened printing photographs to playing music, often saying: "the negative is the score, and the print is the performance." But as Szarkowski rightly pointed out, the metaphor has its limitations; a musician himself, Adams would surely have been familiar with performances in which the score was butchered by incompetent musicians.[77] Adams was remarkably consistent in maintaining quality in the darkroom, whether he printed the work personally or, in later years, worked with an assistant. However, over time the available print papers changed, and Adams' vision of how to interpret particular negatives shifted. He did not limit or edition his photographs, so for works that were perennially in demand, often many different variations exist, spanning the artist's career. While it is not universally true, generally it is the case that in later years he came to print darker, with more contrast, favoring a selenium toning bath that increased permanence but registered a slight purple tint when applied in certain concentrations.

Although this accomplishment is frequently overlooked among his many achievements, Adams was a pioneer in the production of giant photographic enlargements, often as big as 10 to 12 feet (3 to 4 meters) long. This element of his work originated in the 1930s[78] but accelerated dramatically with a commission he undertook for the U.S. government in the 1940s. In 1937 Adams was approached by Secretary of the Interior Harold Ickes to create a series of oversized photo "murals" of American national parks for a new museum being created by his department in Washington, DC.[79] Adams and Ickes discussed the project for the next several years. Ickes conceived of the Interior Museum, which opened in March 1938, as a place where monumental photographs and paintings would be shown side by side in a grand public display. For photographs to hold their own with paintings, Ickes reasoned, they would have to be similar in scale— and that meant printing them larger than anyone had ever done for an exhibition.

In 1941 Adams formally accepted the commission, and over the next year he photographed various locations throughout the park system. He finally delivered more than two hundred 8-by-10-inch exhibition prints to the Department of the Interior in November 1942, including iconic works such as the series depicting Old Faithful and *The Tetons and the Snake River* [plate 62].[80] Unfortunately, the mural-sized prints were never made, as their production was shelved when the United States entered the Second World War at the end of 1941.[81]

Despite this setback, Adams retained an interest in making large prints throughout his career. And similar commissions followed, such as the *Fiat Lux* survey Adams agreed to produce for the University of California in 1963.[82] Adams was tasked with photographing the various campuses and research centers across the state university system, but the results included a remarkable number of pictures of natural sites, including more than 40 images of crashing surf, sea cliffs, foam, and tide pools that he photographed at the University of California Marine Laboratory at Bodega Bay, some 60 miles north of San Francisco (not shown).[83]

In his popular manual *The Print* (1983), Adams described his recommended procedure for making "very large" prints. Because they are expensive and difficult to make, he cautioned photographers to plan production carefully, including paper color, before entering the darkroom. "It is usually sufficient to make the print slightly 'warm' or 'cold' in tone if the general tone of the room suggests either quality," he counseled.[84] The three warm-toned murals *Whaler's Cove, Carmel Mission; Point Lobos, Near Monterey;* and *Gravel Bars, American River* [plates 33, 35, and 53] were produced in the mid-1950s for the American Trust Company Building in San Francisco (American Trust later became Wells Fargo Bank). The precise location where the murals hung is not recorded, but the domed granite building of the bank headquarters still stands at the corner of Market, Grant, and O'Farrell Streets. An architectural guide of Adams' time remarked on the "Corinthian Columns, Tavernelle marble pilasters, and Caen stone walls," that "lent richness" to the 65-foot-high banking room.[85] The warmth of the American Trust murals would have complemented the Beaux-Arts–style building. In a later interview, Adams revealed another reason for choosing such warm paper. Toning his prints "egg yolk brown" as he described it, gave the pictures more permanence.[86]

Possibly the most intriguing expression of Adams' interest in unconventional modes of printing was his production of "Japanese-style" folding screens, which curator Karen Haas has traced back to the creation of the no longer extant *Leaves, Mills College,* exhibited in Chicago in 1936[87] and purchased by Harold Ickes. Adams later destroyed that picture because it was aging badly. The replacement he gave Ickes was a snow scene made from a completely different

negative, so it is impossible to know exactly what the original looked like. However, according to Adams' account, it depicted water, with the viewer looking down on a waterway from a bridge.[88] Although he continued to produce folding screens through the 1970s, examples of this technique are comparatively rare in his art: Haas concludes that Adams produced only 12 to 15 over the course of his career.[89] To make these screens, Adams cut mural-sized prints into three or four panels, adhered them to plywood or masonite, and then framed them with hinged aluminum. Most were made to be included in specific exhibitions, so it is not always clear if they were designed to be seen in domestic environments, as true Japanese screens frequently were.

The extraordinary *Grass and Pool* [figure 13] dates from a period of tremendous creativity in Adams' work. Standing on round metal feet, it was designed to be shown directly on the floor. For Adams, part of the appeal of making screens of this kind must have been the ability to thwart conventional expectations about what a photograph should look like and where it could be shown. Like many modernists, Adams viewed photographs not just as images but also as objects; the sheer physical presence of a photograph reinforced its significance as a work of art. Within the ƒ/64 school, even small prints were often meticulously trimmed and dry-mounted onto mat board with edges exposed, revealing the materials with which they had been made. In this emphasis on the photograph's physicality, the modernists unwittingly drifted perilously close to the pictorial predecessors they so famously rejected, who were known for foregrounding the shape, texture, and tonality of their pictures.

In *Grass and Pool,* the three articulated panels can be angled to catch the light differently, the rhythm of the fold cleverly mirroring the angular pattern of the exposed grass. The tripartite theme established in the three panels is repeated in the photograph itself, which consists of three tonal bands—light gray for the grasses, dark gray for the water, and black for the shadows. Grasses cut across the surface like streaking comets in a night sky; flotsam and specks of foam resemble stars and planets. The effect is amplified by small, bright circles of overexposure scattered throughout the frame, seemingly bleeding through the composition like miniature solar coronas.

Figure 13
Ansel Adams
Grass and Pool, the Sierra
Nevada, California, 1938
Japanese-style, three-panel
folding screen

Grass and Pool provides clues to the interpretation of other related compositions, such as *Foam* [plate 24] and *Merced River, Yosemite Valley* [plate 73], which prefigures the experimental films of Stan Brakhage (1933–2003). These photographs show Adams at his most daring but also at his most romantic, with photographic representation used as a touchstone for the viewer's imagination. Each photograph is not so much a record of fact as it is an object of contemplation.

Producing the *Grass and Pool* screen, the American Trust murals, and other oversized prints required hanging unexposed paper vertically on a darkroom wall and mounting an enlarger horizontally so it could project across the room to expose the paper. For the bigger American Trust prints, existing papers were not large enough to do the job on one sheet, so Adams had to print in two sections, mounting them in perfect registration to hide the seam. He viewed this extremely labor-intensive process as worthwhile because it enabled him to make pictures that he considered completely unreal in scale but at the same time convincing in their lifelike representations.[90]

Adams railed against the common expression that a photographer "takes" a picture. To him, photographs are most emphatically "made," as there was nothing easy or arbitrary about his work. Consciously or not, every photograph represents a series of nested decisions, beginning with the chosen subject and ending with the desired effect on the viewer.

All that work was trying at times. With tongue planted firmly in cheek, Adams made that clear in a few impromptu lines to the Newhalls: "Was going to write to you today, but had the experience of having my camera case rolled in the surf; all my spare time has been consumed in getting sand and water out of a lot of equipment. Ruined most of the sheet film holders—but not much other serious damage! WHAT A LIFE. This job is tough."[91]

"Is photography an art or craft?" Adams had asked in 1937.[92] "No conclusions have been reached," he surmised, "nor is any agreement in sight, for it is impossible to define any medium of emotional expression in dictionary terms."[93] His efforts may not have been enough to satisfy a lexicographer, but Adams spent a substantial part of his career trying to identify that "certain something" that distinguishes a fine photograph.[94] In his prolific writings, he made many valiant attempts. In the end, though, photographs may speak better than words. And definitions, like water, are fluid.

Note on Citations
The best compilation of Ansel Adams' correspondence remains the selection of letters published in 1988: Mary Street Alinder and Andrea Gray Stillman, eds. *Ansel Adams: Letters and Images, 1916–1984* (Boston: Little, Brown). Where possible, this publication has been cited (as *Letters*). However, a number of letters and postcards in the Ansel Adams and Newhall Archives at the Center for Creative Photography (CCP) at the University of Arizona have not been published or are excerpted in publication; they are cited here from the originals and referenced by collection number. All referenced postcards are filed under the same number: AG48:6.

1 Ansel Adams, "Retrospect: Nineteen-Thirty-One," *Sierra Club Bulletin* 17, no. 1 (February 1932): p. 1.

2 Ibid.

3 Ibid., p. 3–4.

4 Ibid., p. 4 (*aesthete* spelled *esthete* in the original).

5 Ansel Adams, *Ansel Adams: An Autobiography,* with Mary Street Alinder (Boston: Little, Brown, 1985), p. 40.

6 Ibid., p. 42.

7 Ibid., p. 43.

8 Ibid.

9 Ansel Adams, *Conversations with Ansel Adams, 1972, 1974, and 1975,* interview by Ruth Teiser and Catherine Harroun, oral history transcript, 1978, Bancroft Library, University of California, Berkeley, 1978, p. 28.

10 Ibid., pp. 28 and 30.

11 Unpublished note to Nancy Newhall, 1948, AG 48:2/1. In addition to the version reproduced here, variant prints of these rare images exist in the Ansel Adams Archive at the CCP. They are marked in an unknown hand (possibly Beaumont Newhall's), "Prints for N.N. [Nancy Newhall] Extremely valuable (?) Most early pix by A.A. Portals of the Past."

12 Thomas Albright, *Art in the San Francisco Bay Area, 1945–1980: An Illustrated History* (Berkeley: University of California Press, 1985), p. 2.

13 Christian Brinton, *Impressions of the Art at the Panama-Pacific Exposition* (New York: John Land, 1915), p. 22.

14 For the conservatism of previous fairs, see Phillip Prodger, "The World in Saint Louis: The Art Palace at the 1904 World's Fair," *Apollo* 160, no. 514 (December 2004): pp. 63-69.

15 Albright, p. 2.

16 Terry St. John, quoted in Albright, p. 2.

17 This title is referenced in an undated note, CCP AG 48:2/1. See also note 11.

18 This and the preceding quotations, Adams, *Conversations,* p. 28.

19 In truth, he stopped photographing sooner. Towards the end of his life, Adams spent little time behind the camera, preferring to concentrate on the printing of his work.

20 John Szarkowski, quoted in *Ansel Adams: A Documentary Film,* written and directed by Ric Burns, produced by Ric Burns and Marilyn Ness (Sierra Club Productions and Steeplechase Films, 2002).

21 Ansel Adams to Nancy Newhall, 5 January 1950, unpublished postcard.

22 Adams, "Retrospect: Nineteen-Thirty-One," p. 4.

23 Adams, *Conversations,* p. 8.

24 Adams, *Autobiography,* p. 73.

25 The published prints in the *Parmelian* folio were made with Kodak paper. However, when Adams sold individual "fine photographs" from the series, he frequently printed them on Dassonville paper.

26 Adams, *Conversations,* p. 74.

27 Ibid., p. 51.

28 Adams to Beaumont Newhall, 8 August 1953, unpublished postcard.

29 Adams, *Conversations,* p. 327.

30 Ansel Adams, "What Is Good Photography?" *Camera Craft,* January 1940, p. 44.

31 *Photographs of the Sierra Nevada by Joseph N. LeConte, Prints from the Original Negatives by Ansel Adams,* Bancroft Library, Berkeley, 1971.071.

32 Adams, *Conversations,* p. 18.

33 *Letters,* p. 211.

34 Adams, *Conversations,* p. 98.

35 Ibid., p. 18.

36 *Letters,* pp. 88–89.

37 Ansel Adams, quoted in *Ansel Adams, Yosemite and the Range of Light* (Boston: Little, Brown, 1979), p. 12.

38 Adams, *Conversations,* pp. 18–19.

39 Adams to Nancy Newhall, 23 March 1949, unpublished postcard.

40 Adams to Beaumont Newhall, 10 April 1948, unpublished letter, CCP AG48:2:4.

41 Ibid.

42 Adams to Beaumont and Nancy Newhall, 16 April 1948, unpublished letter, CCP AG48:2:5.

43 Adams to Beaumont and Nancy Newhall, 8 May 1948, unpublished letter, CCP AG48:2:5, p. 1.

44 Adams to Beaumont and Nancy Newhall, 12 May 1948, unpublished letter, CCP AG48:2:5, p. 2.

45 Adams to Nancy Newhall, 16 April 1948, unpublished letter, CCP AG48:2:5.

46 Ibid.

47 Ansel Adams and Edward Joesting Adams, *Islands of Hawaii* (Honolulu: Bishop National Bank, 1958).

48 Adams to Nancy Newhall, 6 May 1948, unpublished letter, CCP AG48:2:5.

49 Adams to Beaumont and Nancy Newhall, 20 June 1948, unpublished letter, CCP AG48:2:5.

50 Ibid.

51 Adams to Beaumont and Nancy Newhall, 25 June 1949, unpublished postcard.

52 Adams to Beaumont and Nancy Newhall, 15 March 1948, letter, CCP AG48:2:4. Some of the quoted text is unpublished; an edited version appears in *Letters,* p. 195.

53 Adams to Nancy Newhall, 15 September 1948, in *Letters,* p. 205.

54 Adams to Edward Weston, 19 September 1945, in *Letters,* p. 166.

55 Harry M. Callahan, ed., *Ansel Adams in Color* (Boston: Little, Brown, 1993), p. 7.

56 Beaumont Newhall to Ansel Adams, 18–25 November 1949, unpublished letter, CCP AG48:6, p. 5.

57 Ibid.

58 Adams to Nancy Newhall, 15 December 1949, unpublished postcard.

59 Mary Street Alinder, *Ansel Adams: A Biography* (New York: Henry Holt, 1996), p. 263.

60 Ibid.

61 Adams, *Conversations,* p. 120.

62 Newhall to Adams, 18–25 November 1949, p. 1.

63 Adams, *Conversations,* pp. 147, 562.

64 *Letters,* p. 47.

65 Adams, *Autobiography,* p. 178.

66 Ibid., p. 179.

67 Newhall to Adams, 18–25 November 1949, p. 4.

68 Ibid., p. 2.

69 Strand was no stranger to aquatic imagery himself. In addition to his photographs of Maine, Nova Scotia, and Gaspé, his film *Redes* (or *The Wave*), 1936, featured fisherman working on the Mexican coast.

70 Newhall to Adams, 18–25 November 1949, p. 2.

71 Ibid., p. 3.

72 Adams to Nancy Newhall, 5 January 1950, unpublished postcard.

73 For more on the instantaneous photography movement, see Phillip Prodger, *Time Stands Still: Muybridge and the Instantaneous Photography Movement* (New York: Oxford University Press, 2003).

74 Paul Hickman and Terence Pitts, *George Fiske: Yosemite Photographer* (Flagstaff, AZ: Northland Press, 1980), p. 42.

75 Ibid., p. viii.

76 Adams to Beaumont and Nancy Newhall, 19 September 1949, unpublished postcard.

77 John Szarkowski, *Ansel Adams at 100* (Boston: Little, Brown, 2001), p. 39.

78 See, for example, the excellent discussion in Karen Haas and Rebecca Senf, *Ansel Adams in the Lane Collection* (Boston: MFA Publications, 2005).

79 Peter Wright and John Armor, *The Mural Project: Photography by Ansel Adams* (Santa Barbara, CA: Reverie Press, 1989), pp. iii–viii. Adams and Ickes met in 1936.

80 Ibid.

81 In 2010 a selection of 26 digital enlargements made from the exhibition prints was installed at the Interior Museum.

82 Ansel Adams and Nancy Newhall, *Fiat Lux: The University of California* (New York: McGraw-Hill, 1967).

83 See Jason Weems, *Unseen Ansel Adams: Photographs from the Fiat Lux Collection* (San Diego: Thunder Bay Press, 2010), pp. 18–33.

84 Ansel Adams, *The Print* (Boston: Little, Brown, 1983), pp. 173–74.

85 The Writer's Program, San Francisco, *San Francisco, the Bay and Its Cities* (San Francisco: City and County of San Francisco, 1940), p. 189. In 1959 American Trust moved into an office building designed in the International Style by Skidmore, Owings, and Merrill at One Bush Plaza.

86 Adams, *Conversations,* p. 139.

87 Haas, in Haas and Senf, *Ansel Adams,* p. 141.

88 Ibid.

89 Ibid.

90 Adams to Nancy Newhall, 5 June 1950, unpublished postcard.

91 Adams to Beaumont and Nancy Newhall, 23 August 1949, unpublished postcard.

92 Ansel Adams, "Choosing a Way in Photography," *Zeiss Magazine,* March 1937, p. 47.

93 Ibid.

94 Ibid.

Interpretation of the Natural Scene

1. The Earth in Space: Astronomical Picture
 Moon rising over snowpeaks

 The sea and sky.

 Small detail of life — moss, lichens, grass, etc.

2. Aspects of the Earth:

 The basic rocks
 Early sedimentations
 the effect of ice
 the effect of water
 the effect of wind
 the effect of sun

 the elements of nature
 snow
 ice
 rain
 mist
 fog
 wind
 erosion
 river
 shore
 glaciers
 lakes
 waterfalls

 volcanism
 hot springs
 geysers
 steamblows

 fossils
 vegetation
 sea life
 animals

 clouds

 human activities
 and appropriate exploitations

— Ansel Adams to Beaumont and Nancy Newhall, July 1948, Gastineau Hotel, Juneau, Alaska

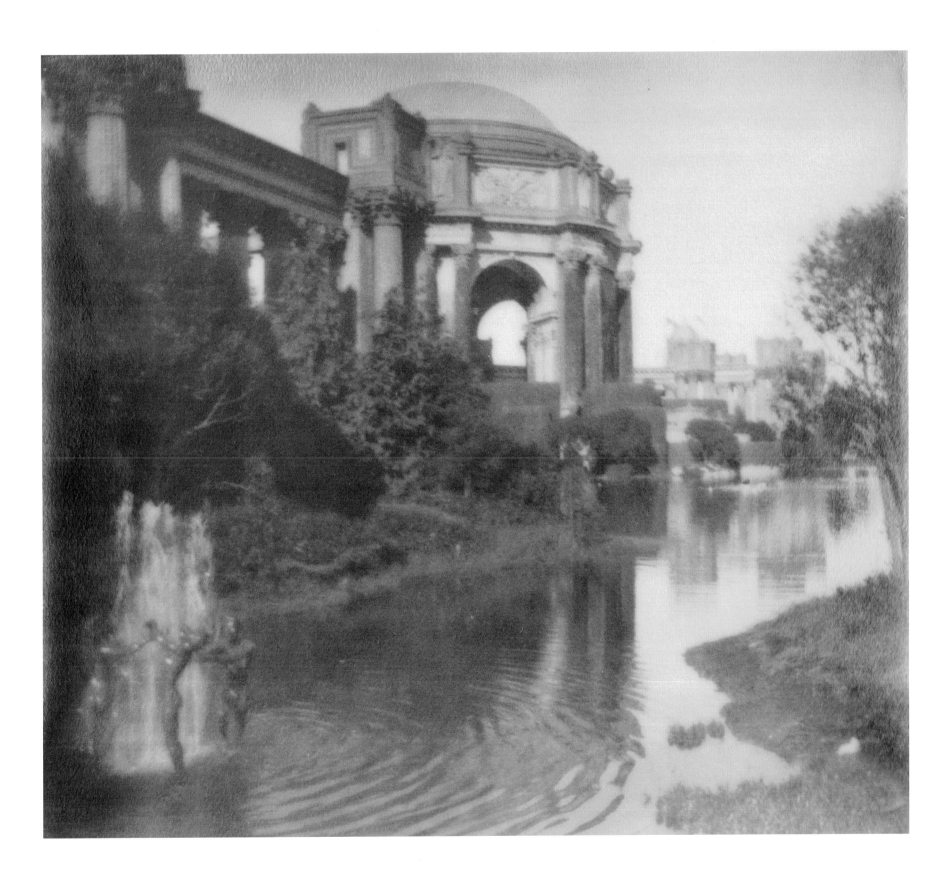

Plate 1
*Panama-Pacific Exposition,
San Francisco* (also titled
Portals of the Past), 1915

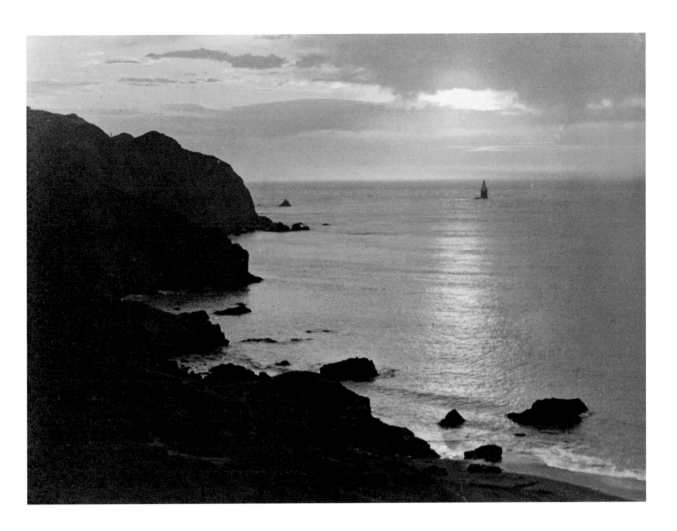

Plate 2
China Beach,
about 1919

Plate 3
Shipwreck, Helmet Rock,
Lands End, San Francisco,
about 1919

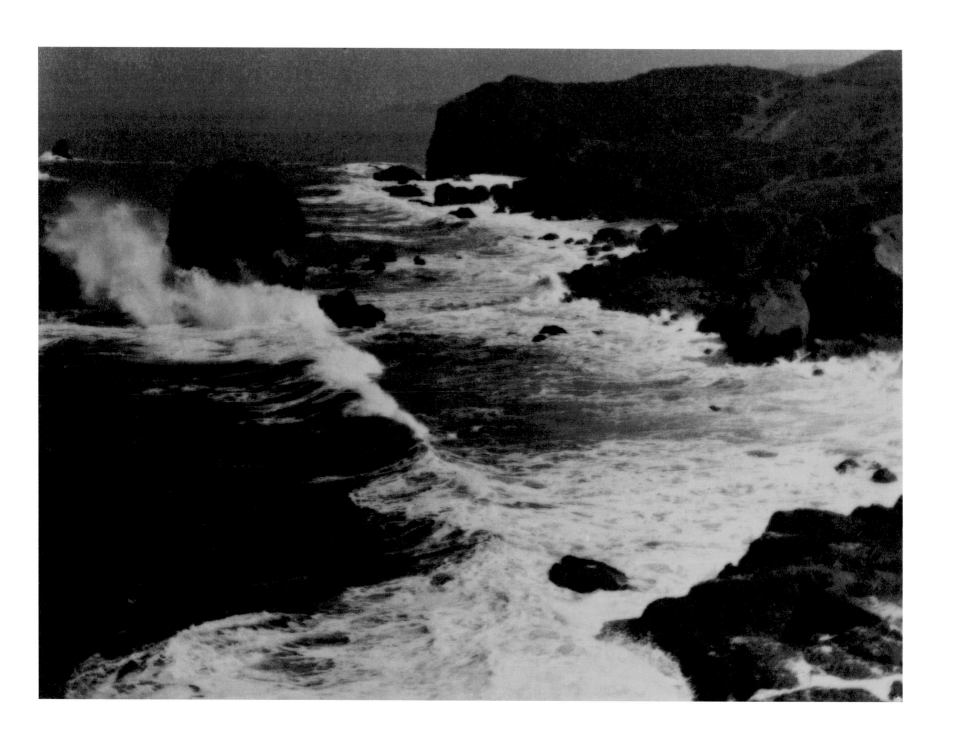

Plate 4
*Helmet Rock #2, San Francisco
Coast*, about 1925

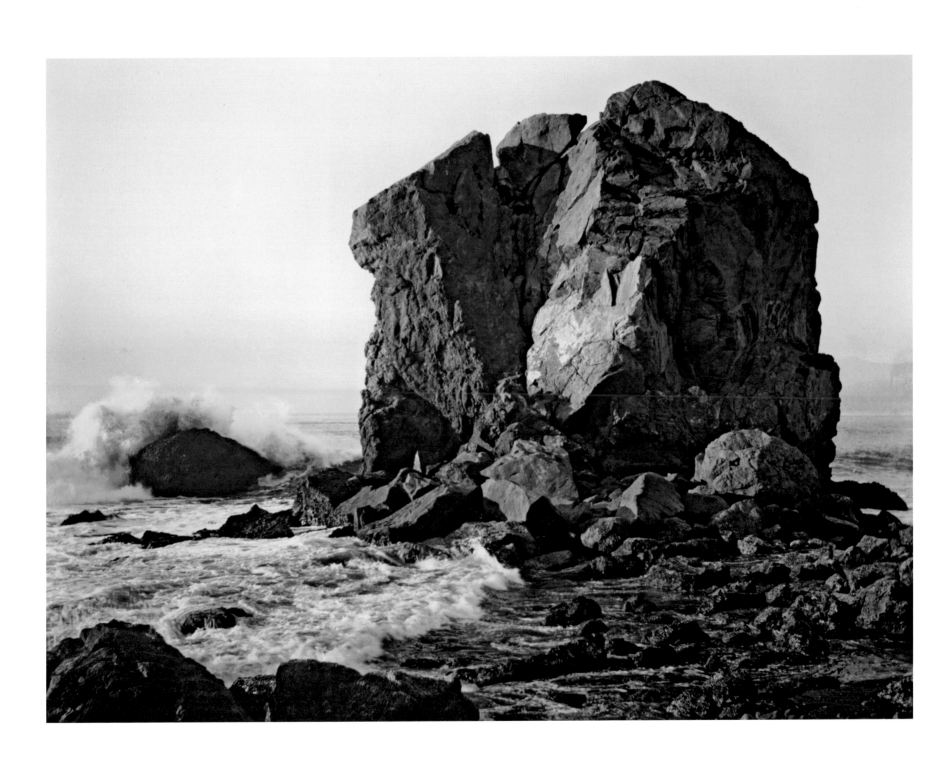

Plate 5
Helmet Rock, Lands End,
San Francisco, 1918

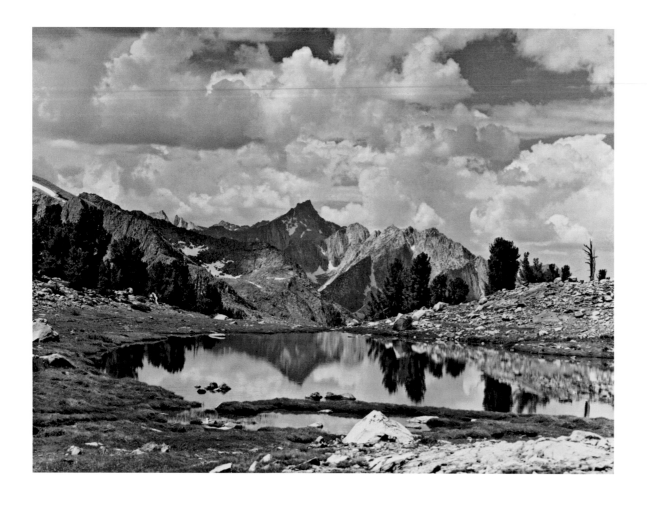

Plate 6
*Mount Clarence King,
Pool, Kings Canyon
National Park,*
about 1925

Plate 7
*Mirror Lake, Mount
Watkins, Spring,
Yosemite National
Park,* 1935

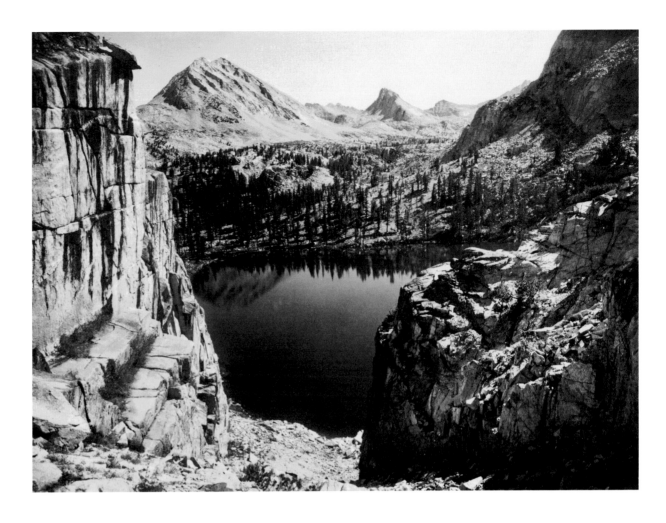

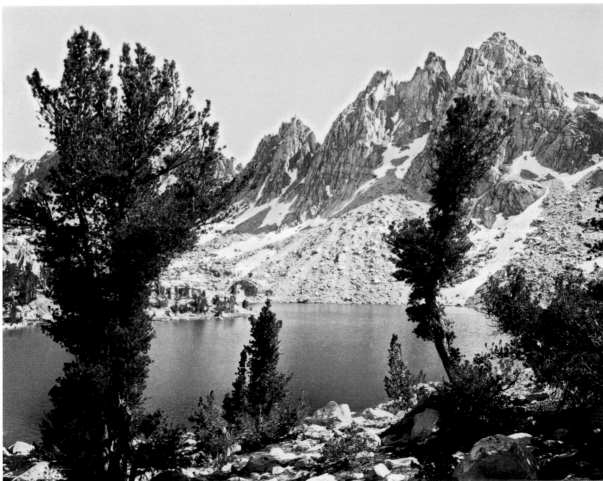

Plate 8
*Marion Lake, Kings
Canyon National
Park, California,*
about 1925

Plate 9
*Kearsarge Pinnacles,
Southern Sierra,*
about 1925

Plate 10
Lake Washburn, Yosemite,
about 1918

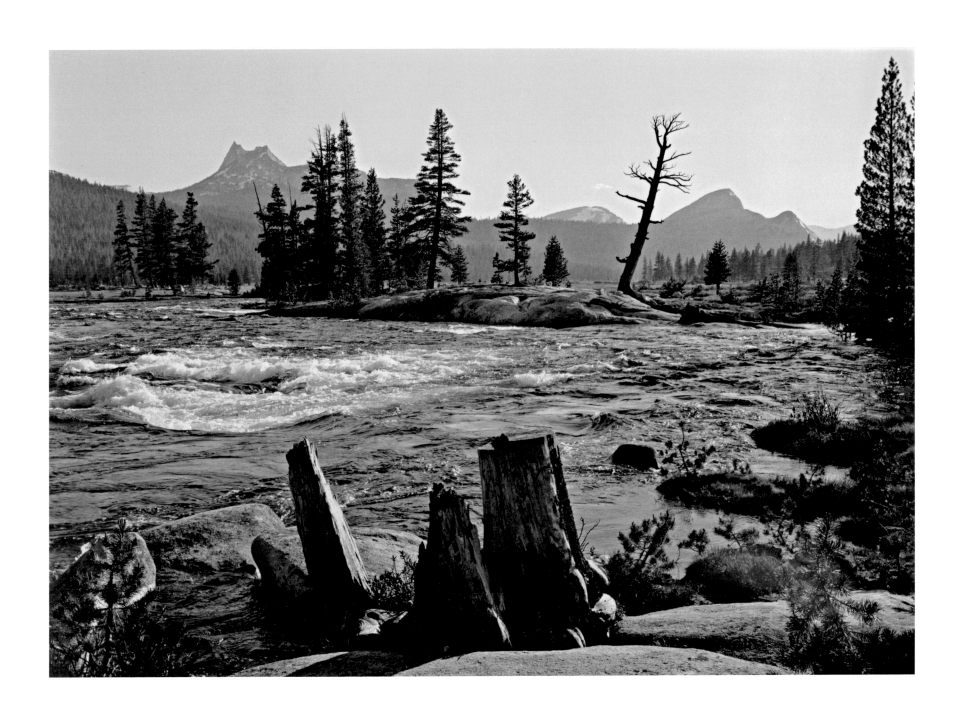

Plate 11
Cathedral Peak, Tuolomne River, Yosemite,
about 1944

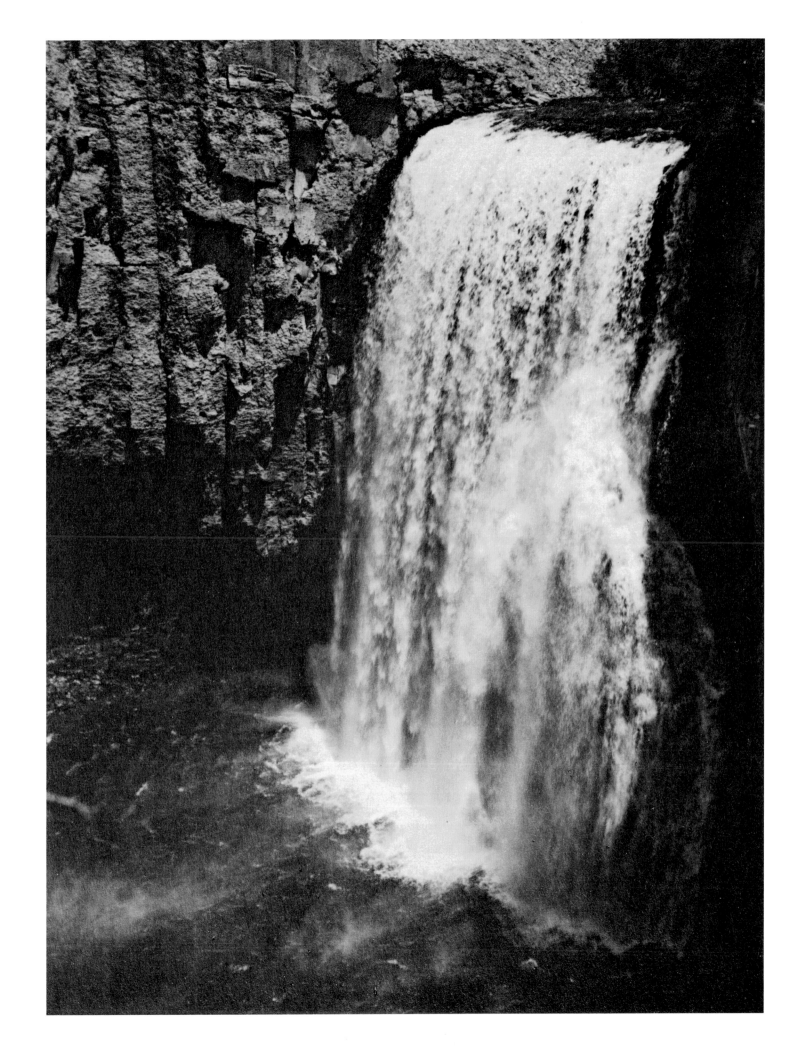

Plate 12
Rainbow Falls,
about 1929

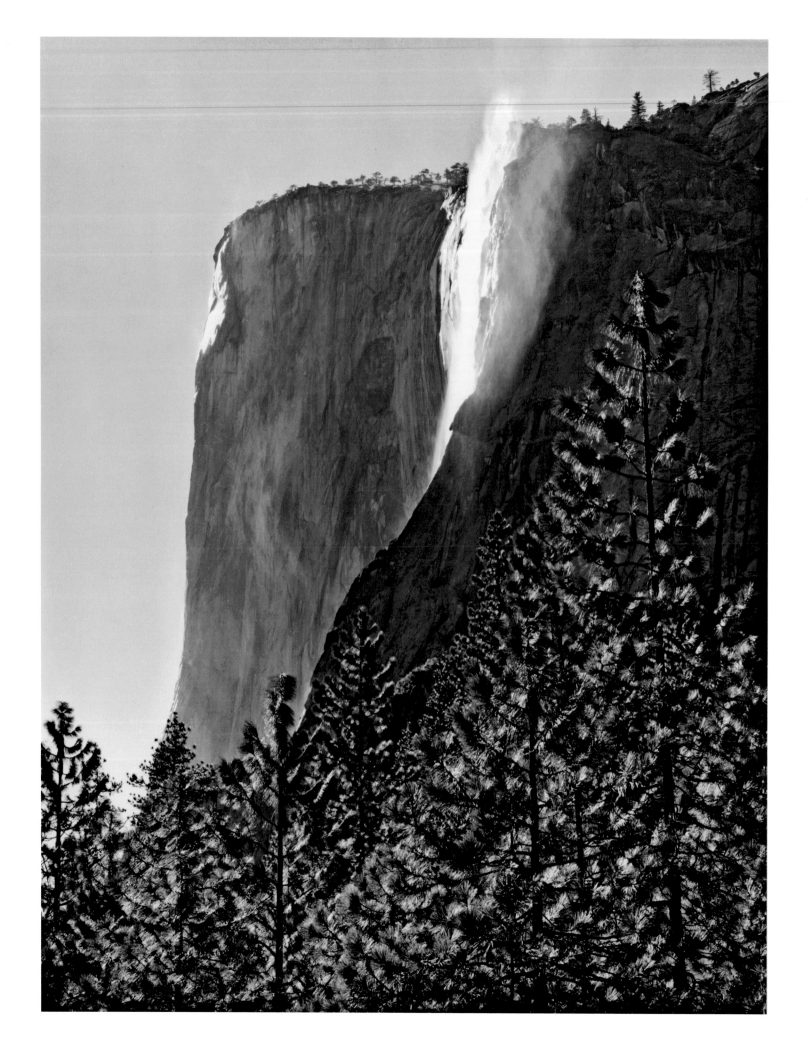

Plate 13
El Capitan Fall,
Yosemite Valley,
1952

Plate 14
Fall in Upper Tenaya Canyon,
Yosemite National Park, California,
about 1920

Plate 15
Diamond Cascade, Yosemite
National Park, 1920

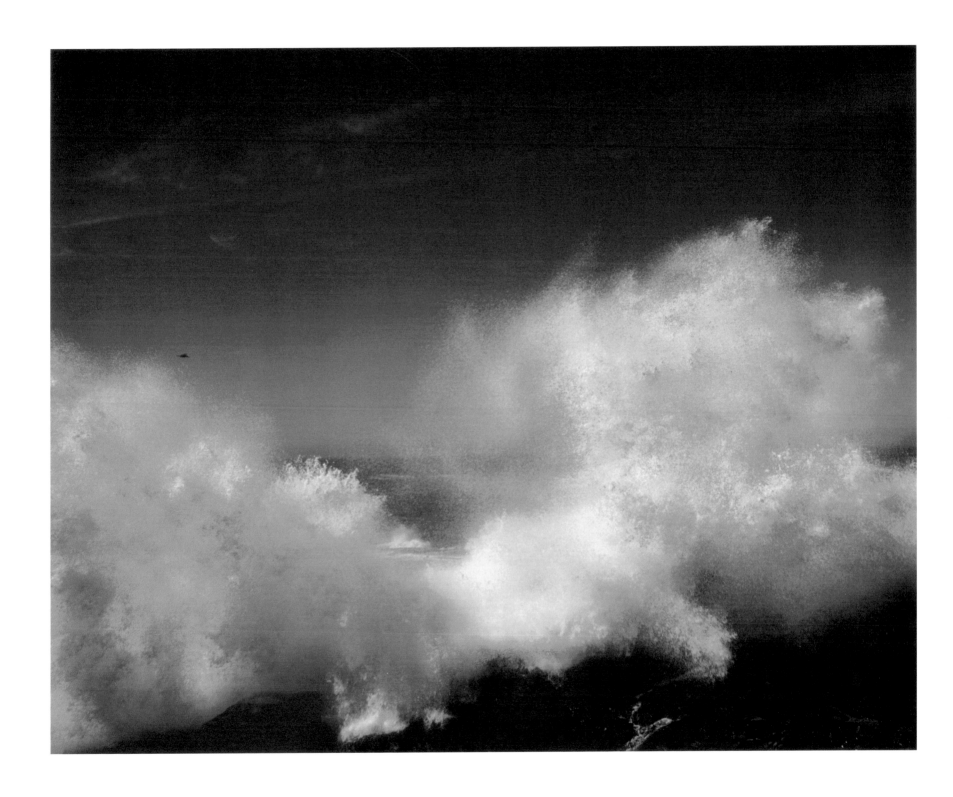

Plate 16
Surf, Point Lobos State Reserve,
California, 1963

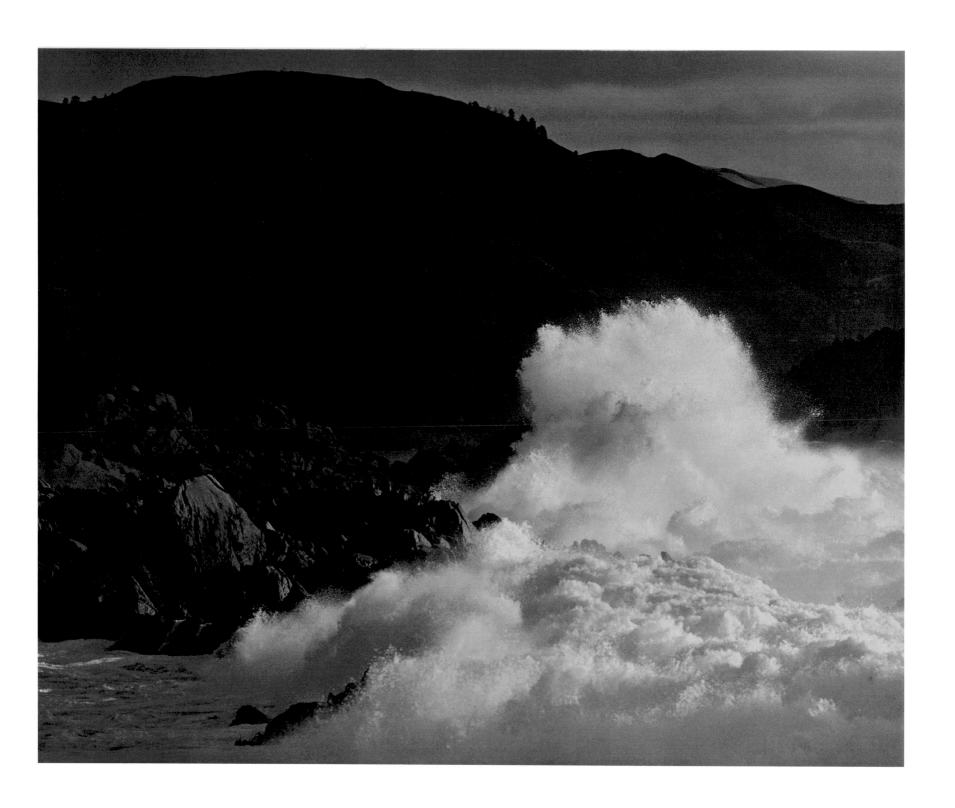

Plate 17
Wave, Pebble Beach, California,
1968

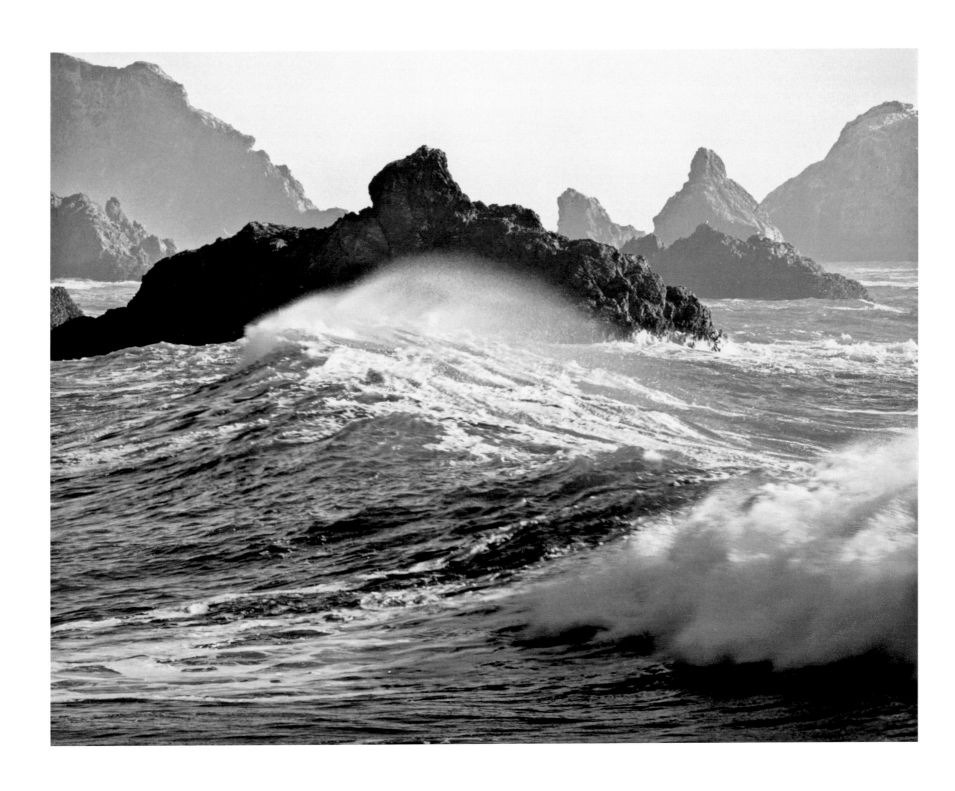

Plate 18
Waves, Dillon Beach,
1964

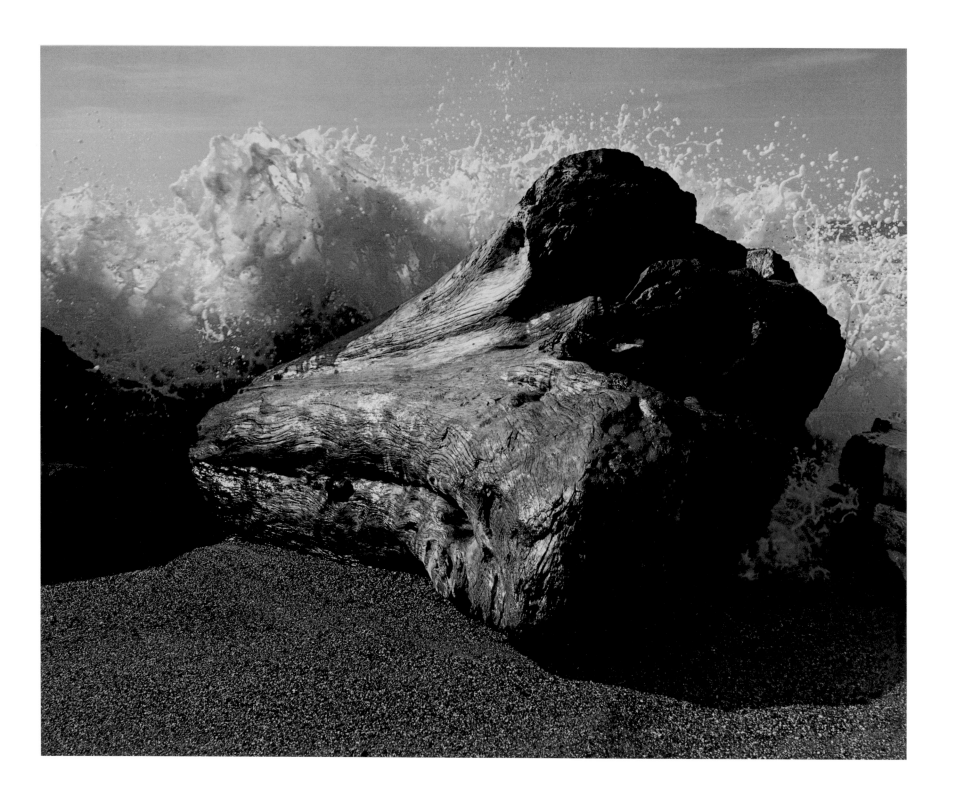

Plate 19
Wave and Log, Dry Lagoon,
Northern California,
about 1960

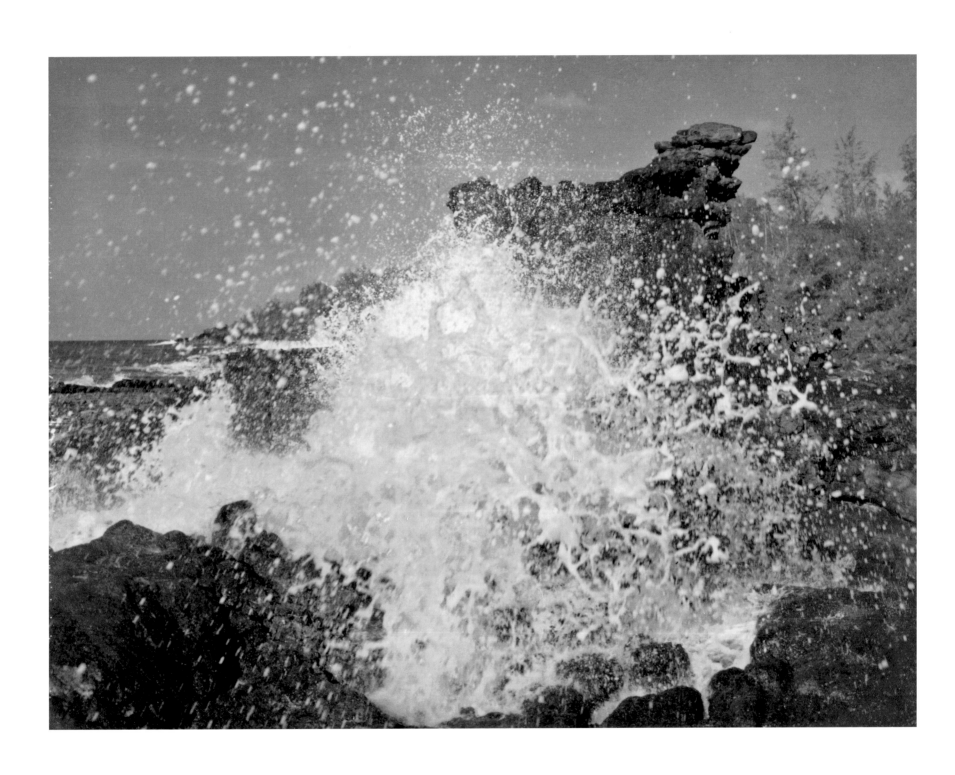

Plate 20
Ocean Spray,
about 1960

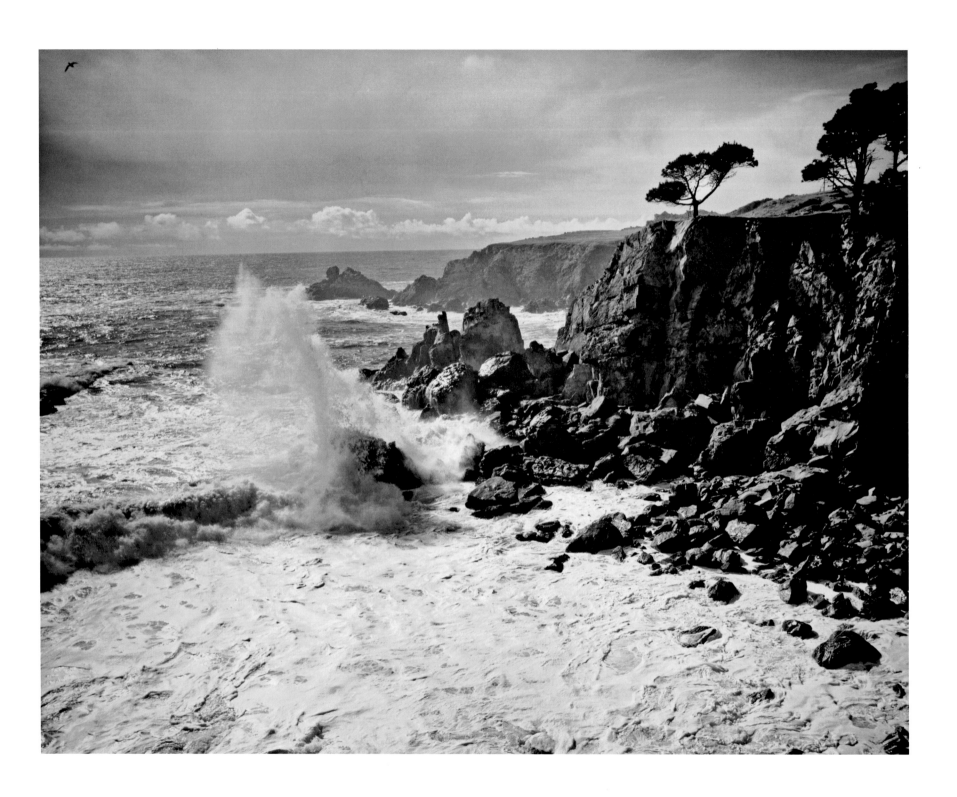

Plate 21
Untitled, about 1960

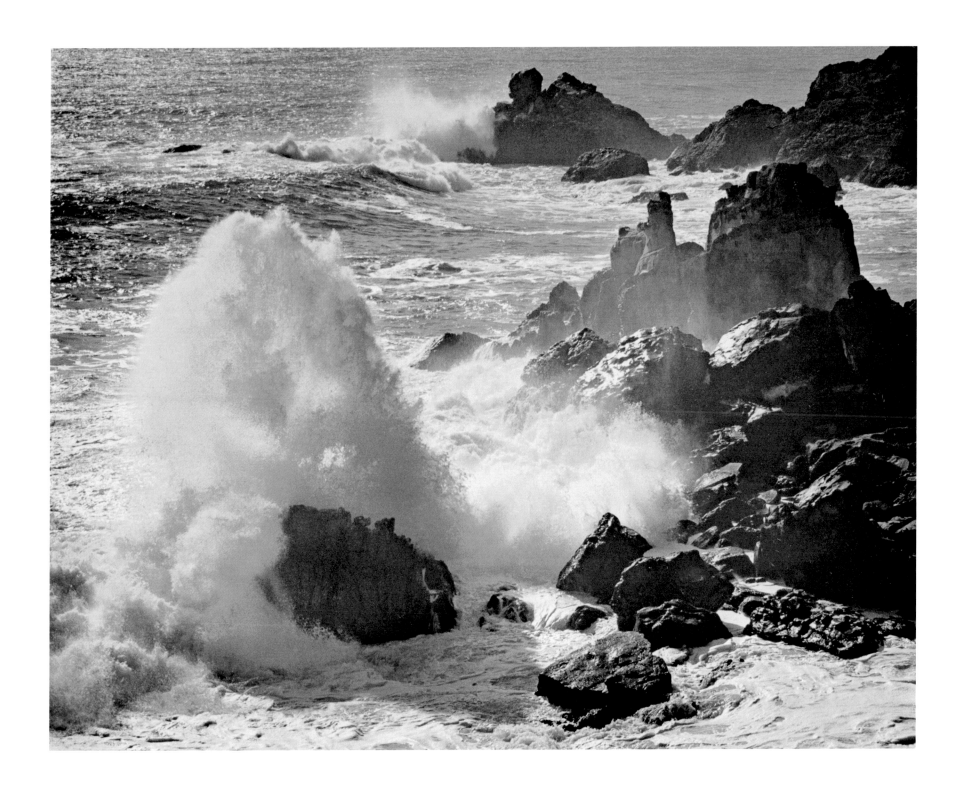

Plate 22
Storm Surf, Timber Cove,
California, 1963

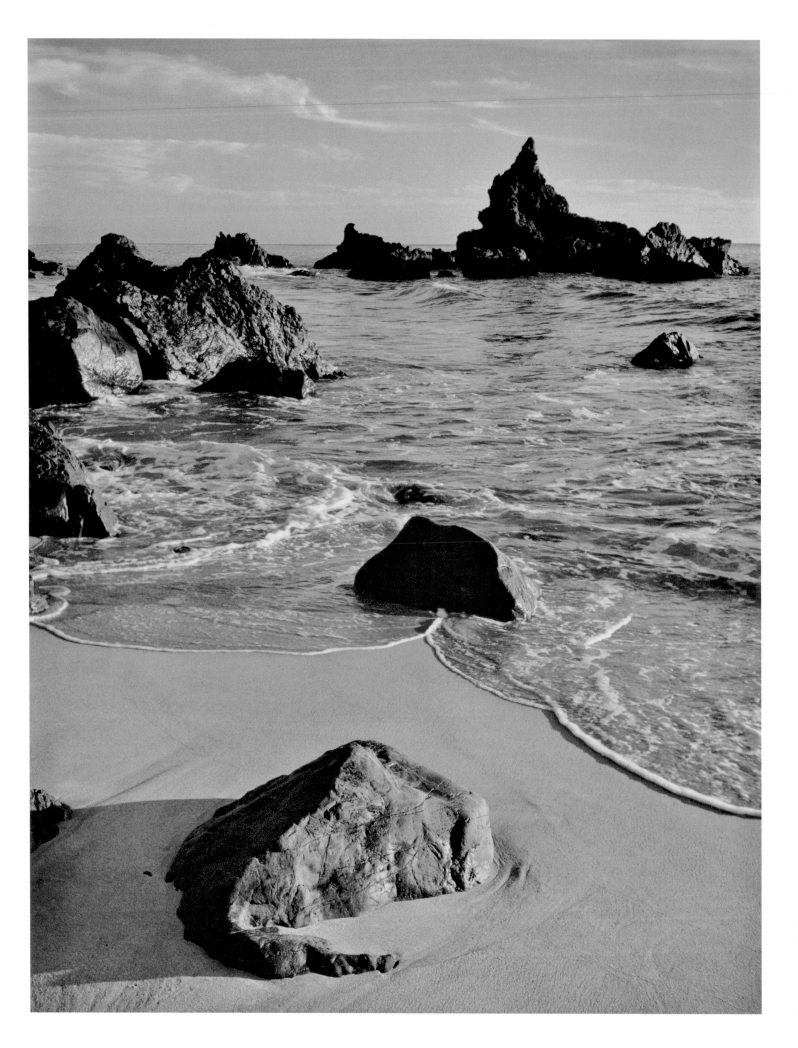

Plate 23
*Surf and Rock,
Monterey County
Coast, California,*
1951

Plate 24 (opposite)
Foam, about 1960

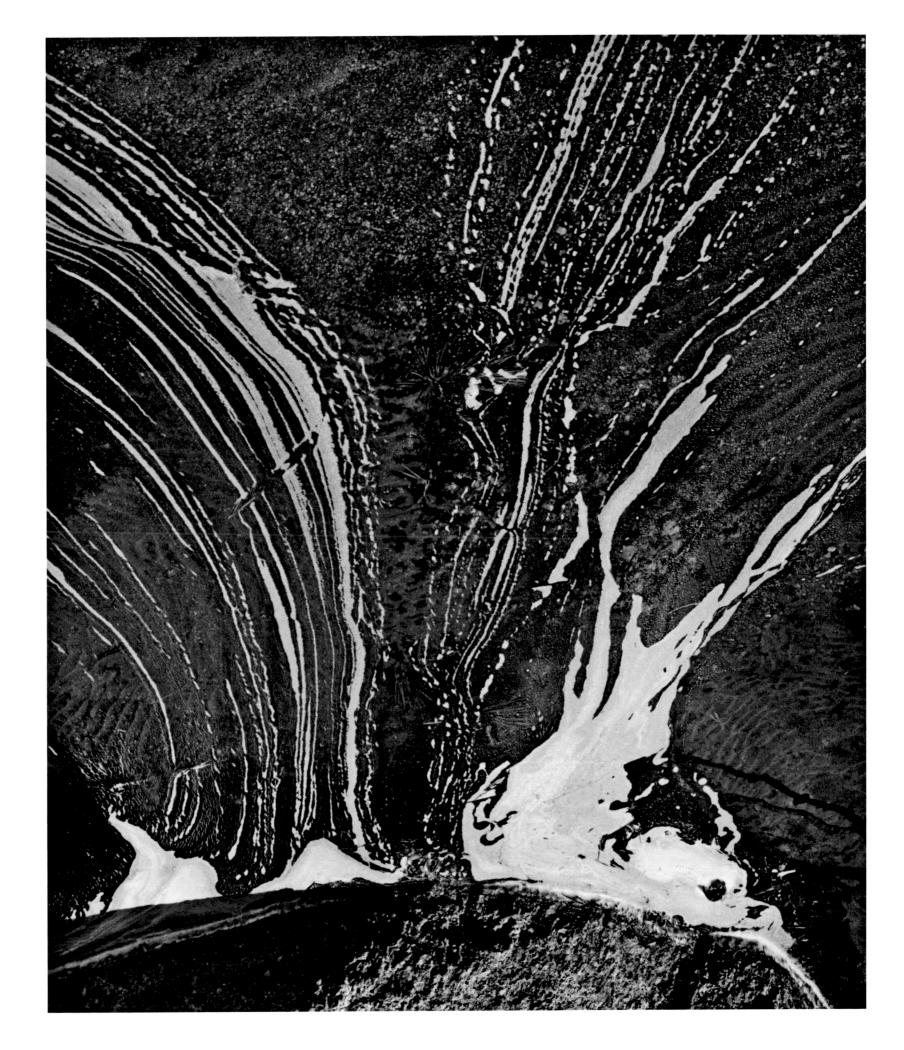

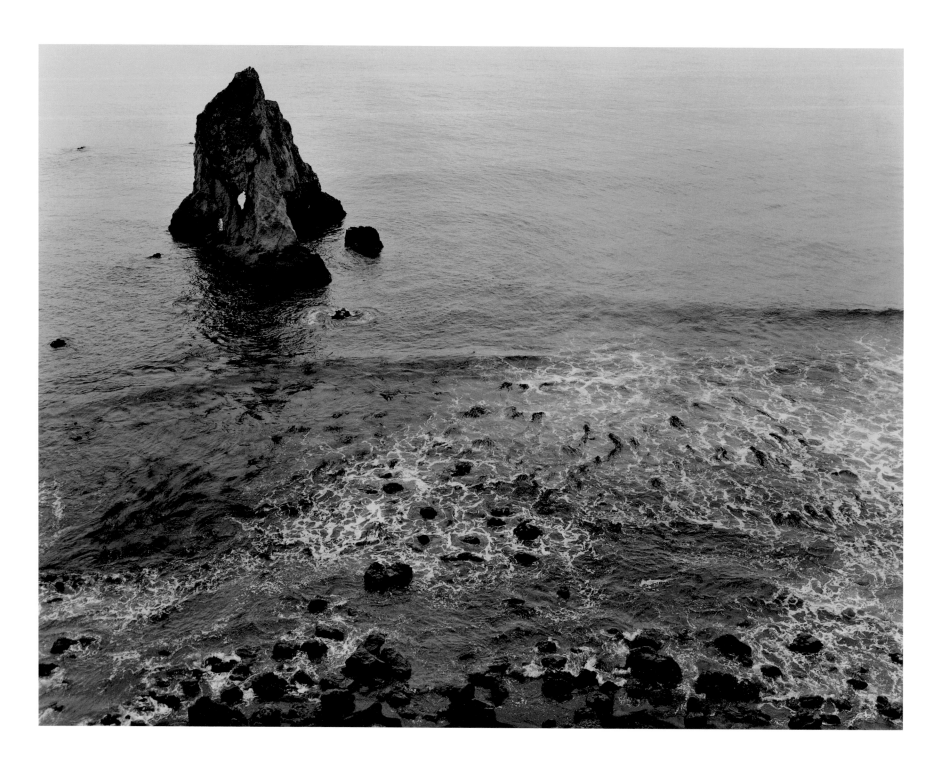

Plate 25
North Coast, California,
about 1939

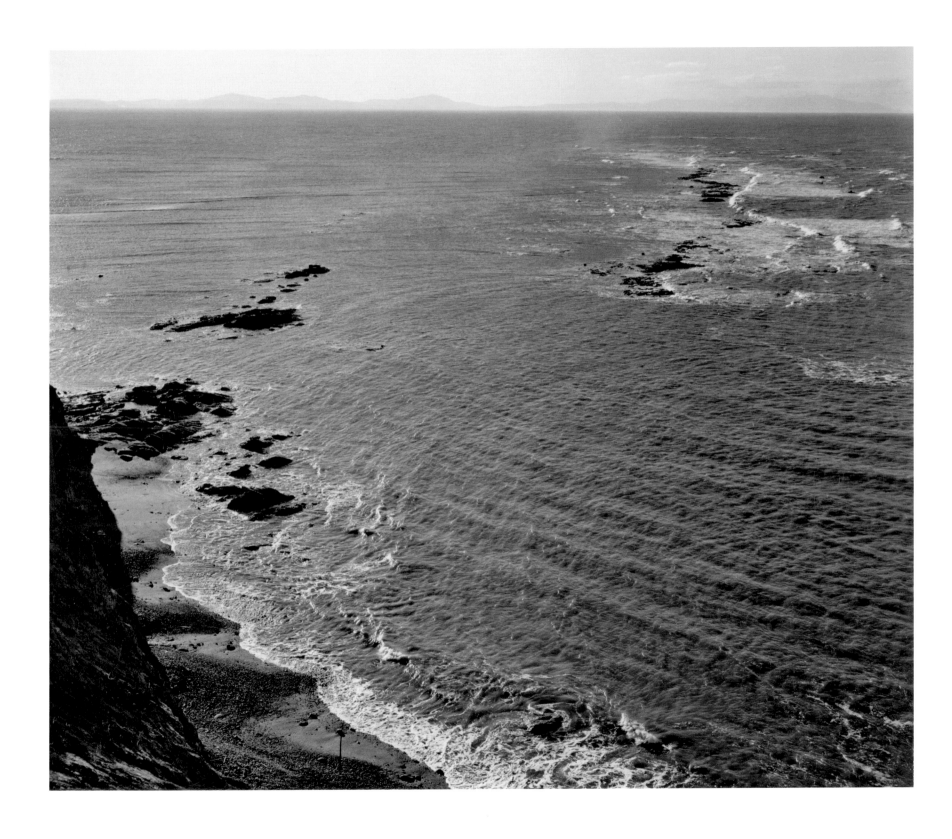

Plate 26
Ocean, Near Bolinas,
California, about 1938

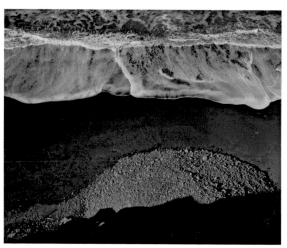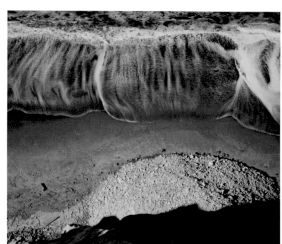

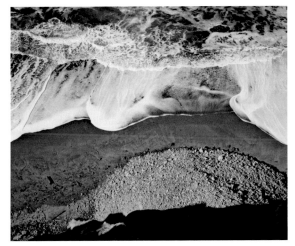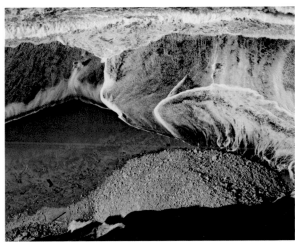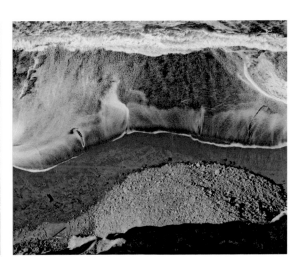

Plates 27–31
Surf Sequence 1–5,
San Mateo County Coast,
California, 1940

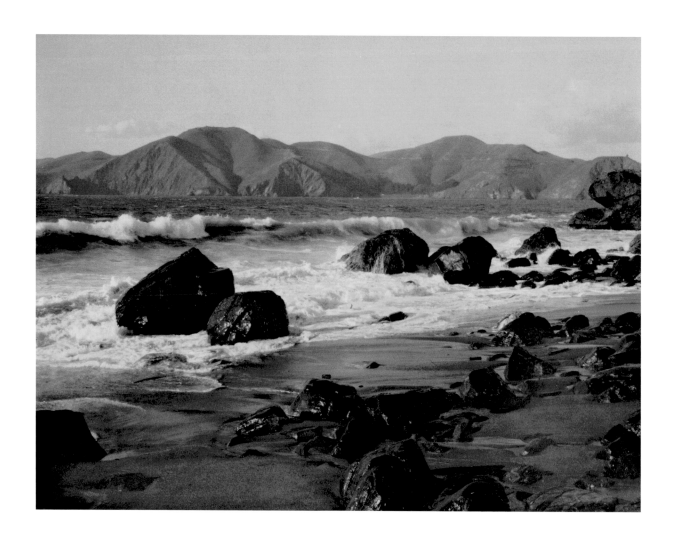

Plate 32
Bakers Beach, San Francisco,
California, 1954

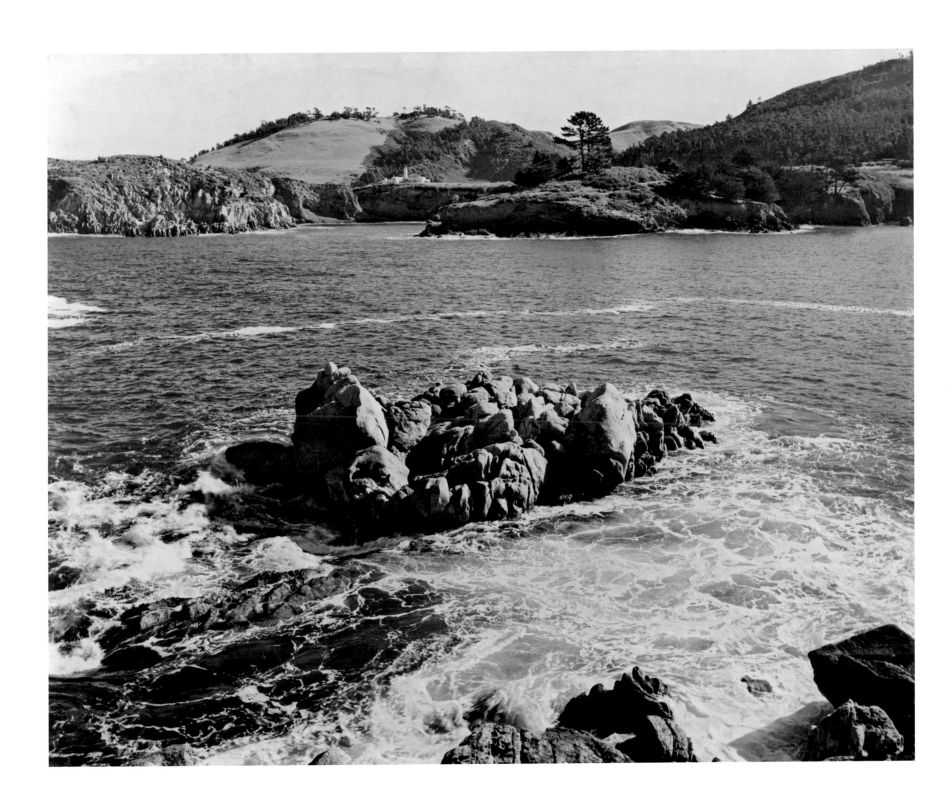

Plate 33
Whaler's Cove, Carmel Mission,
about 1953

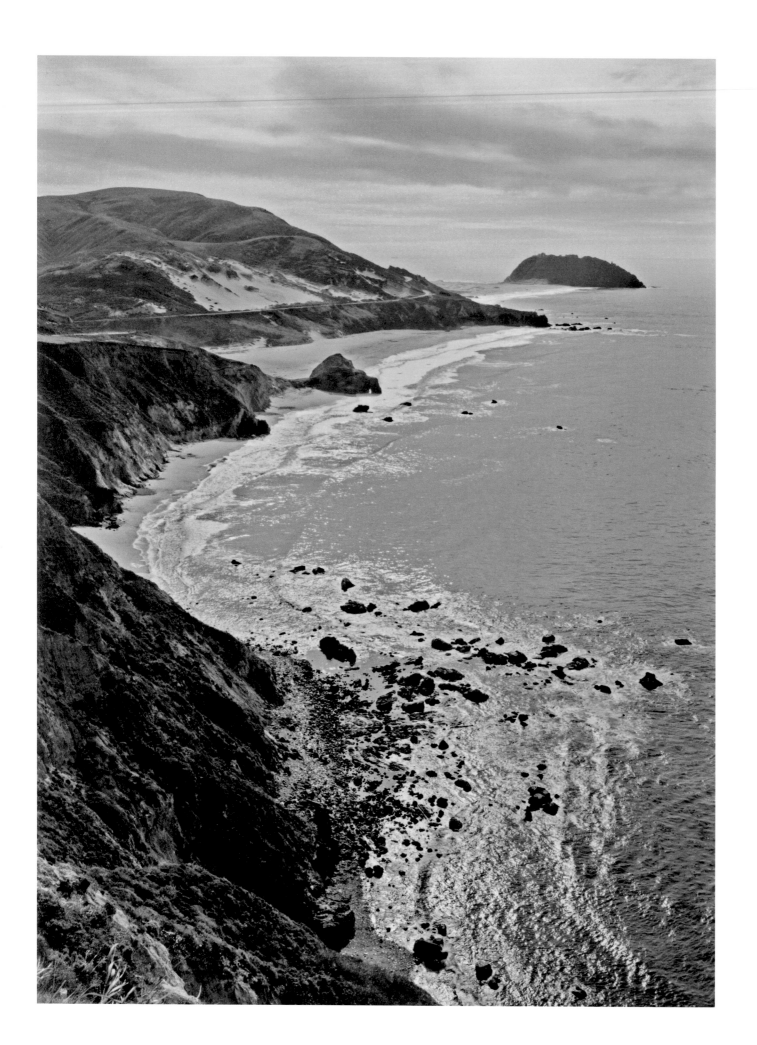

Plate 34
*Point Sur, Monterey
County, California*, n.d.

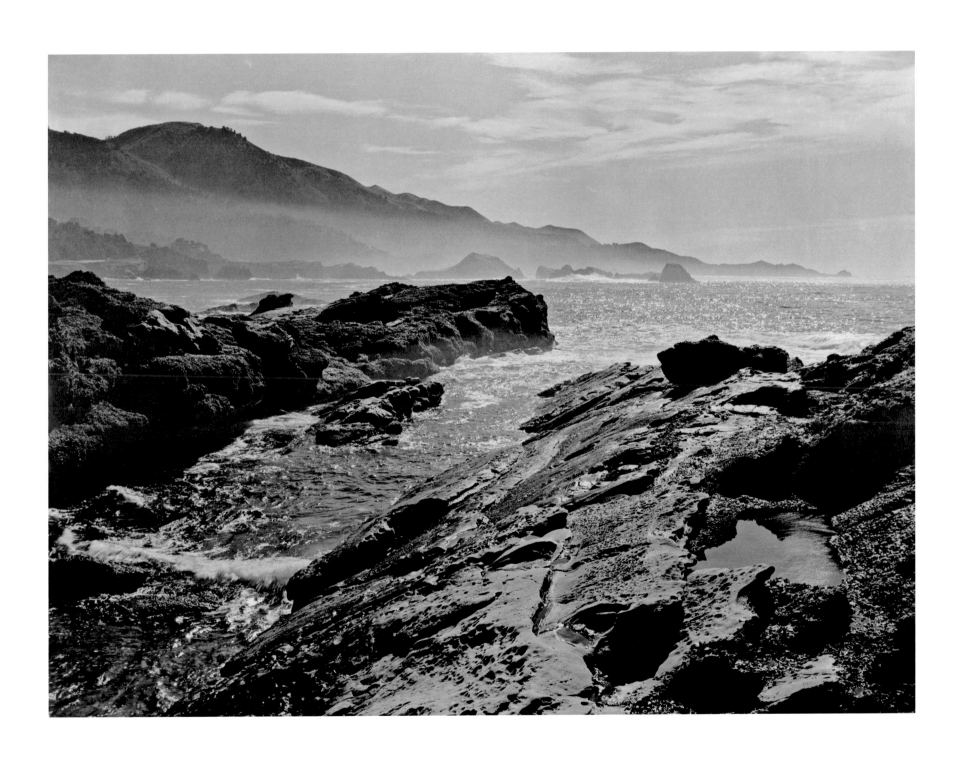

Plate 35
Point Lobos, Near Monterey,
about 1950

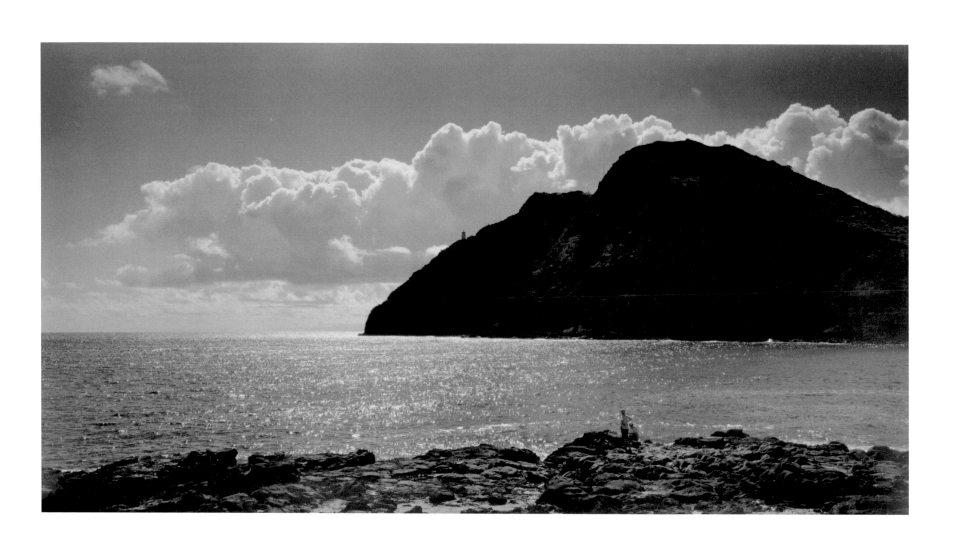

Plate 36
*Makapu Point, Oahu,
Hawaii*, 1957

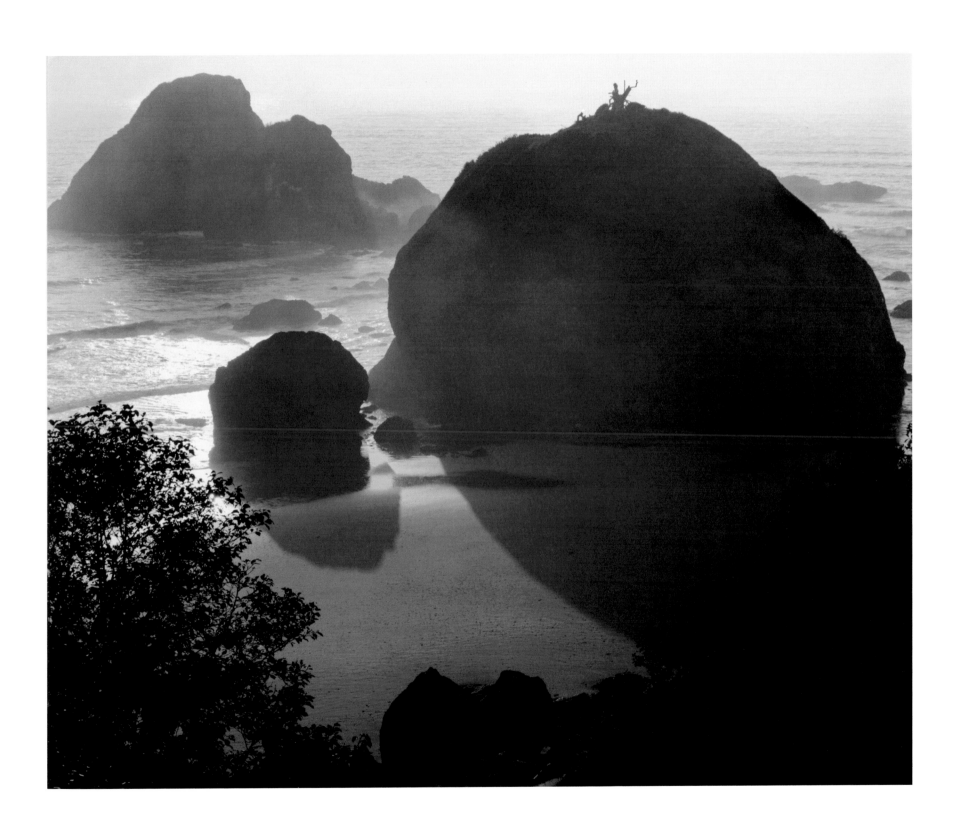

Plate 37
Northern California Coast,
Near Elk, *California*, 1964

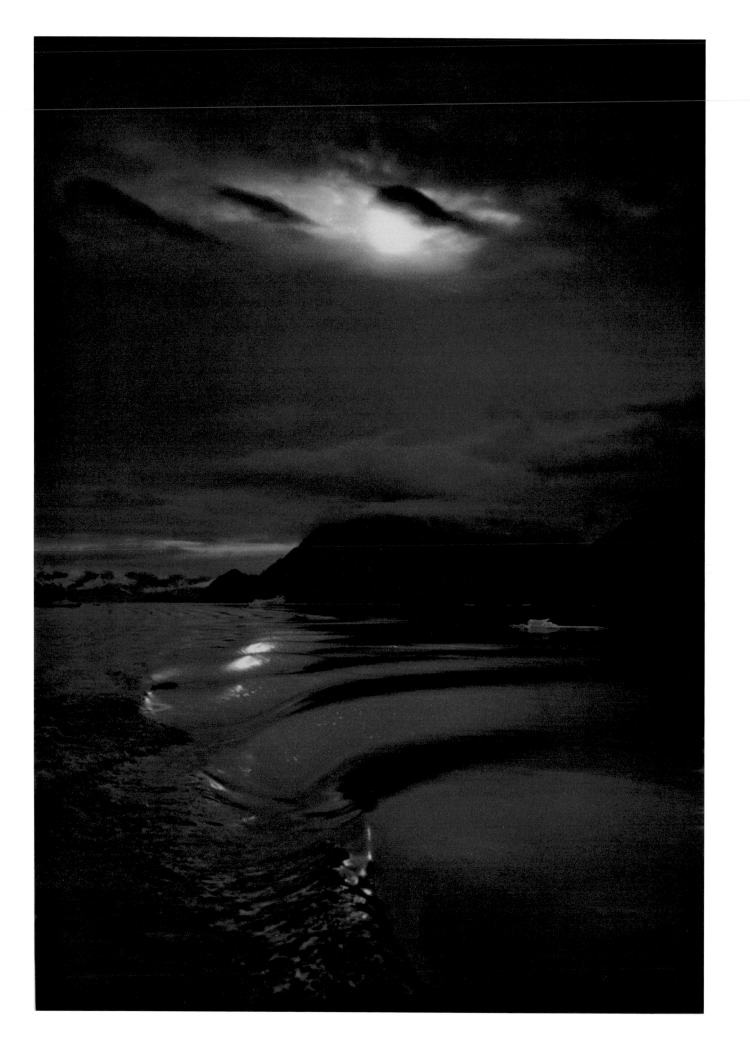

Plate 38
Glacier Bay National Monument, Alaska, about 1948

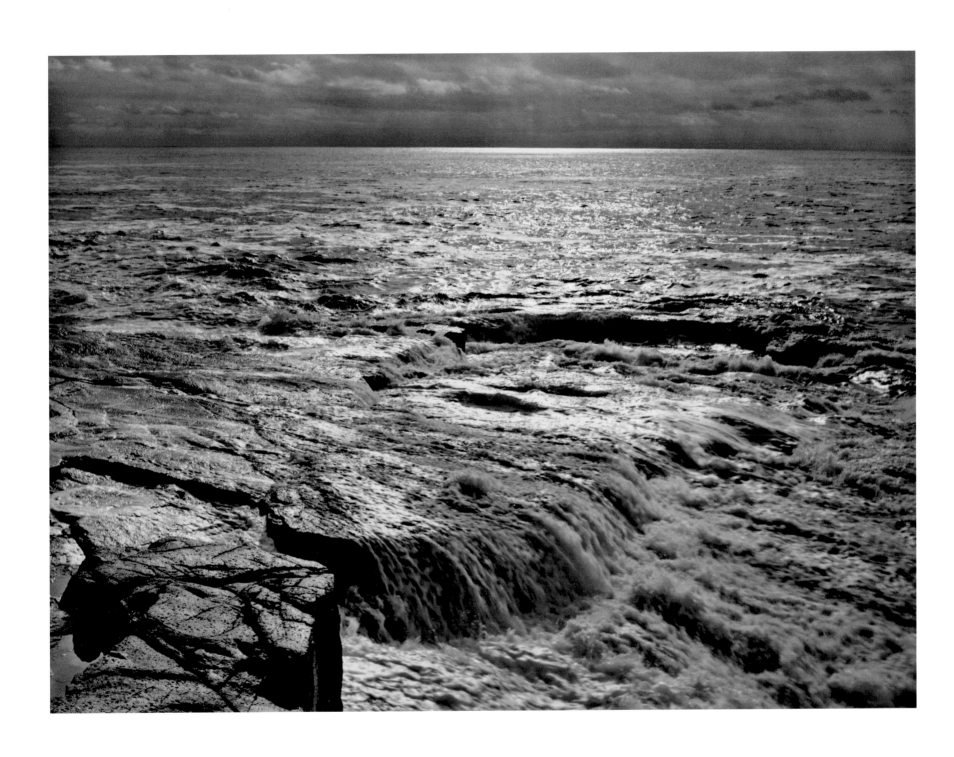

Plate 39
The Atlantic,
Schoodic Point,
Acadia National Park,
Maine, 1949

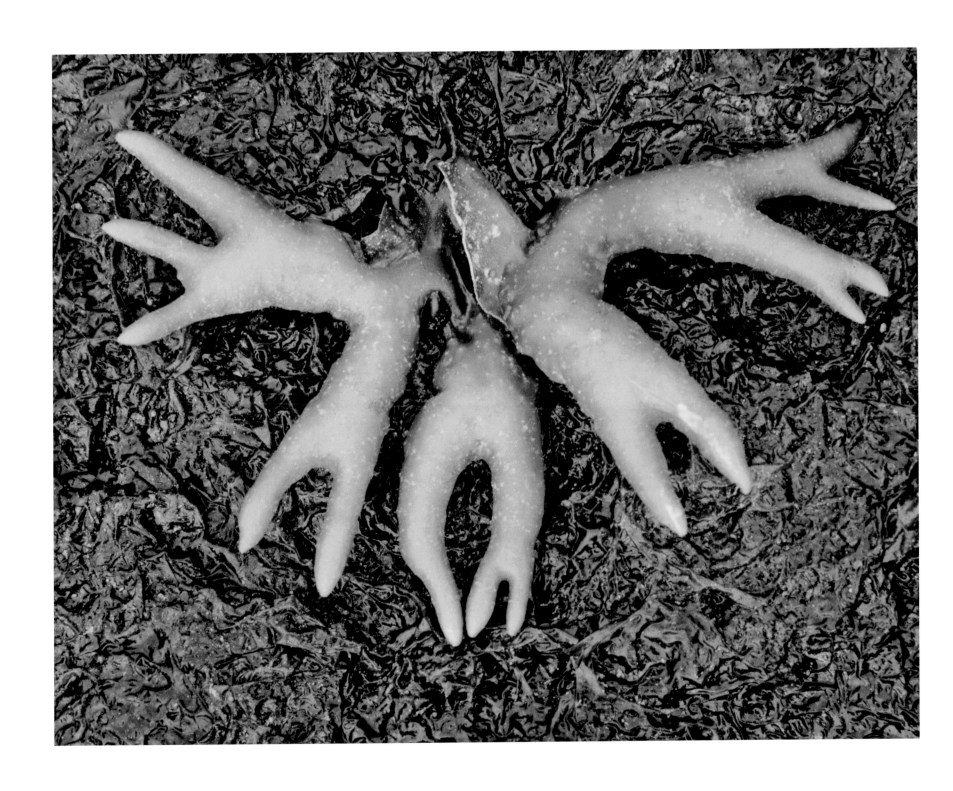

Plate 40
Seaweed, Sandy Cove,
Glacier Bay National
Monument, about 1948

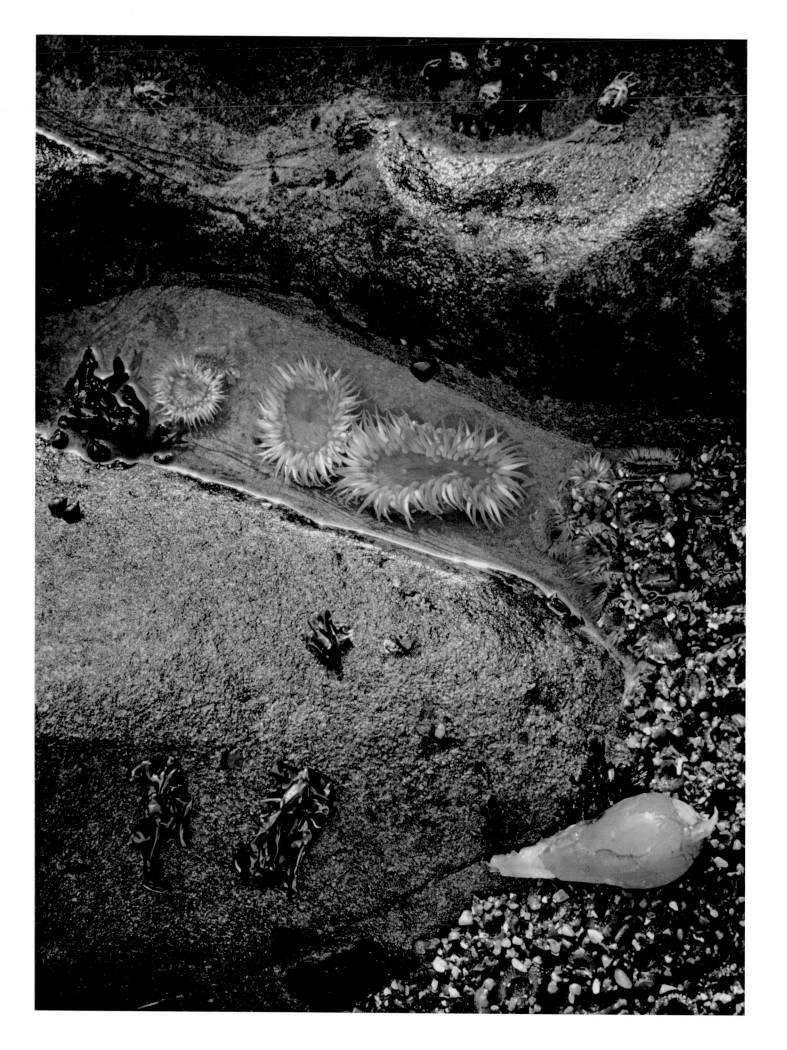

Plate 41
Sea Anemones,
Shore Detail,
Bodega Head,
California, 1969

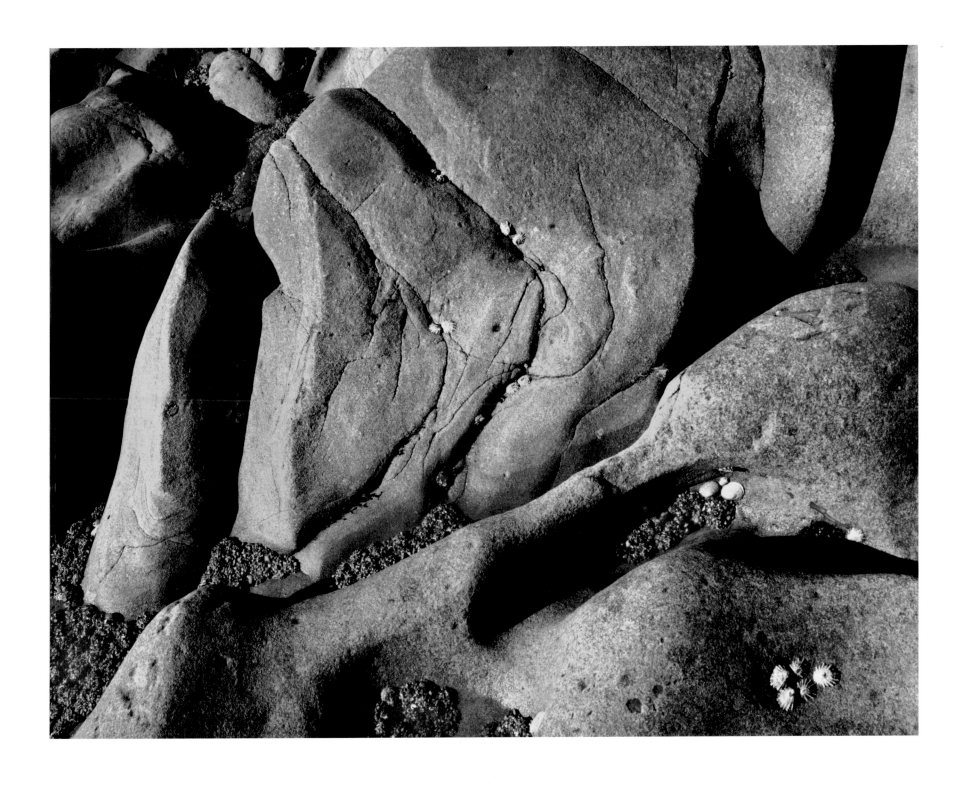

Plate 42
Rocks and Limpets, Point Lobos,
California, 1960

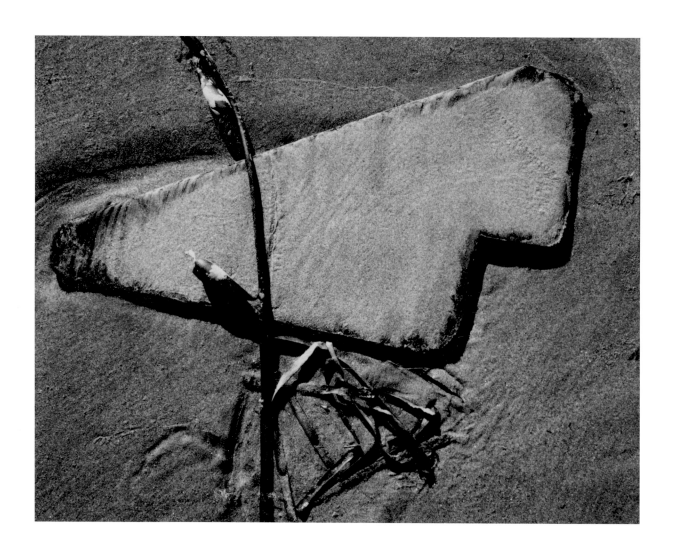

Plate 43
Rock and Sand, Bakers Beach,
San Francisco, California, 1961

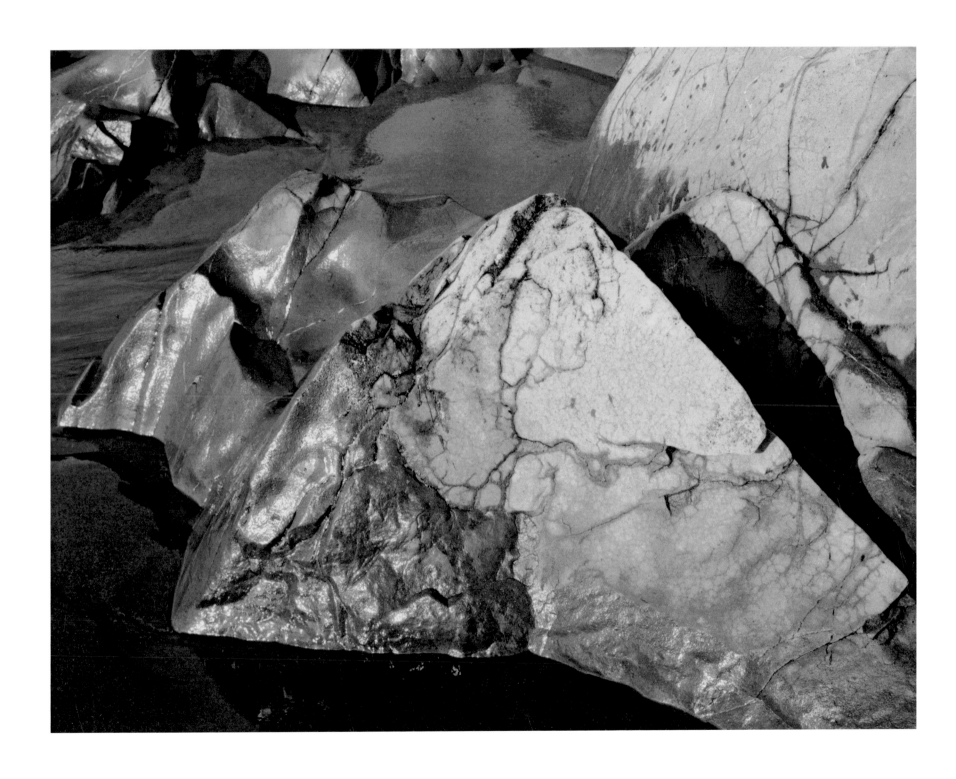

Plate 44
Rocks, Bakers Beach, San Francisco,
California, about 1931

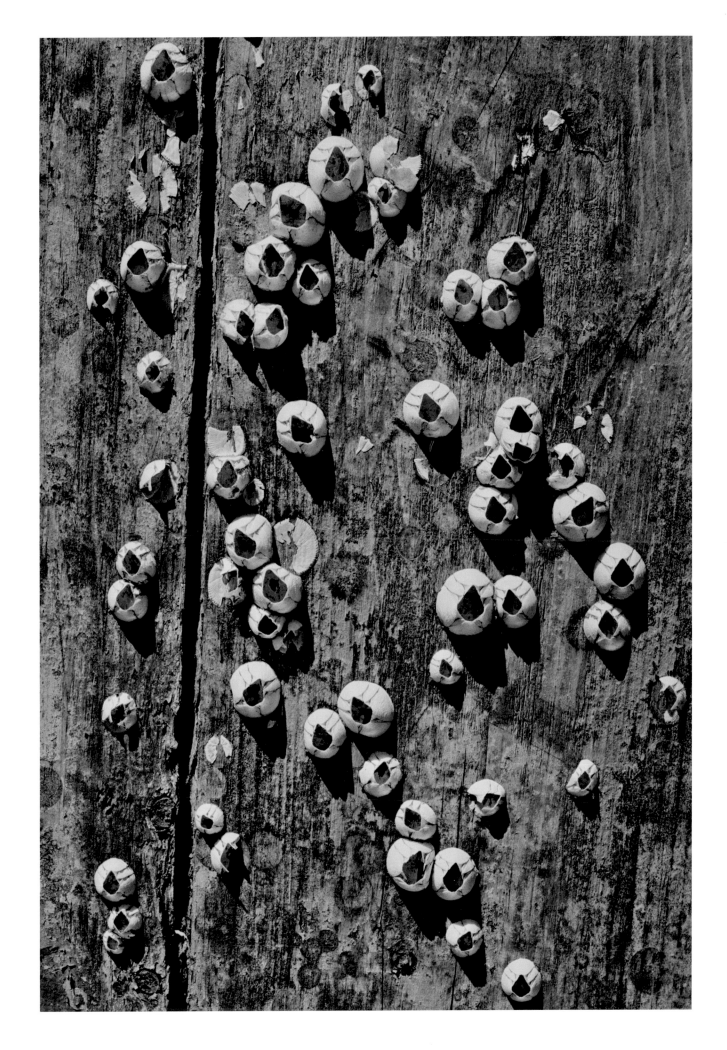

Plate 45
Barnacles,
Cape Cod, 1938

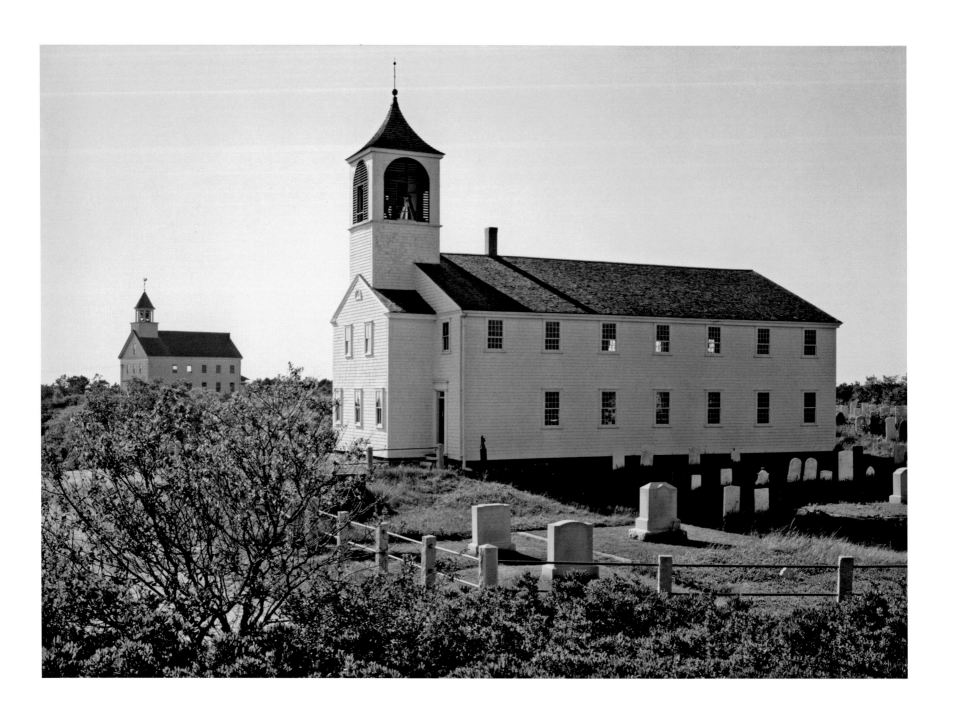

Plate 46
*Churches, Truro, Cape Cod,
Massachusetts*, 1941

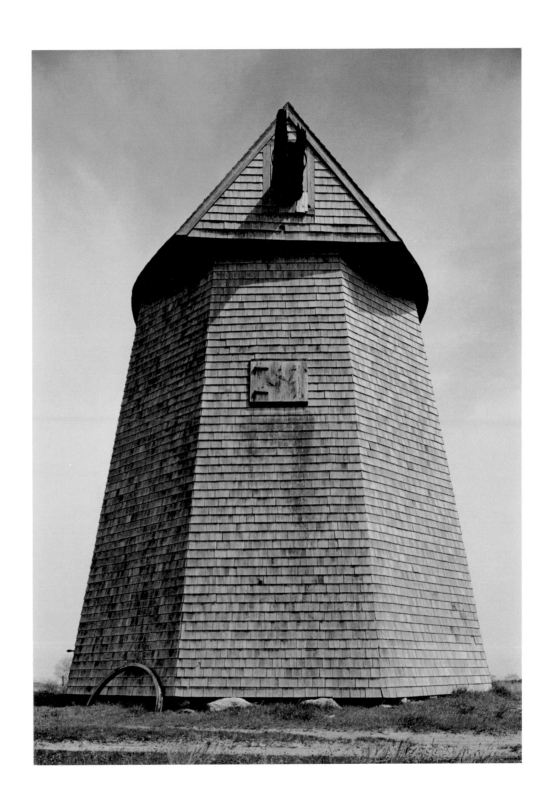

Plate 47
Chatham, Cape Cod,
about 1939

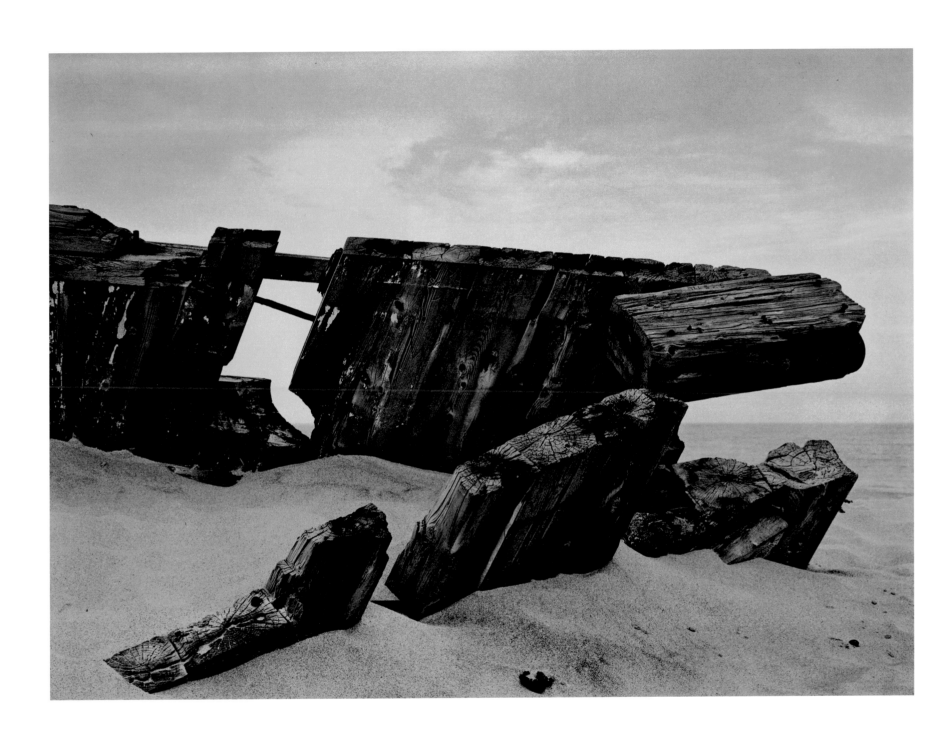

Plate 48
Old Wreck, Cape Cod,
Massachusetts,
about 1936

Plates 49–52
Shipwreck Series, Lands End,
San Francisco,
1931–1934
(numbers 7, 14, 8, and 10)

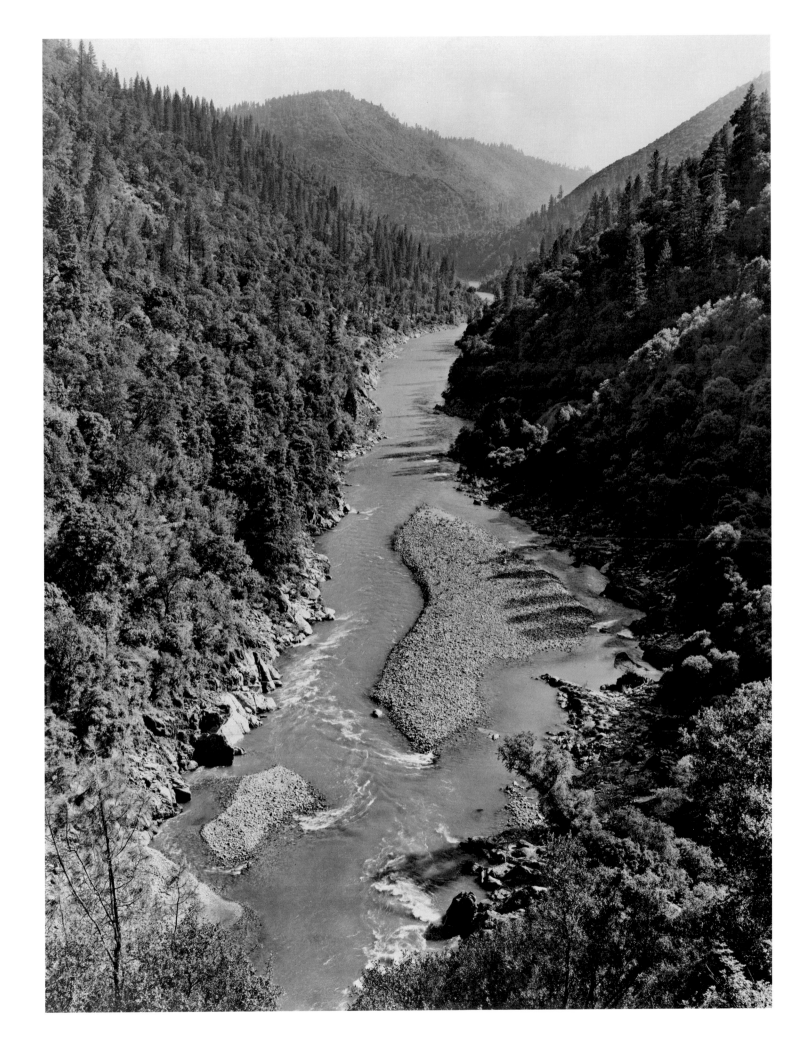

Plate 53
Gravel Bars,
American River,
about 1950

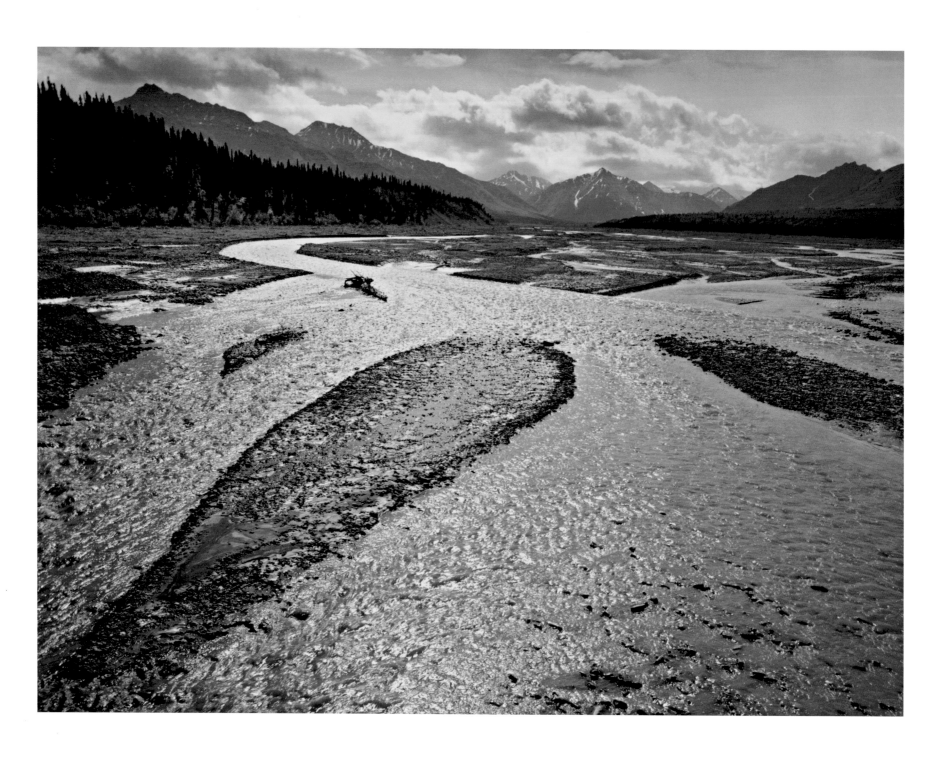

Plate 54
Teklanika River, Mount McKinley
National Park, Alaska, 1948

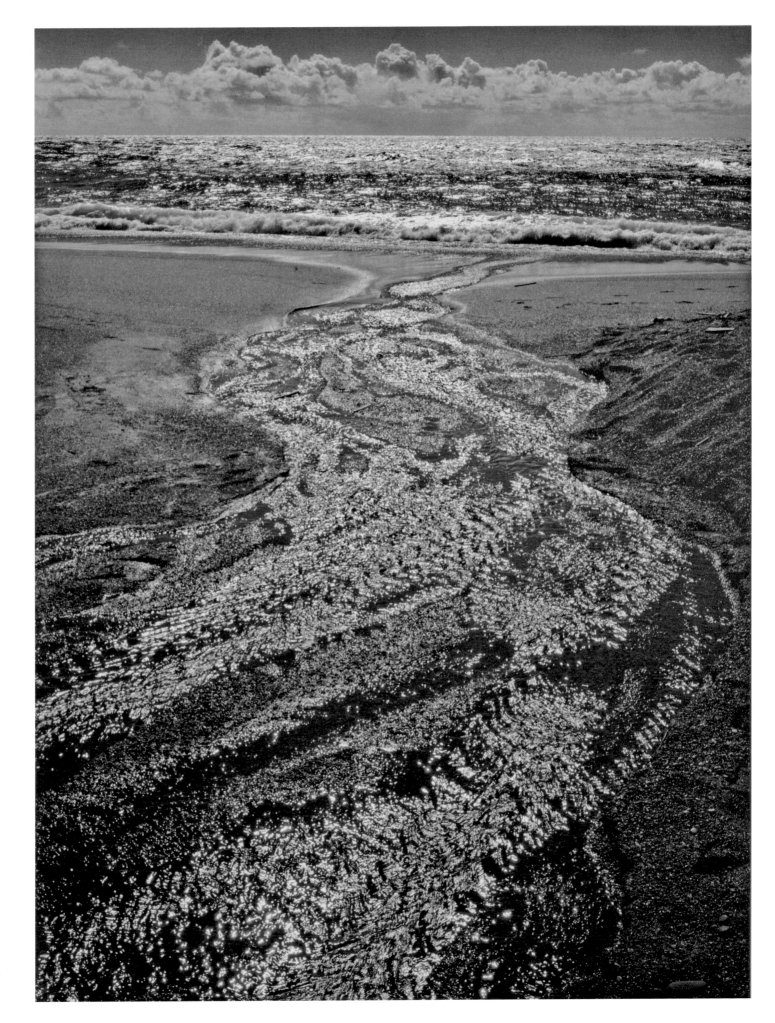

Plate 55
*Stream, Sea, and Clouds,
Rodeo Lagoon, Marin
County, California*, 1962

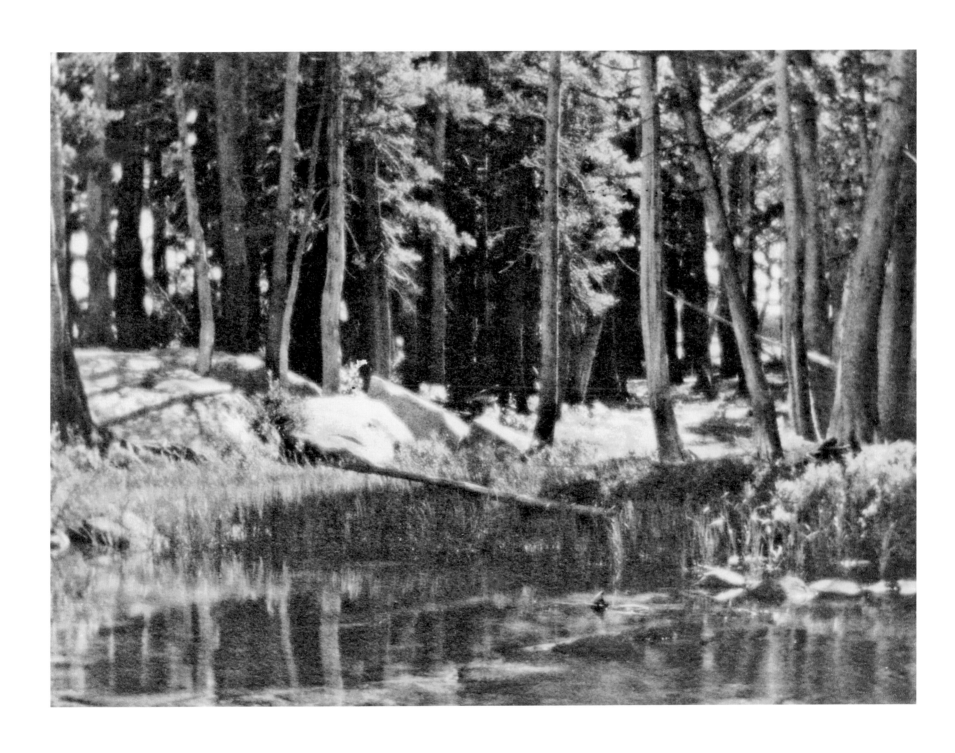

Plate 56
*A Grove of Tamarack
Pine Near Timber Line,*
about 1921

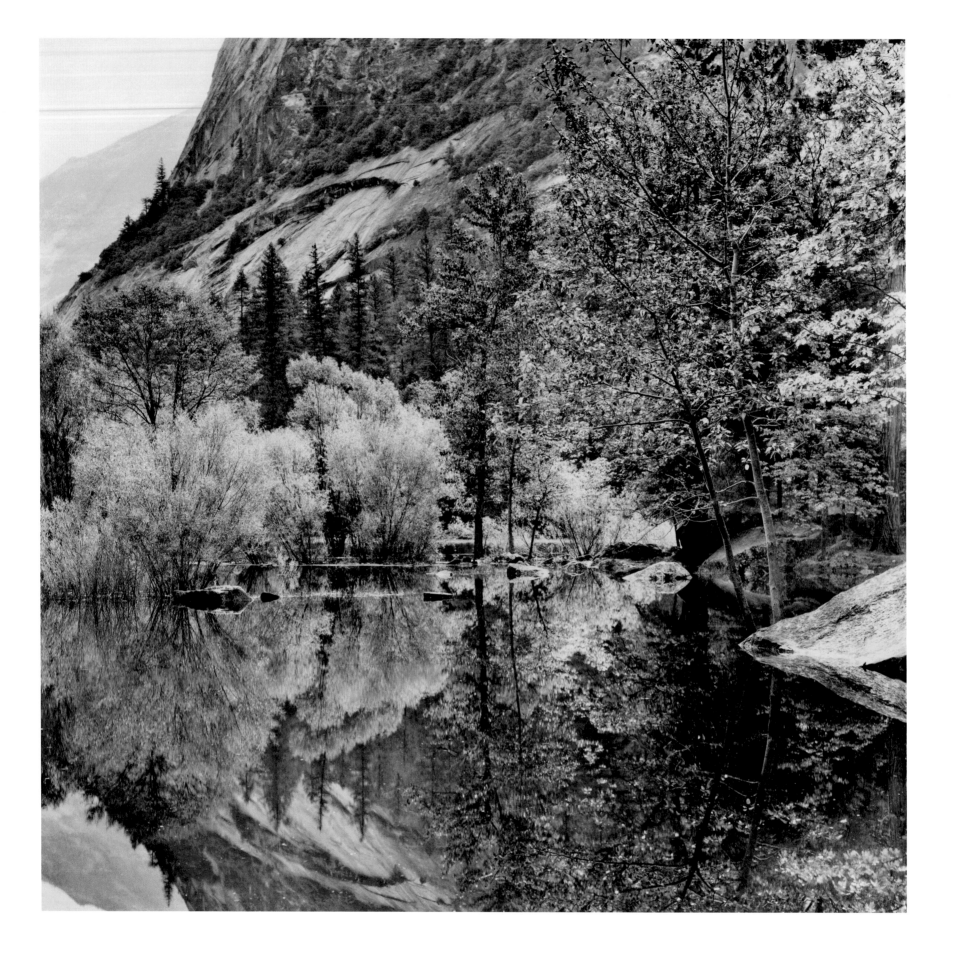

Plate 57
Mirror Lake, California,
about 1950

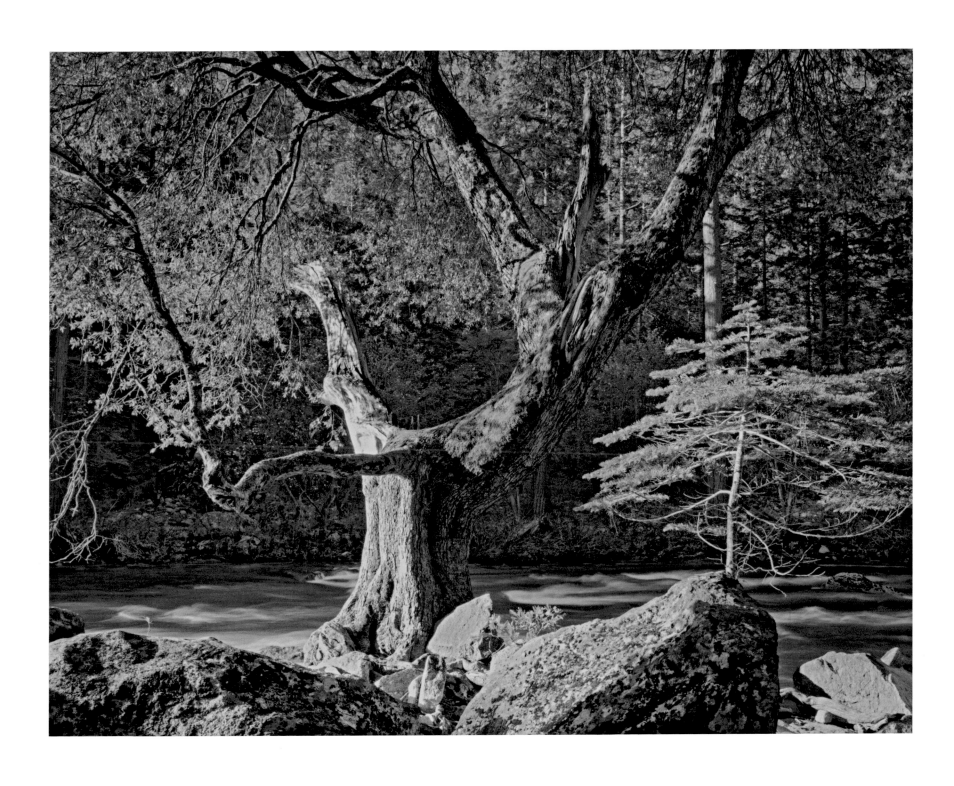

Plate 58
*Early Morning Merced
River, Autumn, Yosemite
National Park, California,*
about 1950

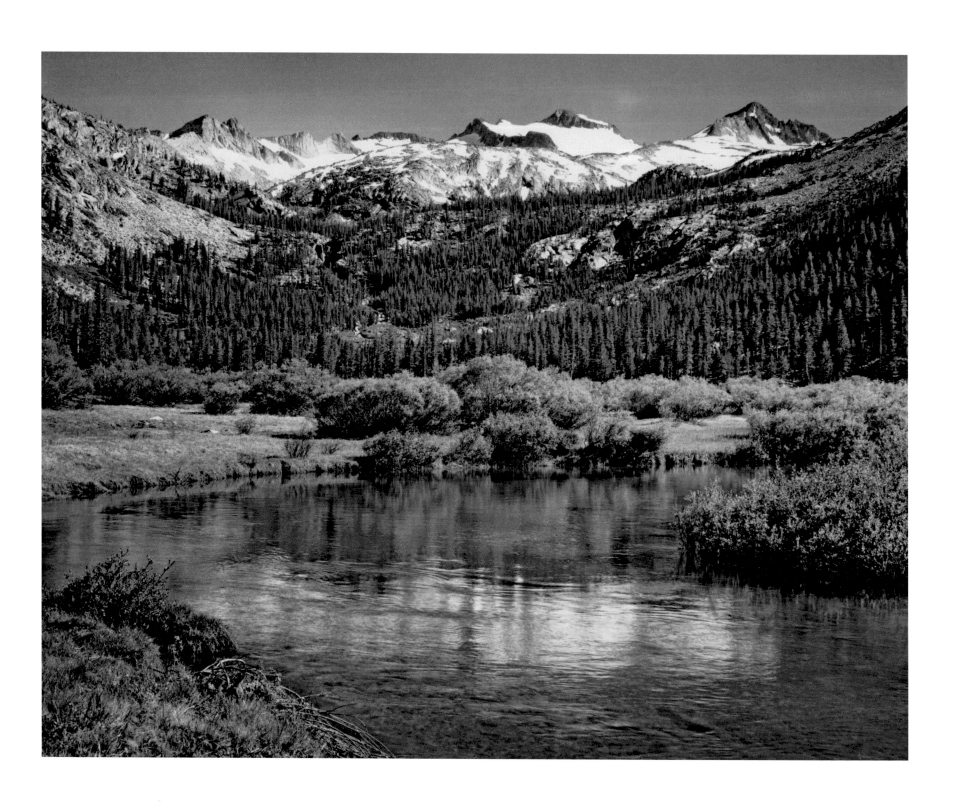

Plate 59
Mount Lyell and Mount Maclure, Tuolumne River, Yosemite National Park, about 1936

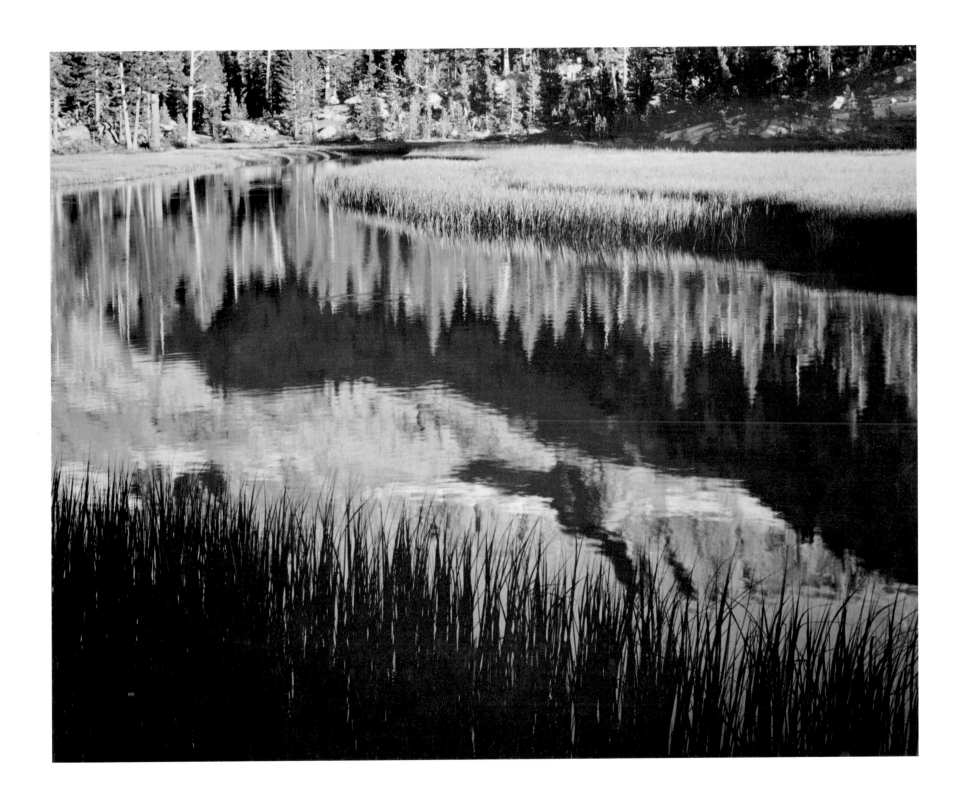

Plate 60
*In the Lyell Fork of
the Merced River,
Yosemite National
Park*, about 1935

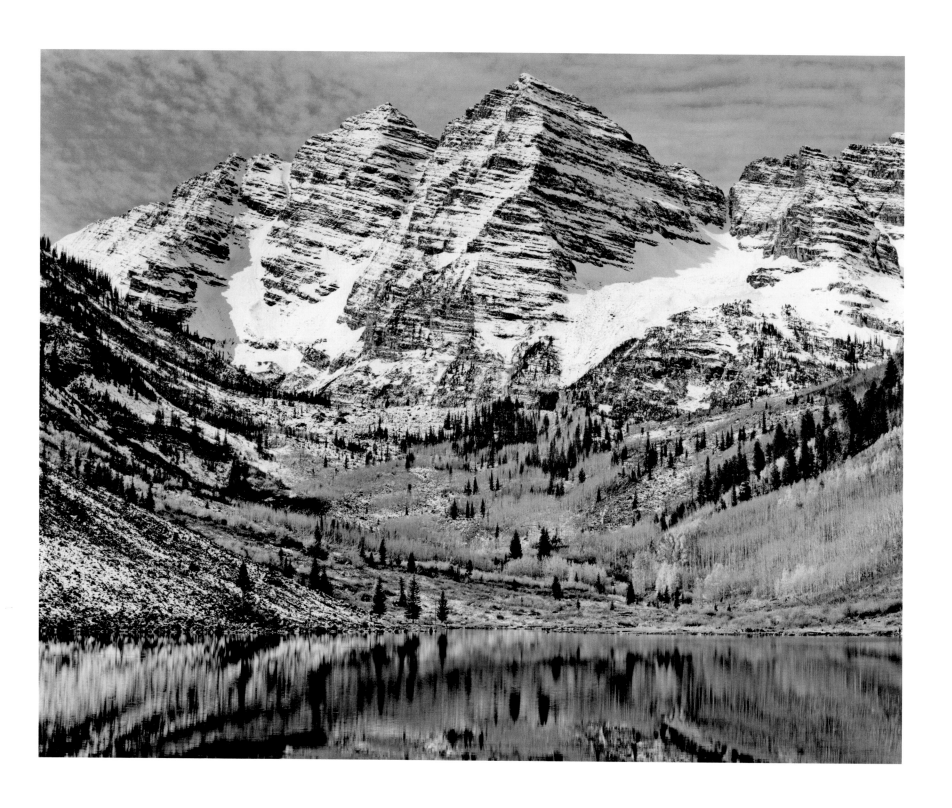

Plate 61
*Maroon Bells, Near
Aspen, Colorado,*
1951

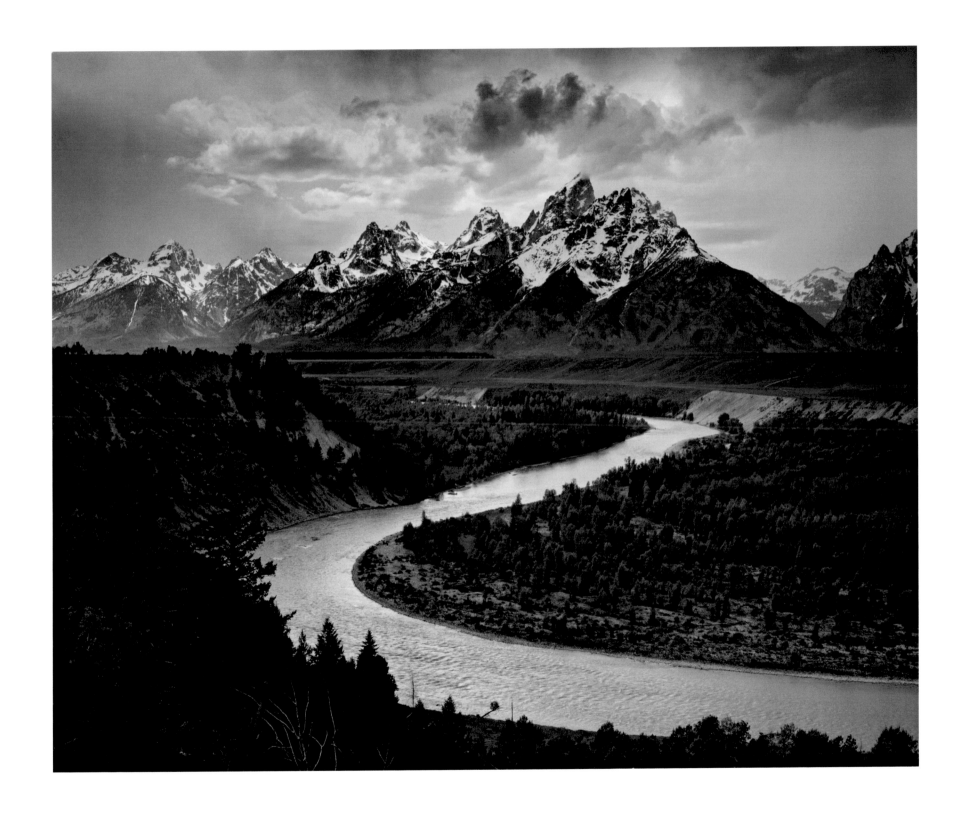

Plate 62
The Tetons and the Snake River,
Grand Teton National Park,
Wyoming, 1942

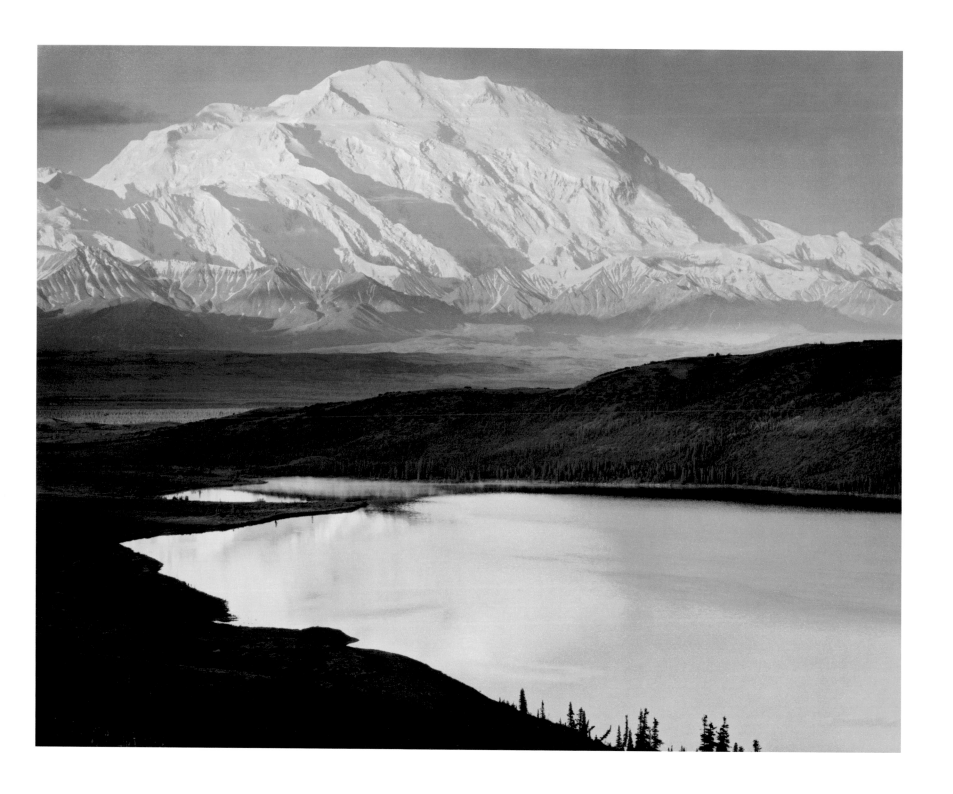

Plate 63
Mount McKinley and Wonder Lake,
Denali National Park, Alaska, 1947

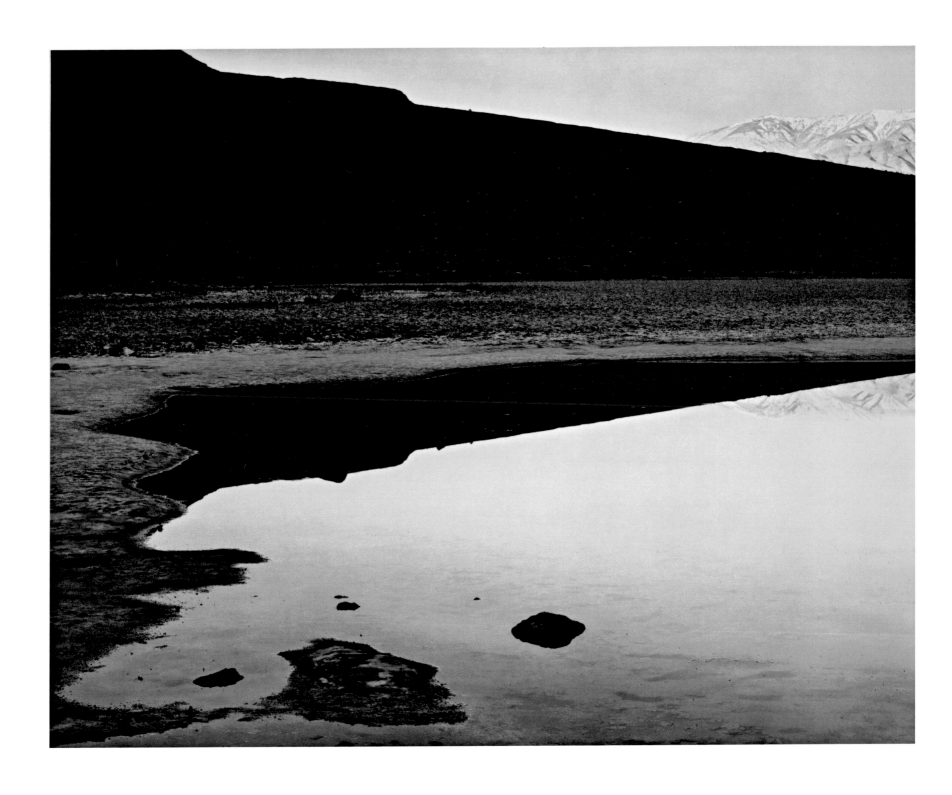

Plate 64
Bad Water, Death Valley
National Monument,
about 1942

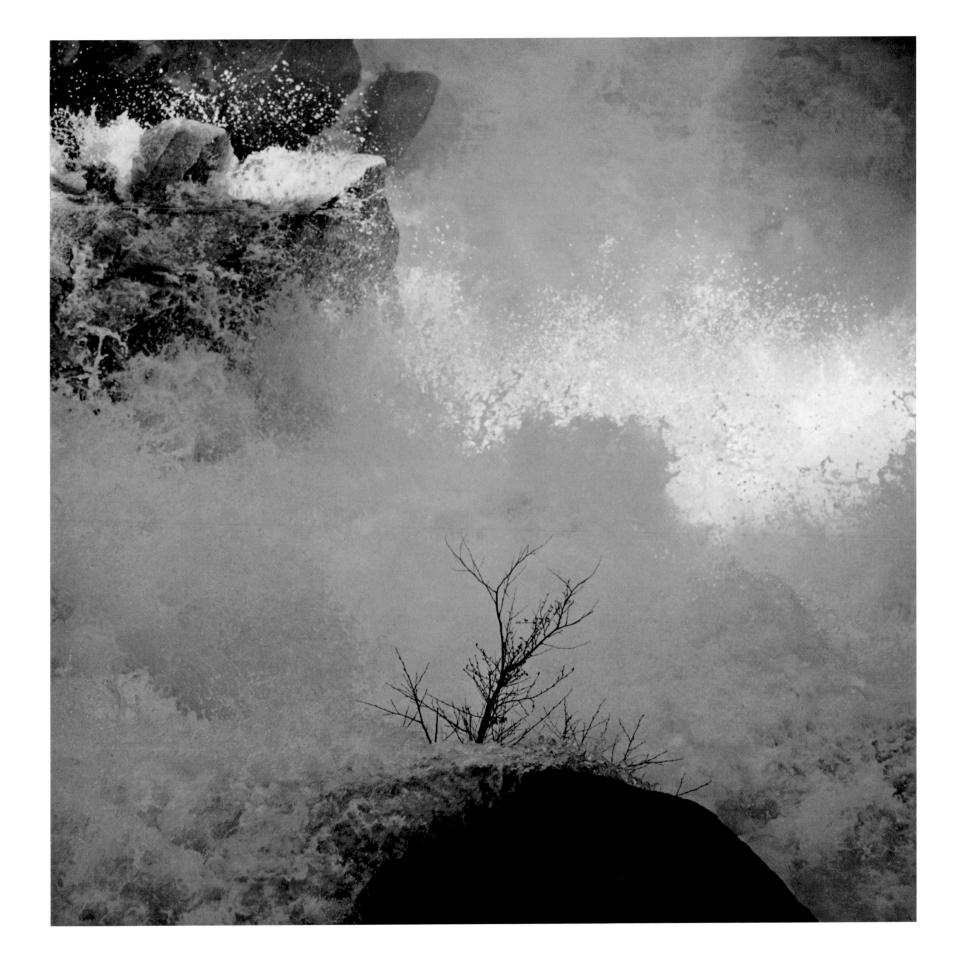

Plate 65
Shrub and Rapids,
Merced River, 1968

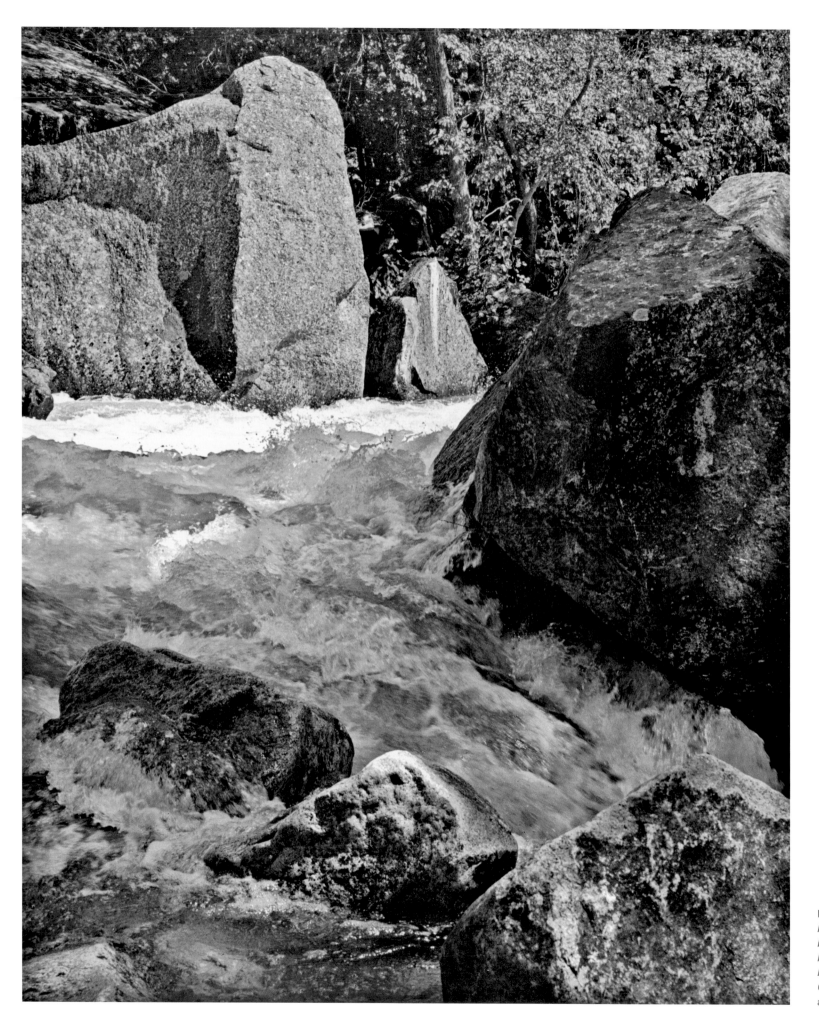

Plate 66
*Merced River
below Cascade
Falls, Yosemite
National Park,
California,*
about 1955

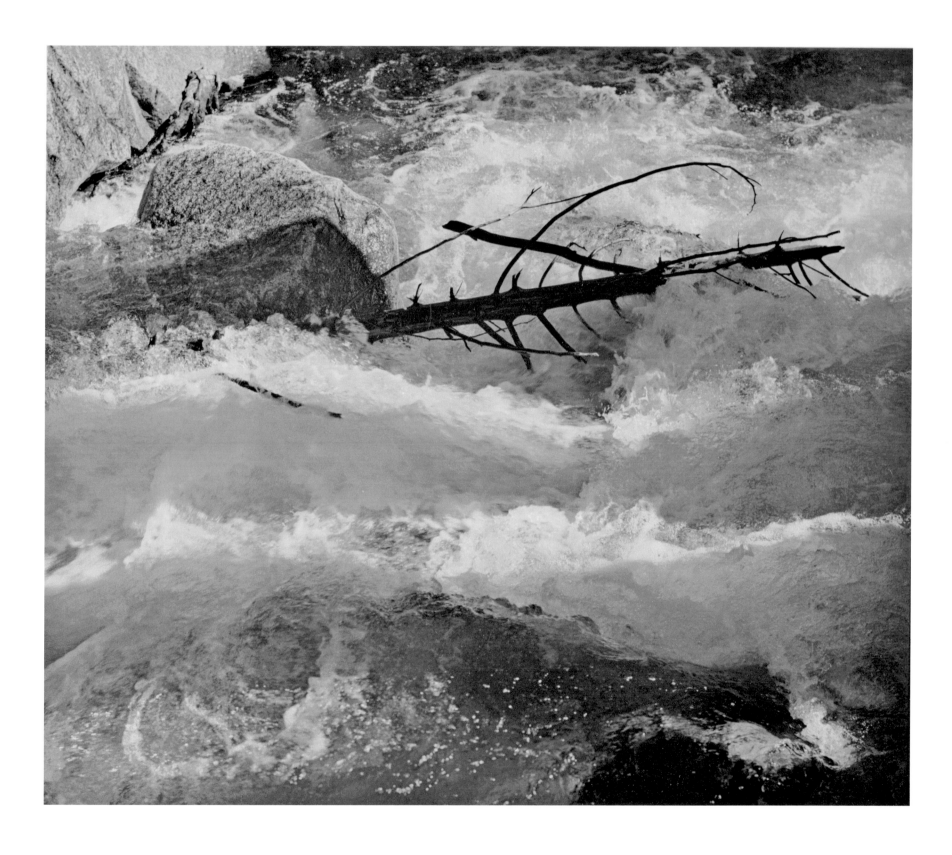

Plate 67
Rapids, Merced River,
Yosemite Valley,
California, 1952

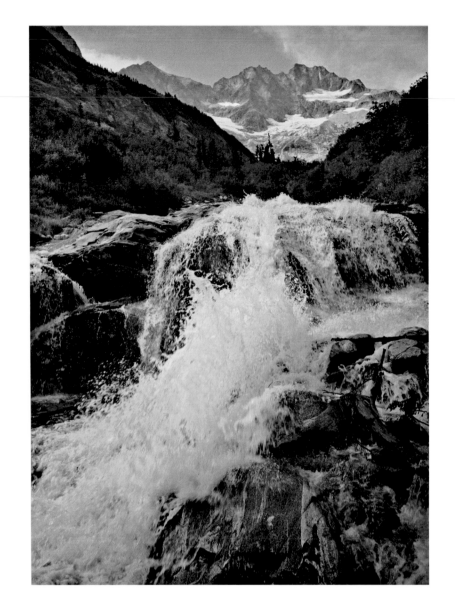

Plate 68
Waterfall, Northern Cascades, Washington, 1960

Plate 69
Cascade, Happy Isles, Yosemite Valley, about 1940

Plate 70
Detail of *Cascade*
Bridge Creek, Northern
Cascades, Washington,
about 1960

Plate 71
Cascade, Yosemite
National Park,
about 1968

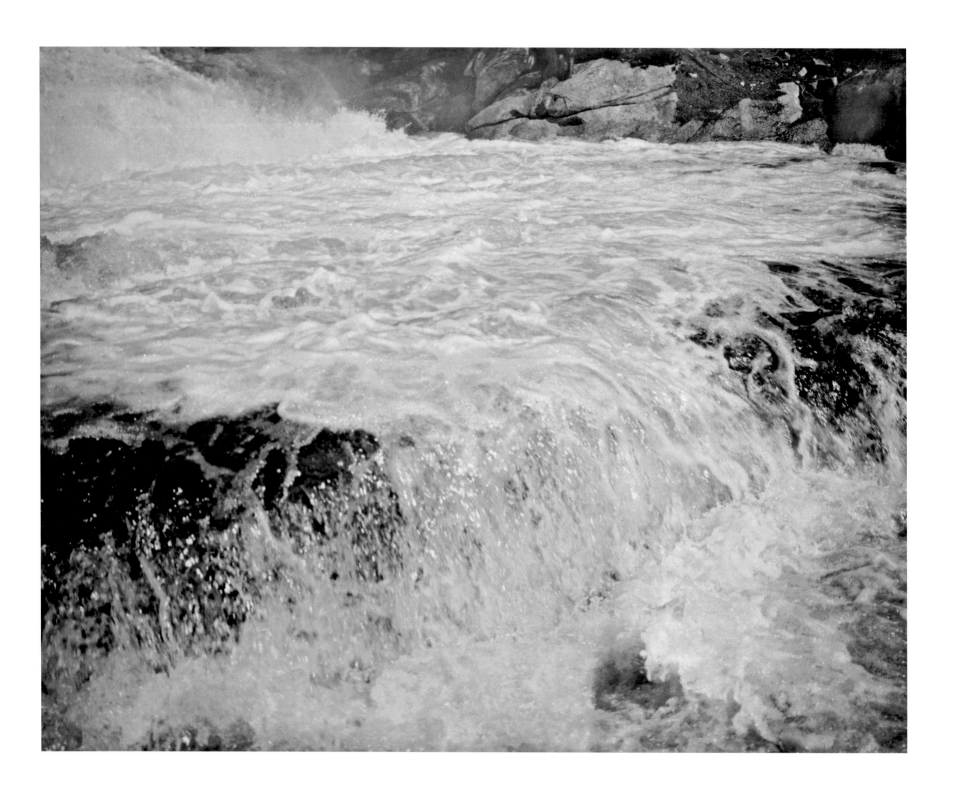

Plate 72
Untitled,
about 1940

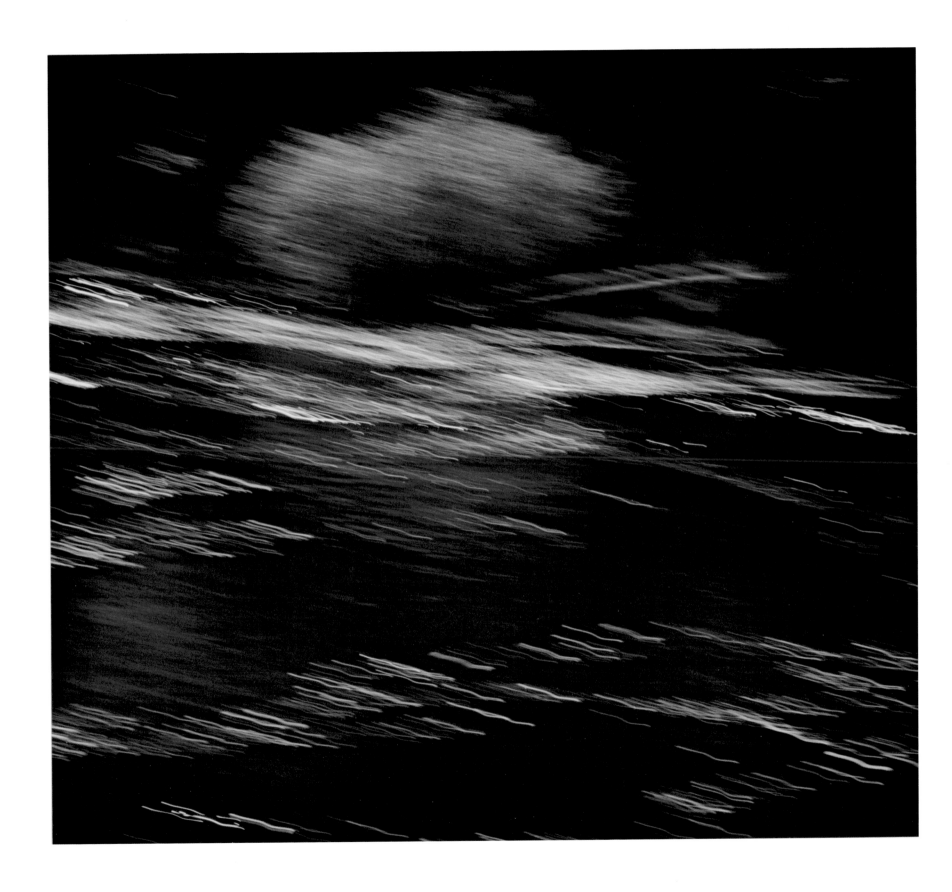

Plate 73
Merced River,
Yosemite Valley, n.d.

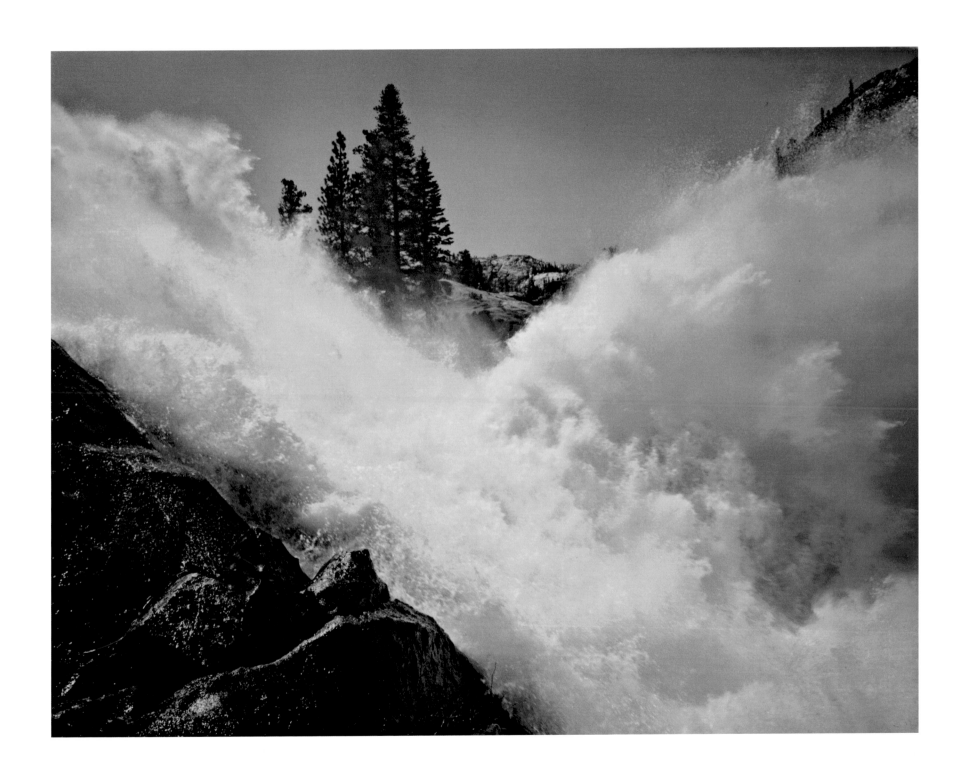

Plate 74
Waterwheel Falls,
Yosemite National Park,
California, about 1948

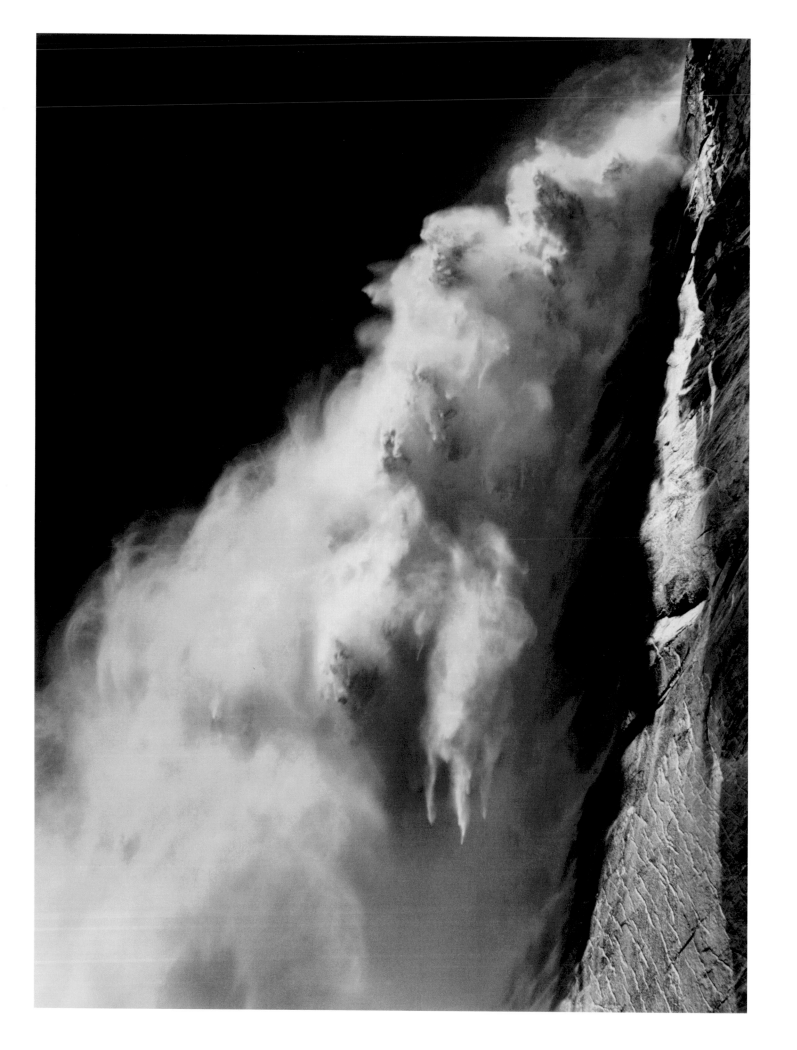

Plate 75
Upper Yosemite Fall,
Yosemite Valley,
about 1946

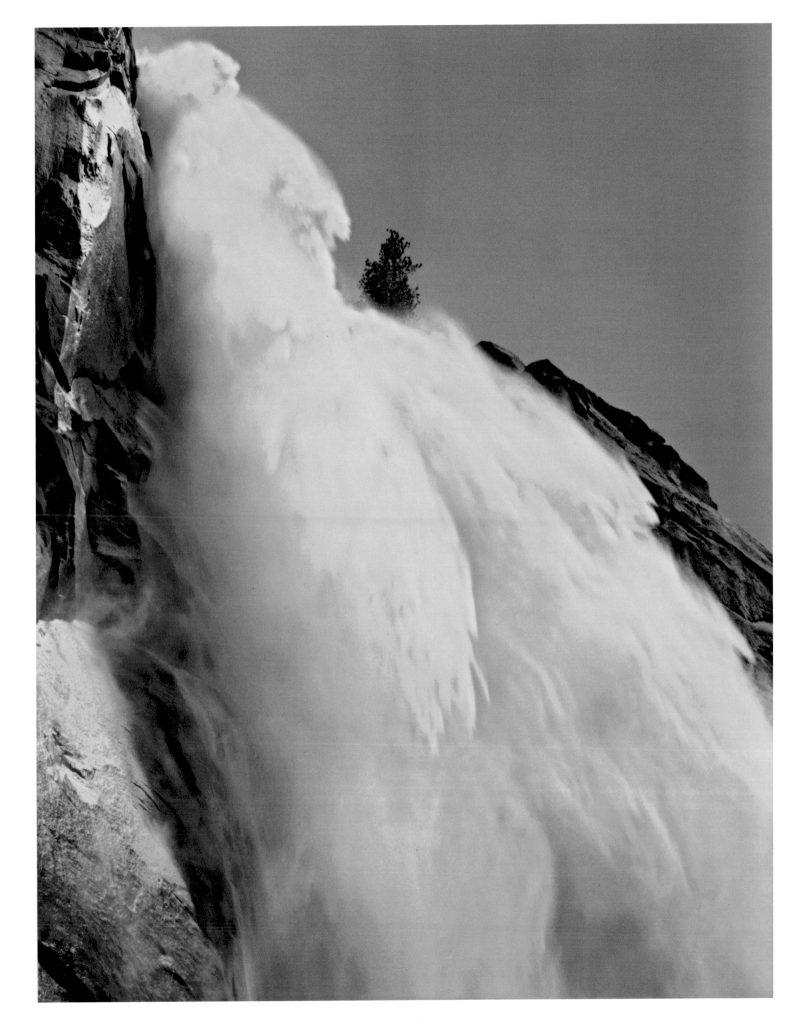

Plate 76
Nevada Fall, Profile,
Yosemite Valley,
about 1946

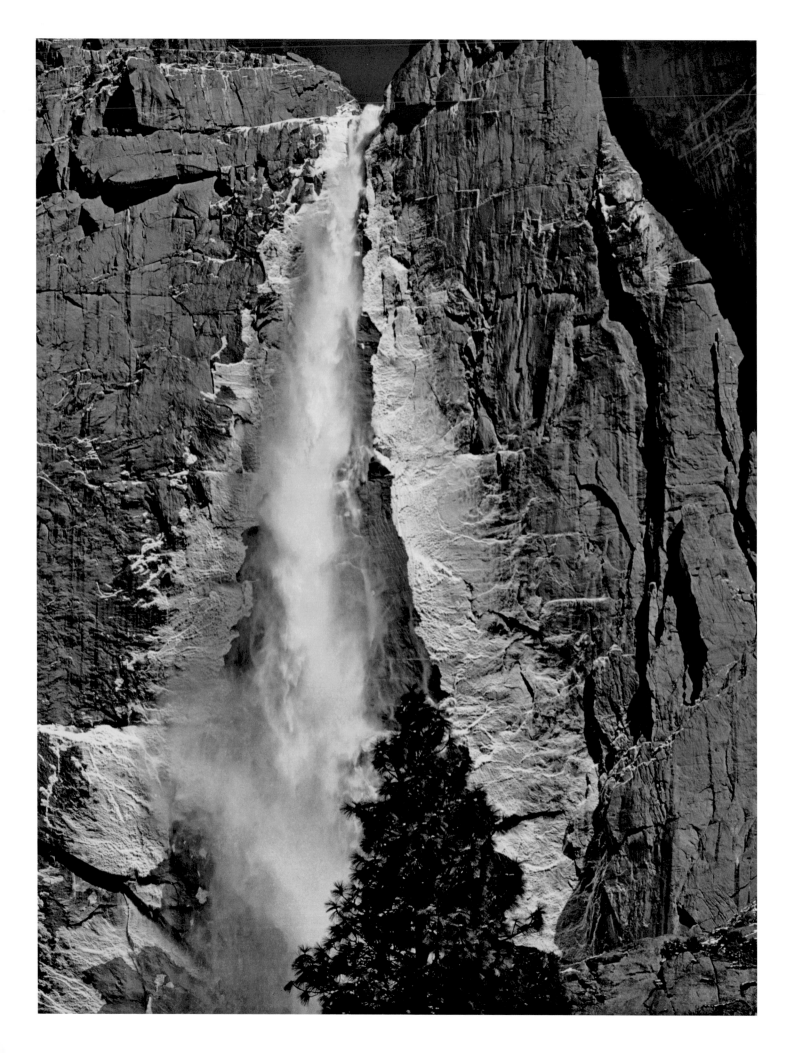

Plate 77
*Upper Yosemite Fall,
Yosemite Valley*,
about 1960

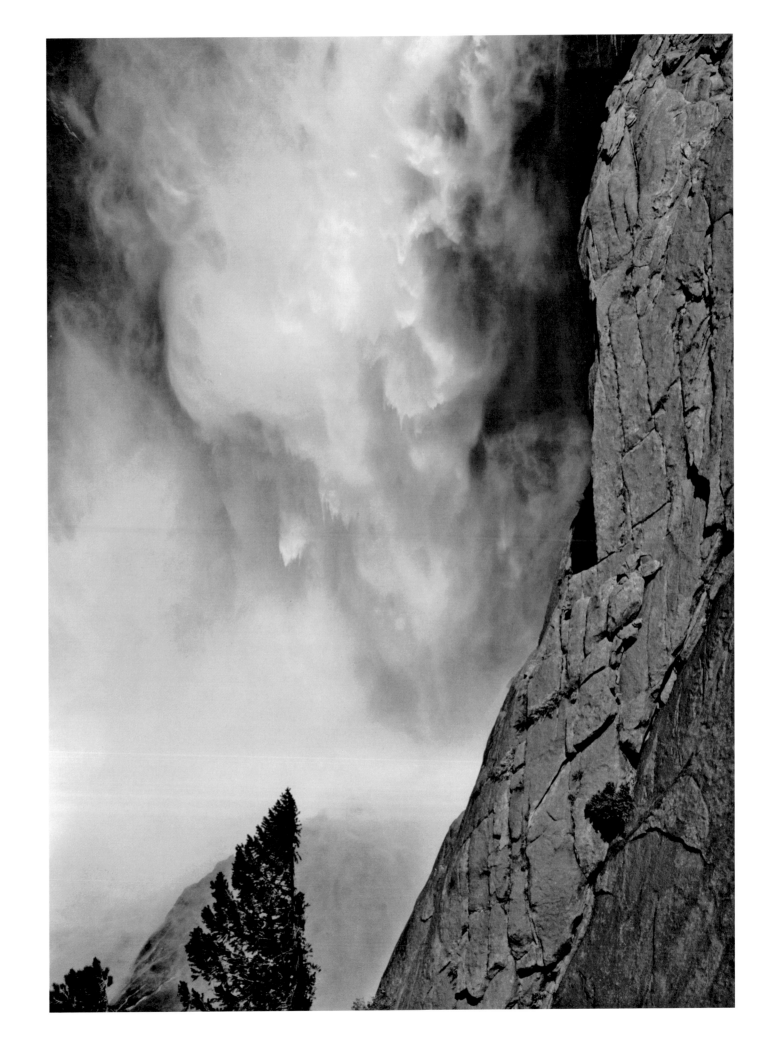

Plate 78
*Base of Upper
Yosemite Fall,
Yosemite National
Park*, about 1950

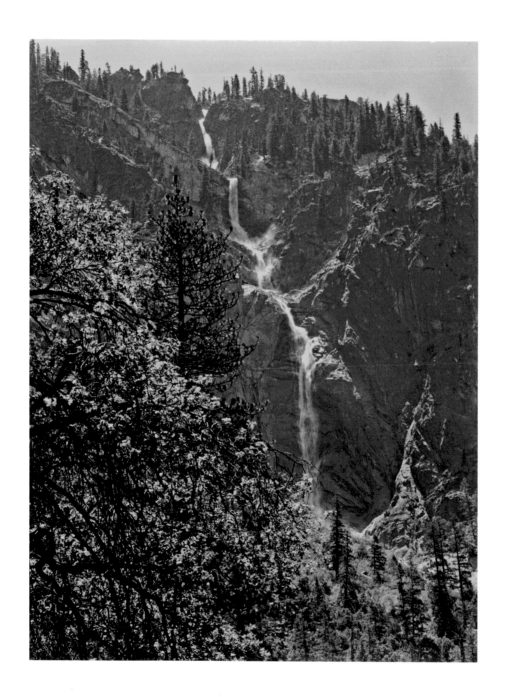

Plate 79
Sentinel Falls, n.d.

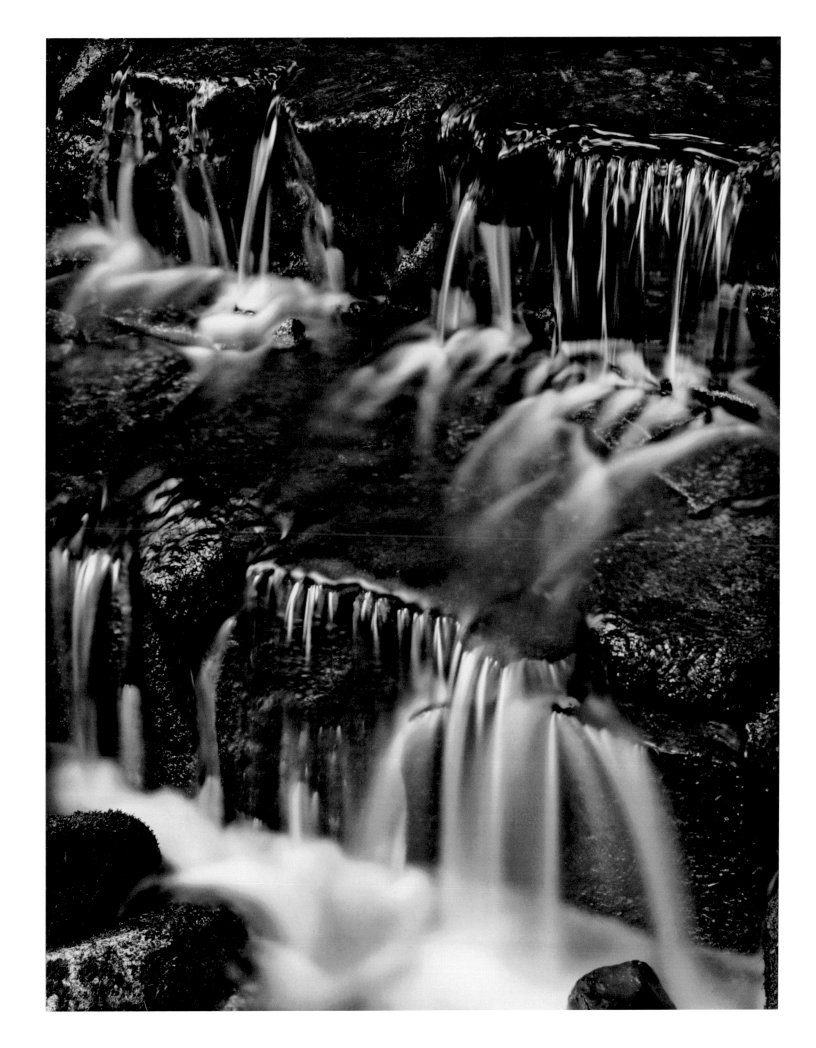

Plate 80
Fern Spring, Dusk,
Yosemite Valley,
California,
about 1962

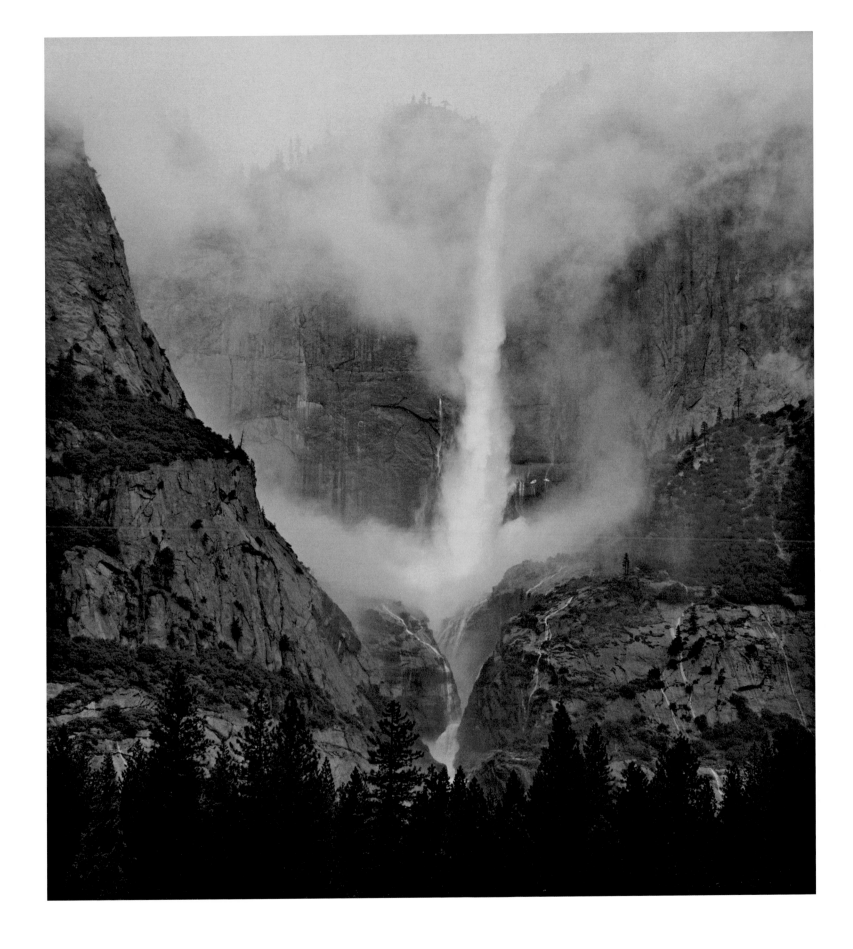

Plate 81
Yosemite Falls, Rain,
Yosemite Valley,
about 1960

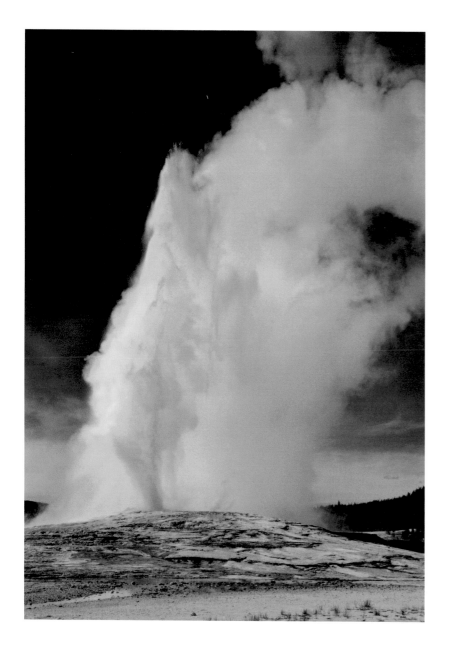
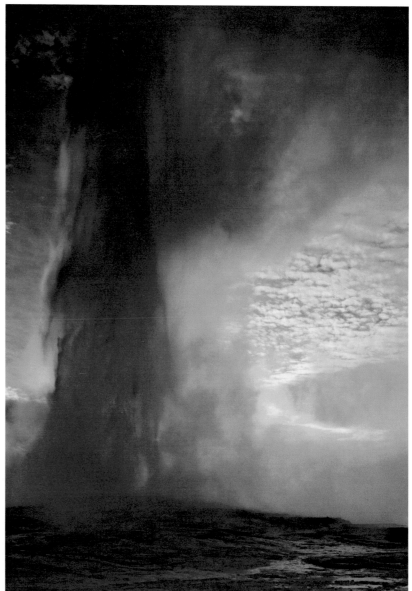

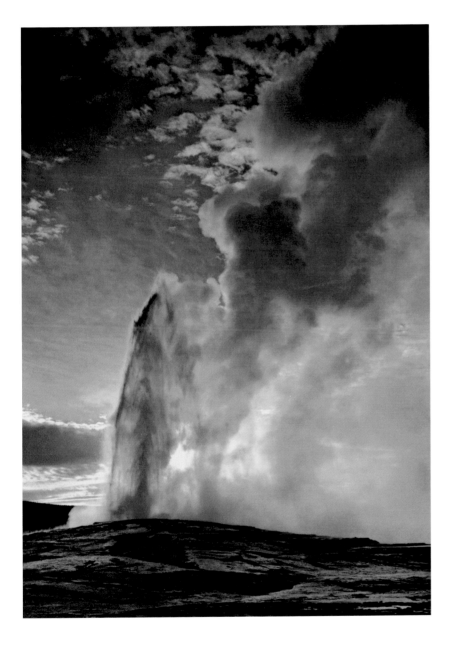
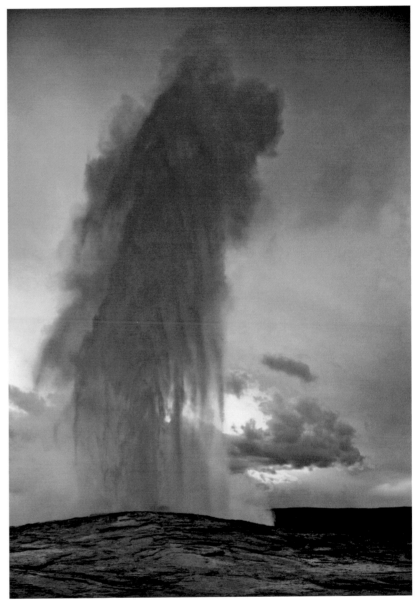

Plates 82–85
Old Faithful Geyser,
Yellowstone National
Park, Wyoming,
about 1942

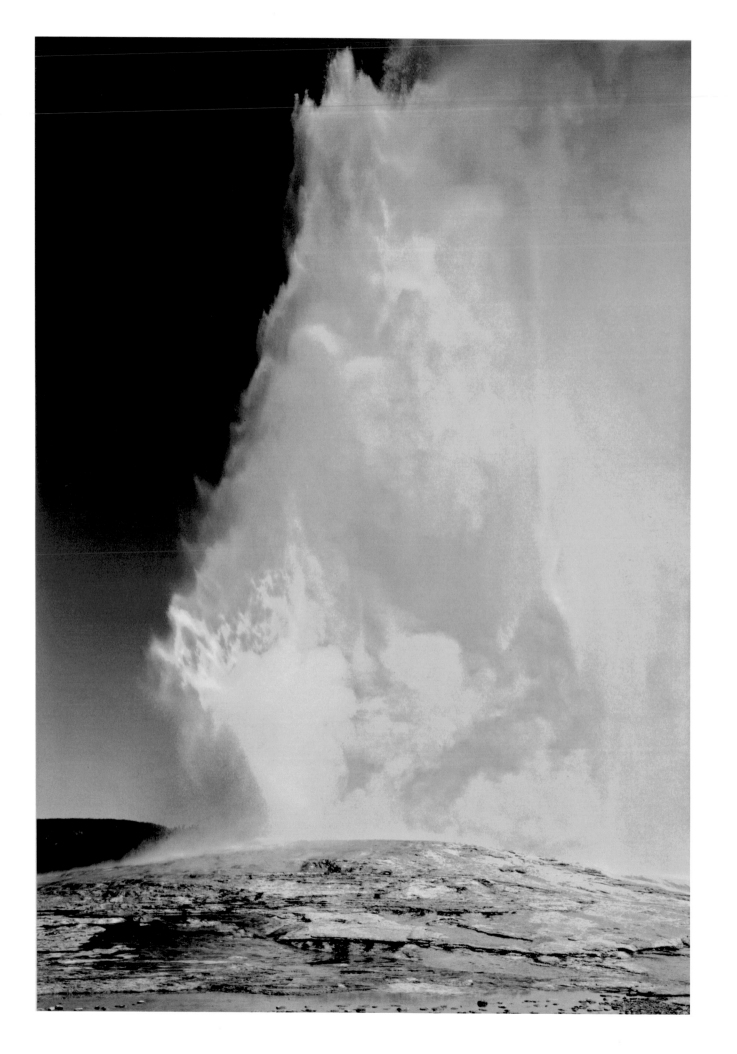

Plate 86
*Yellowstone National
Park, Old Faithful,*
about 1942

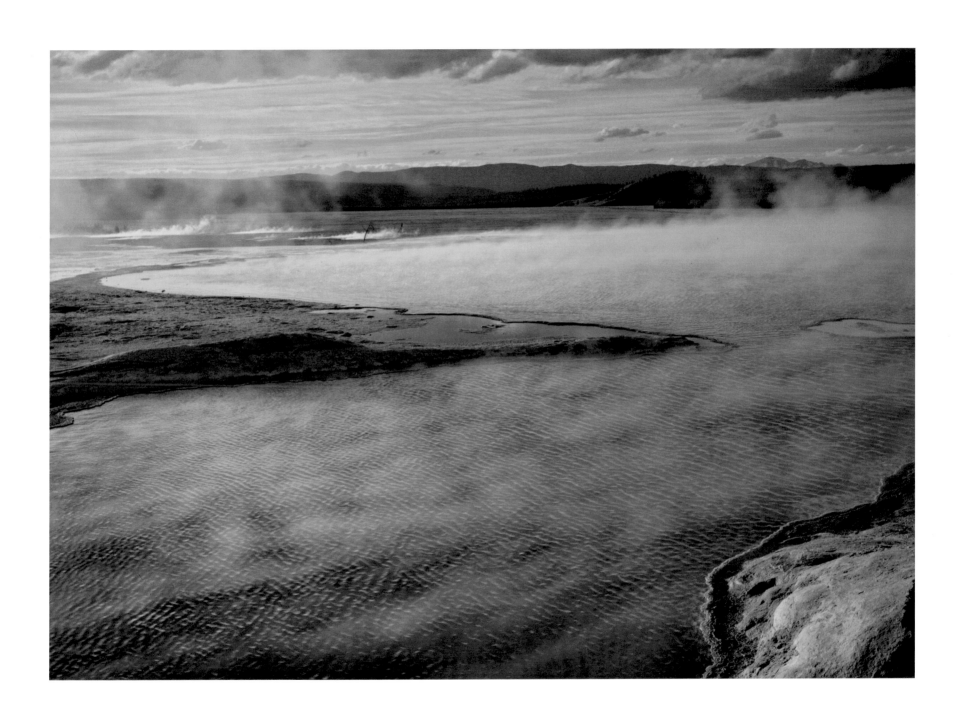

Plate 87
Grand Prismatic Spring,
Midway Geyser Basin,
about 1942

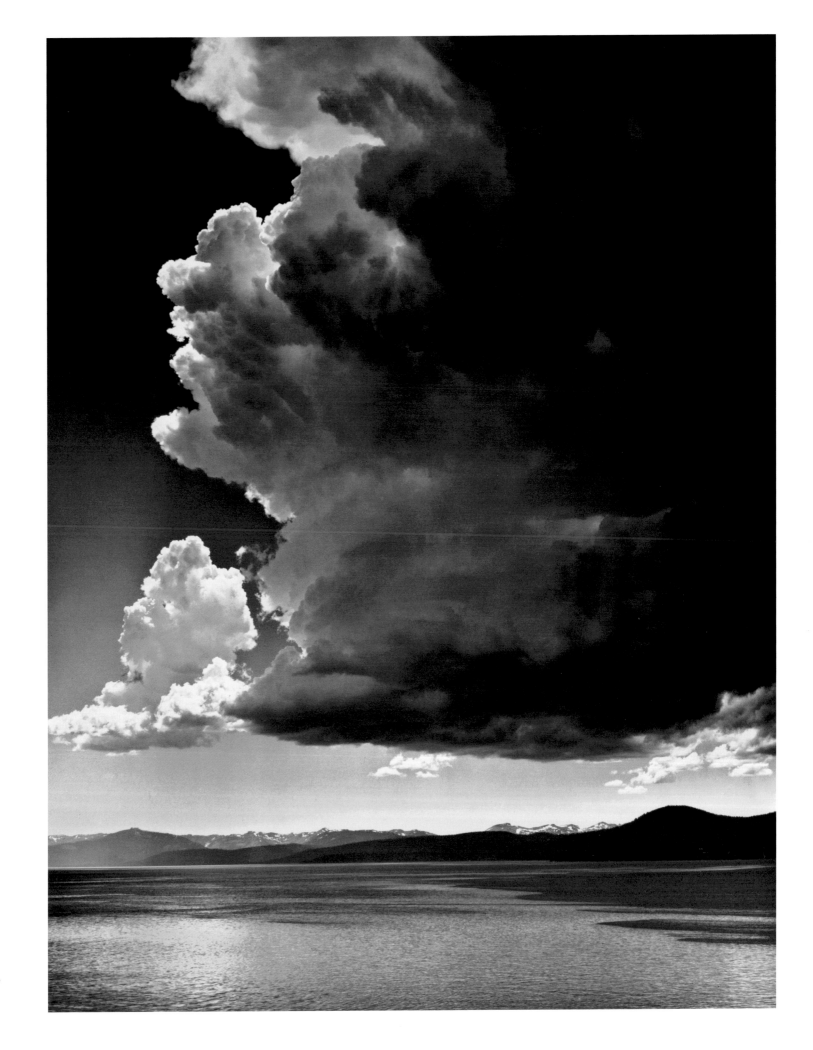

Plate 88
*Thundercloud, Lake
Tahoe, California,*
about 1938

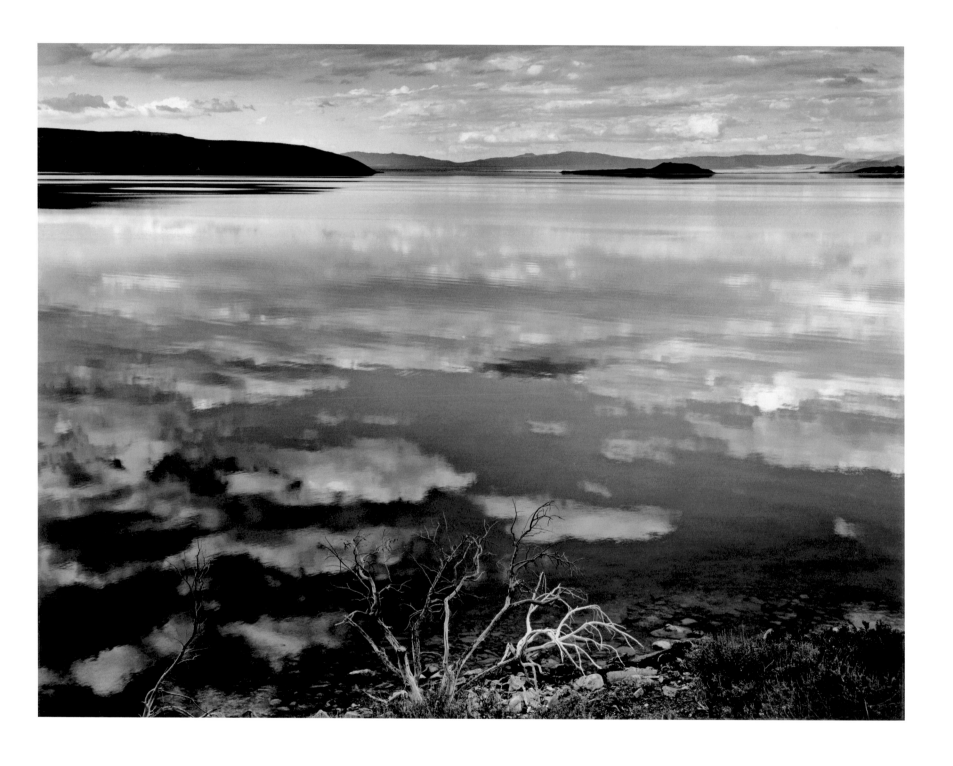

Plate 89
Reflections at Mono Lake,
California, 1948

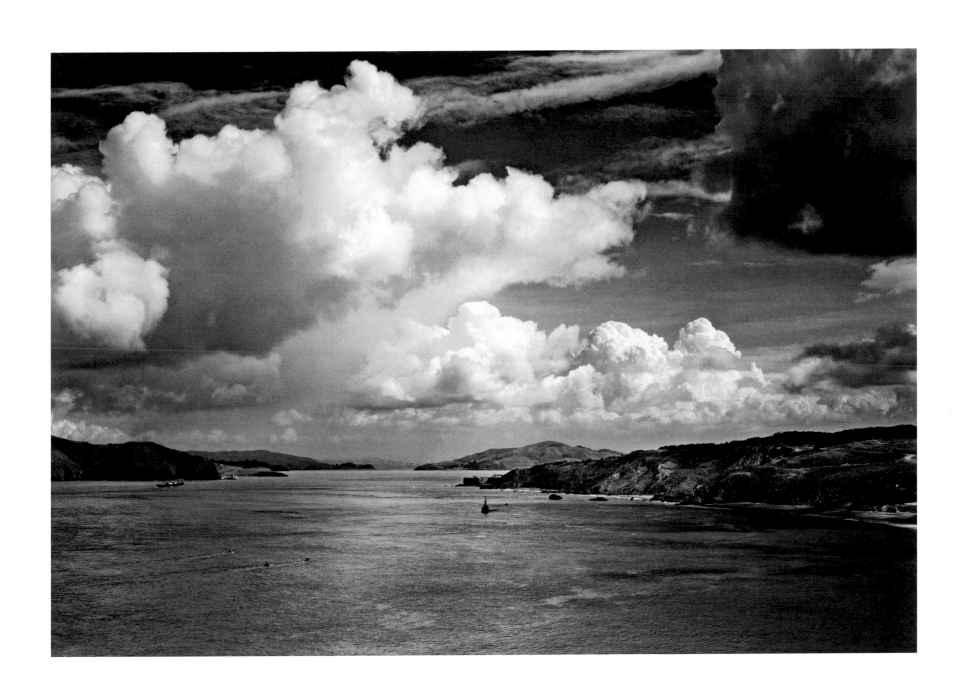

Plate 90
*The Golden Gate Before
The Bridge, San Francisco,*
about 1932

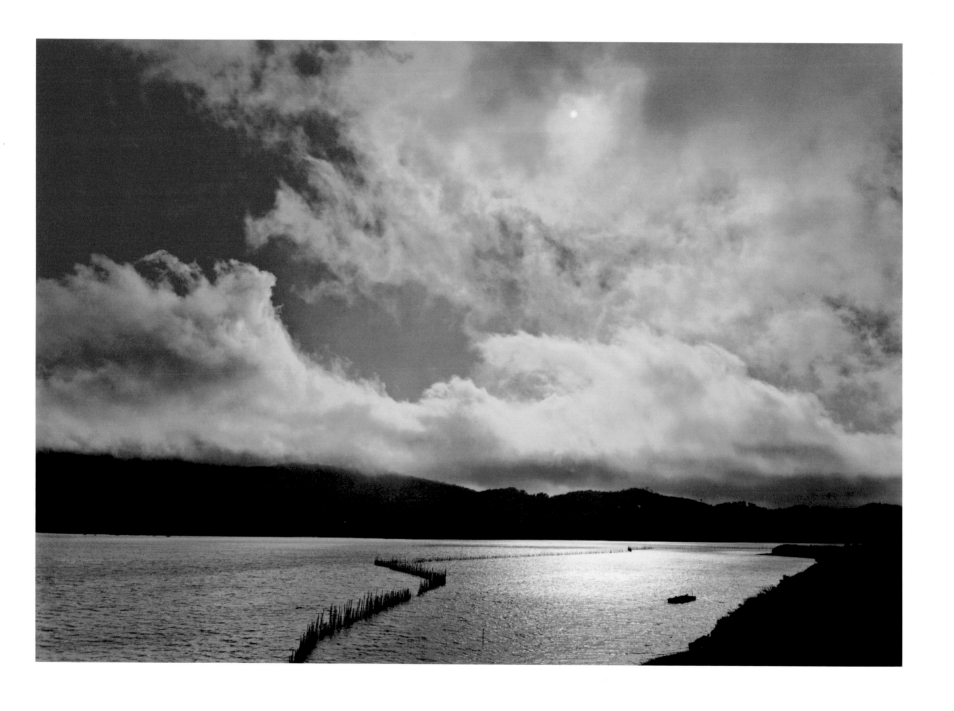

Plate 91
*Sun and Fog, Tomales Bay,
California*, about 1953

Plate 92
Clouds and Sun,
San Francisco,
California, 1959

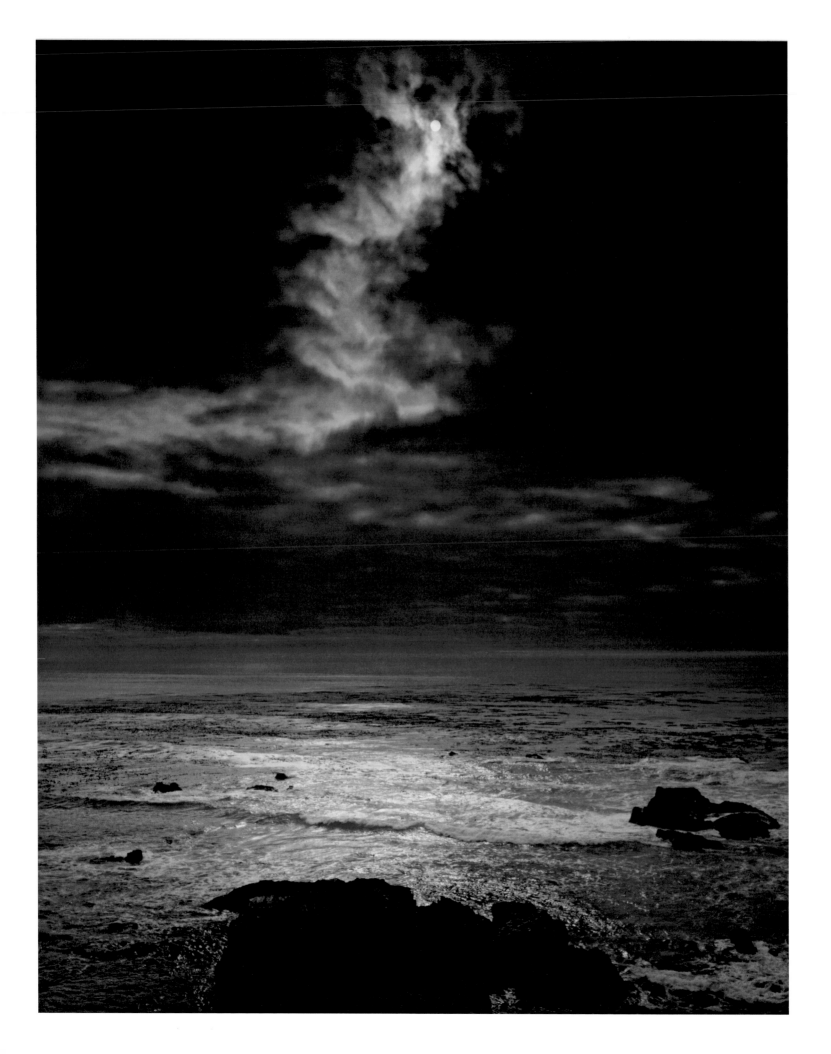

Plate 93
*Sun and Fog,
Point Arena*,
about 1960.

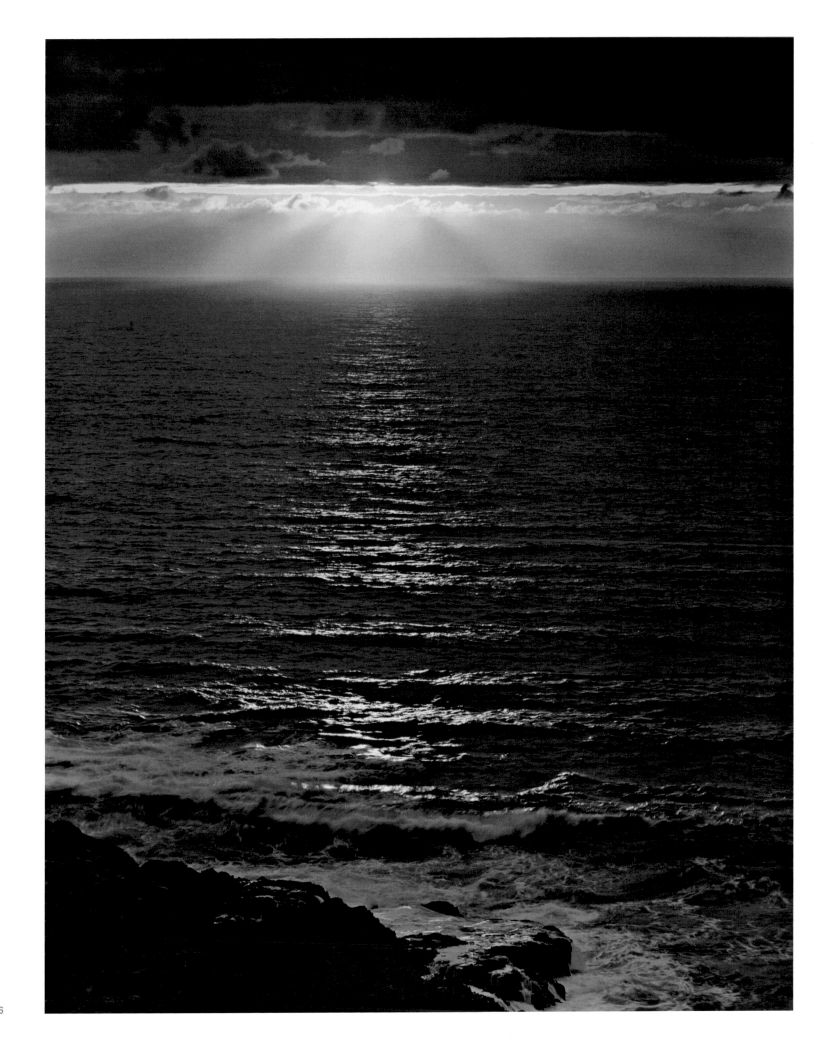

Plate 94
Sundown, the
Pacific, Carmel
Headlands, 1946

Plate 95
Grass, Water and Sun, Alaska,
1948

Plate 96
*Pool, Yellowstone
National Park*, 1965

Plate 97
Submerged Trees, Slide Lake,
Teton Area, about 1965

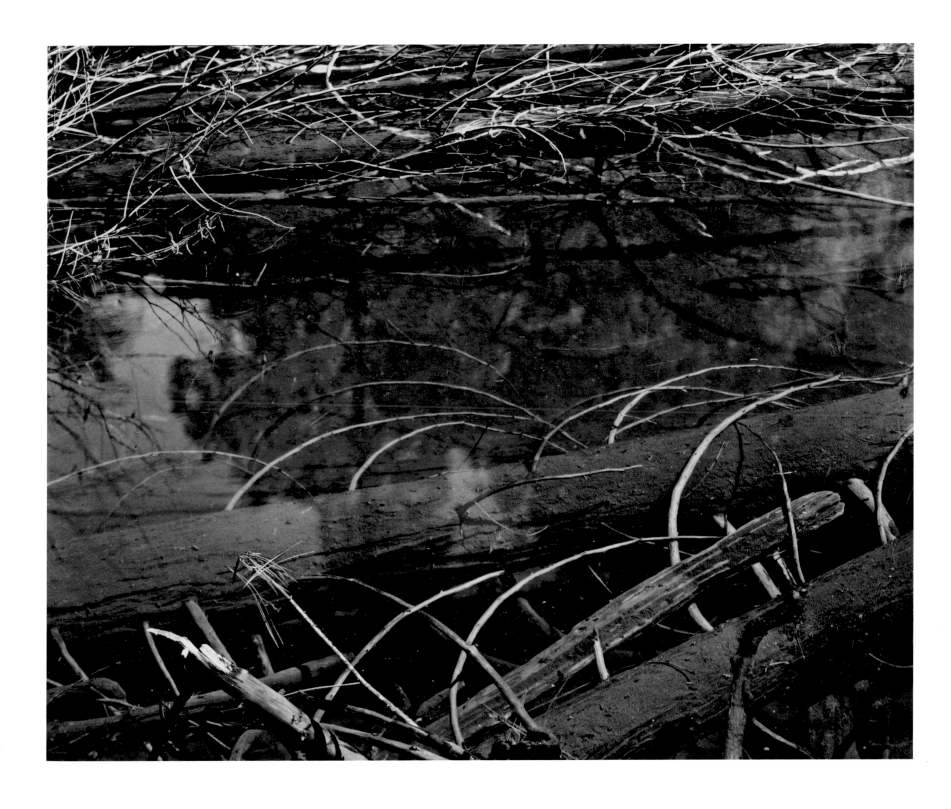

Plate 98
Logs and Water, 1930s

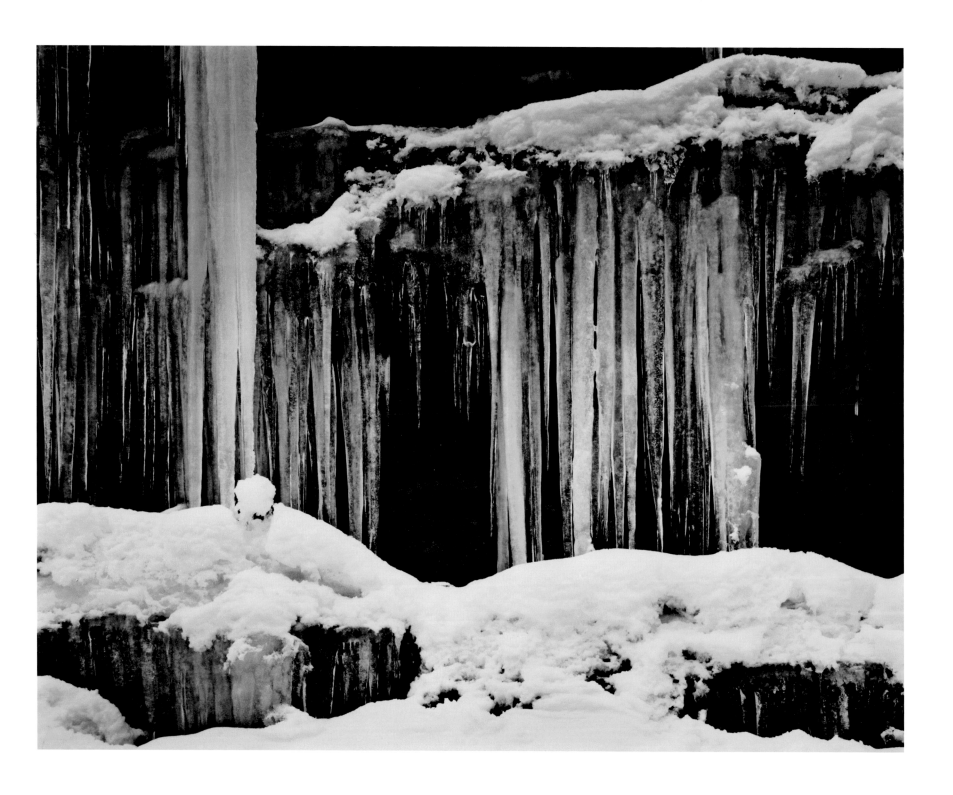

Plate 99
Icicles and Snow,
Yosemite,
about 1940

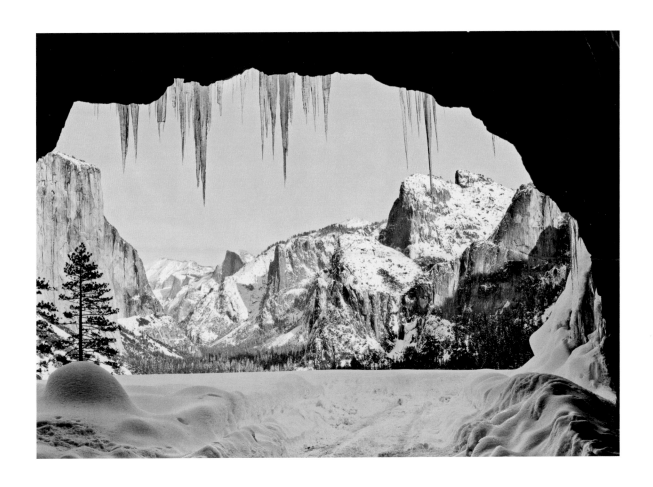

Plate 100
From Wawona Tunnel,
Winter, Yosemite,
about 1935

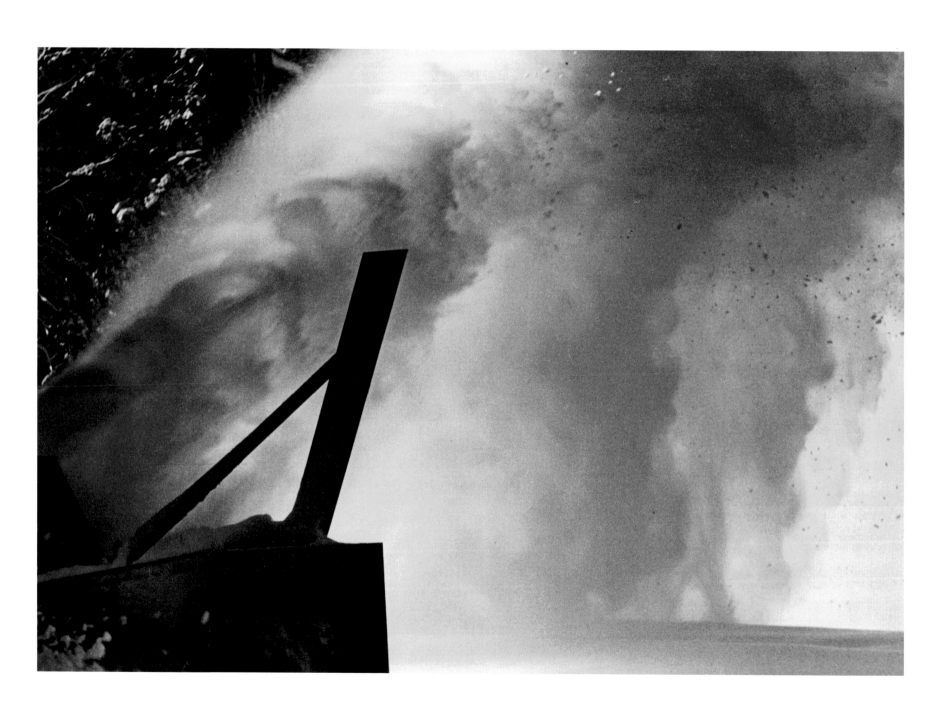

Plate 101
Snow Plough,
about 1935

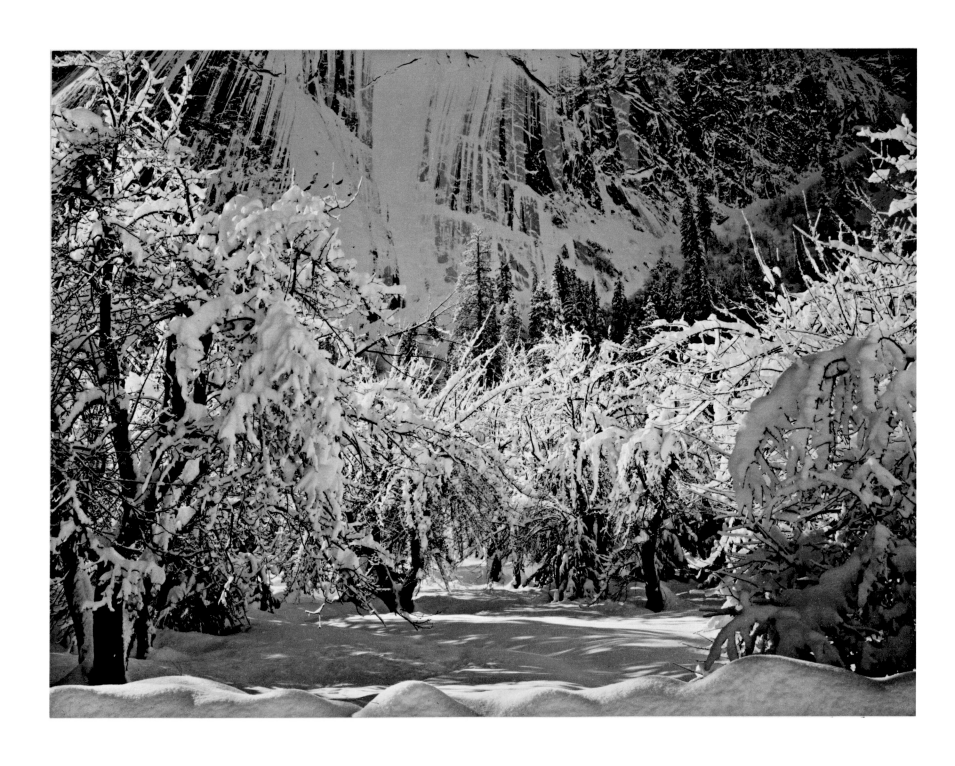

Plate 102
Orchard Cliff, Snow,
Yosemite National Park,
California, 1930s

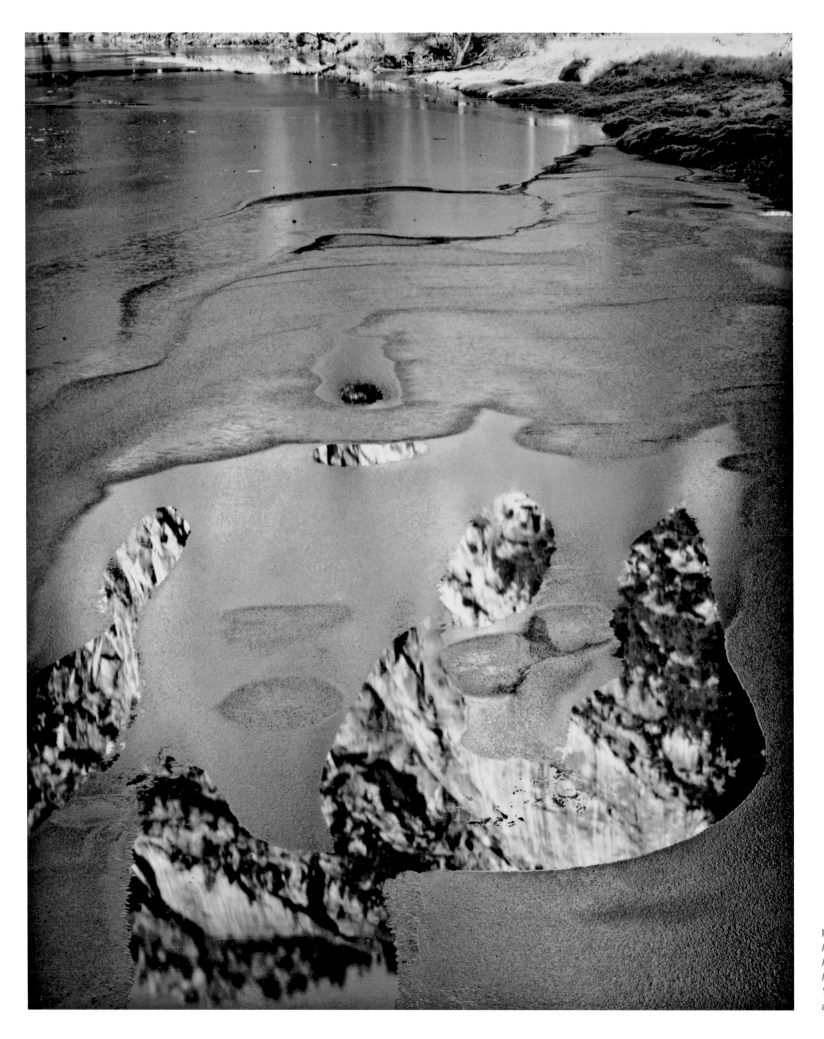

Plate 103
Ice and Water
Reflections,
Merced River,
Yosemite Valley,
about 1942

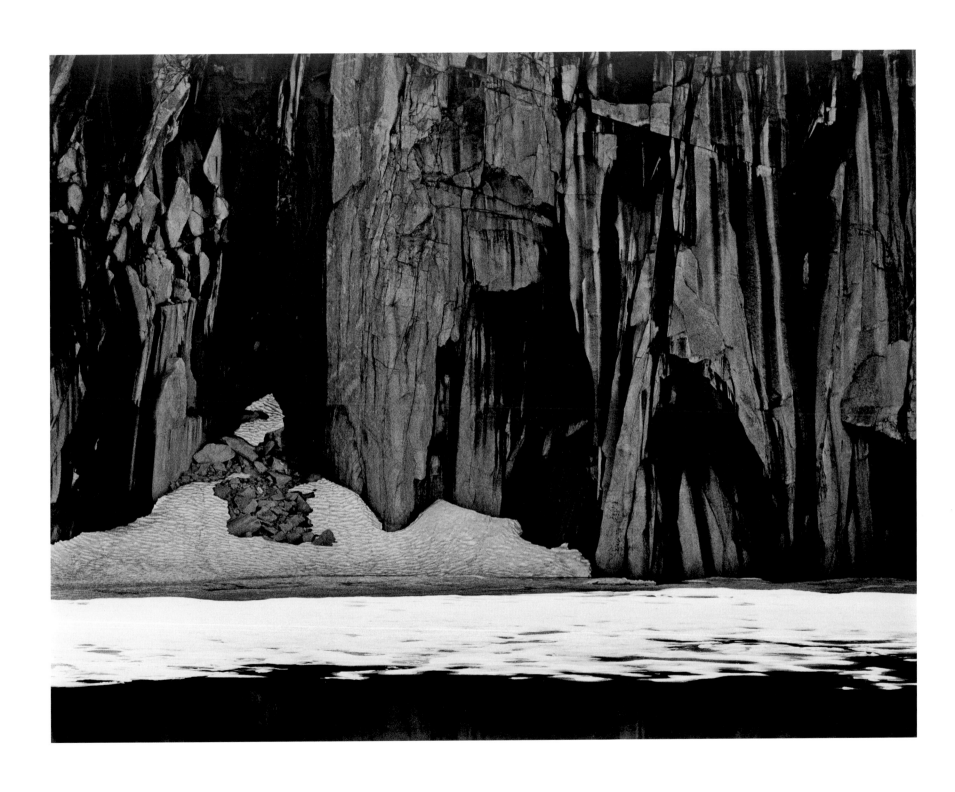

Plate 104
Ice and Cliffs, Kaweah Gap
(Frozen Lake and Cliffs,
Sequoia National Park), 1932

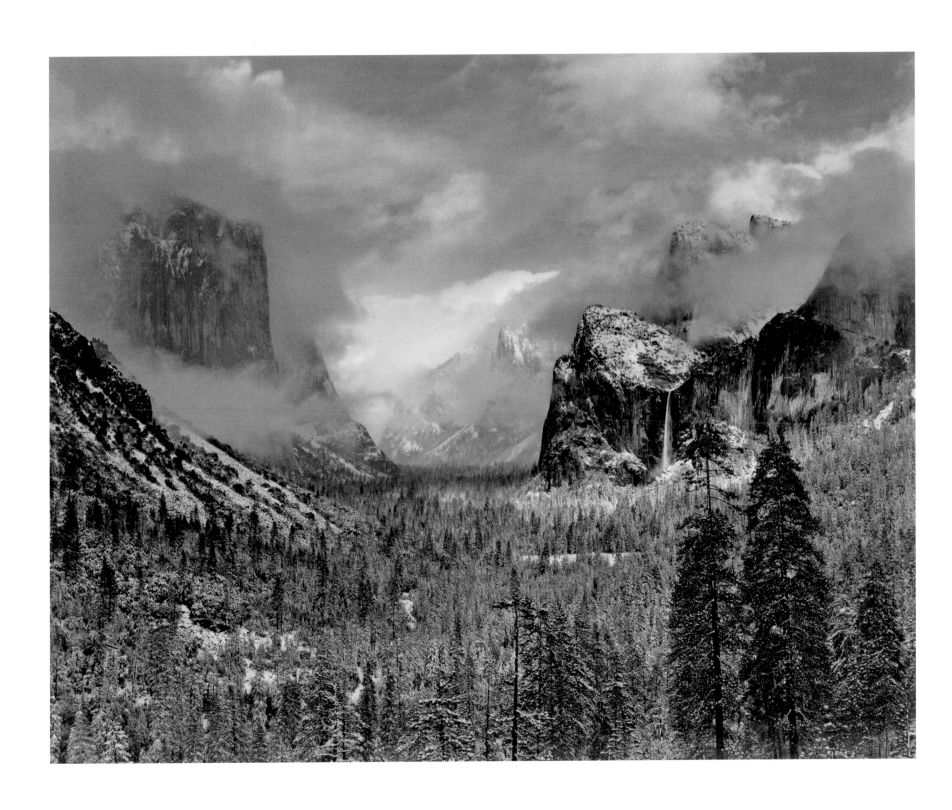

Plate 105
Clearing Winter Storm,
Yosemite National Park,
California, about 1937

To Date or not to Date, that is the question.

Whether tis nobler in the files to suffer

The marks and check-offs of outrageous data

Or to take issue with them and resign

Thyself to random possibilities of both Time and Space.

This is the question which erodes the mind,

Confines the spirit and despoils the Id:

Not what the image is but when was did!

The Ghost of Adams

A N S E L

—Ansel Adams to Beaumont Newhall, May 5, 1961, CCP AG48:6

List of Plates

All works by Ansel Adams (1902–1984); © 2011 The Ansel Adams Publishing Rights Trust. All works are gelatin silver prints and are included in the exhibition unless otherwise noted. Titles are as written by Ansel Adams and have not been revised or corrected.

Plate 1
Panama-Pacific Exposition, San Francisco (also titled *Portals of the Past*), 1915
7 ½ × 8 ½ in. (19.1 × 21.6 cm)
David H. Arrington Collection

Plate 2
China Beach, about 1919
3 × 4 in. (7.3 × 9.9 cm)
Collection Center for Creative Photography, University of Arizona: Ansel Adams Archive, 85.122.23

Plate 3
Shipwreck, Helmet Rock, Lands End, San Francisco, about 1919
2 ¾ × 3 ¾ in. (6.9 × 9.4 cm)
Collection Center for Creative Photography, University of Arizona: Ansel Adams Archive, 85.122.18

Plate 4
Helmet Rock #2, San Francisco Coast, about 1925
5 ¾ × 7 ¾ in. (14.6 × 19.17 cm)
David H. Arrington Collection

Plate 5
Helmet Rock, Land's End, San Francisco, 1918
8 ½ × 11 ⅜ in. (21.6 × 29 cm)
Collection Center for Creative Photography, University of Arizona: Ansel Adams Archive, 84.92.214

Plate 6
Mount Clarence King, Pool, Kings Canyon National Park, about 1925
9 ½ × 13 ⅛ in. (24.7 × 33.5 cm)
Collection Center for Creative Photography, University of Arizona: Ansel Adams Archive, 84.91.265

Plate 7
Mirror Lake, Mount Watkins, Spring, Yosemite National Park, 1935
Series title: *Special Edition Photographs of Yosemite*
7 $^1/_2$ × 9 $^5/_{16}$ in. (19.1 × 23.6 cm)
Collection Center for Creative Photography, University of Arizona: Ansel Adams Archive, 77.66.4

Plate 8
Marion Lake, Kings Canyon National Park, California, about 1925
Series title: *Parmelian Prints of the High Sierras*, 1927 (portfolio)
5 ¾ × 7 ¾ in. (14.4 × 19.6 cm)
Collection Center for Creative Photography, University of Arizona: Ansel Adams Archive, 77.10.10

Plate 9
Kearsarge Pinnacles, Southern Sierra, about 1925
Series title: *Parmelian Prints of the High Sierras*, 1927 (portfolio)
5 ¾ × 7 ¾ in. (14.4 × 19.6 cm)
Collection Center for Creative Photography, University of Arizona: Ansel Adams Archive, 77.10.14

Plate 10
Lake Washburn, Yosemite, about 1918
2 ⅞ × 3 ¾ in. (7.1 × 9.5 cm)
Collection Center for Creative Photography, University of Arizona: Ansel Adams Archive, 85.122.11

Plate 11
Cathedral Peak, Tuolomne River, Yosemite, about 1944
6 ¼ × 9 ½ in. (15.9 × 24.1 cm)
David H. Arrington Collection

Plate 12
Rainbow Falls, about 1929
7 ¼ × 5 ½ in. (18.4 × 14 cm)
David H. Arrington Collection

Plate 13
El Capitan Fall, Yosemite Valley, 1952
9 ¼ × 7 $^1/_{16}$ in. (23.5 × 18 cm)
Collection Center for Creative Photography, University of Arizona: Ansel Adams Archive, 84.91.100
(Exhibited at Peabody Essex Museum only)

Plate 14
Fall in Upper Tenaya Canyon, Yosemite National Park, California, about 1920
4 $^1/_{16}$ × 2 $^7/_8$ in. (10.3 × 7.3 cm)
The Museum of Modern Art, New York, NY, Gift of the photographer, 269.198. Digital image © The Museum of Modern Art/Licensed by SCALA/Art Resource, NY
(Exhibited at Peabody Essex Museum only)

Plate 15
Diamond Cascade, Yosemite National Park, 1920
Copy print from original made for reproduction
6 ½ × 9 in. (16.5 × 22.5 cm)
Collection Center for Creative Photography, University of Arizona: Ansel Adams Archive, S2006.59.7

Plate 16
Surf, Point Lobos State Reserve, California, 1963
10 ½ × 13 ¼ in. (26.6 × 33.7 cm)
Collection Center for Creative Photography, University of Arizona: Ansel Adams Archive/Purchase, 78.152.50

Plate 17
Wave, Pebble Beach, California, 1968
15 ⅝ × 19 ⅝ in. (39.7 × 49.8 cm)
The Lane Collection
Courtesy, Museum of Fine Arts, Boston

Plate 18
Waves, Dillon Beach, 1964
7 ⅜ × 9 ⅜ in. (18.8 × 23.5 cm)
Collection Center for Creative Photography,
University of Arizona: Ansel Adams Archive,
84.92.236

Plate 19
Wave and Log, Dry Lagoon, Northern California,
about 1960
7 ³/₈ × 9 ⁵/₁₆ in. (18.7 × 23.7 cm)
The Lane Collection
Courtesy, Museum of Fine Arts, Boston

Plate 20
Ocean Spray, about 1960
Polaroid, black and white instant print
2 ⅞ × 3 ¾ in. (7.3 × 9.5 cm)
David H. Arrington Collection

Plate 21
Untitled, about 1960
15 ¼ × 19 ¼ in. (38.7 × 49 cm)
Collection Center for Creative Photography,
University of Arizona: Ansel Adams Archive,
84.92.506

Plate 22
Storm Surf, Timber Cove, California, 1963
7 ¼ × 9 ⅛ in. (18.2 × 23.2 cm)
Collection Center for Creative Photography,
University of Arizona: Ansel Adams Archive,
77.14.13

Plate 23
Surf and Rock, Monterey County Coast, California,
1951
19 × 14 ¼ in. (48.2 × 36.1 cm)
Collection Center for Creative Photography,
University of Arizona: Ansel Adams Archive/
Purchase, 76.83.85

Plate 24
Foam, about 1960
10 ⅝ × 9 ⅛ in. (27 × 23.3 cm)
Collection Center for Creative Photography,
University of Arizona: Ansel Adams Archive/
Purchase, 84.91.249

Plate 25
North Coast, California, about 1939
6 ⅞ × 9 in. (17.5 × 22.9 cm)
The Lane Collection
Courtesy, Museum of Fine Arts, Boston

Plate 26
Ocean, Near Bolinas, about 1938
7 ½ × 9 in. (18.6 × 22.5 cm)
Collection Center for Creative Photography,
University of Arizona: Ansel Adams Archive,
84.92.239

Plates 27–31
Surf Sequence 1–5, San Mateo County Coast,
California, 1940
pl. 27: 6 ¹⁵/₁₆ × 8 ¹/₂ in. (17.6 × 21.4 cm); pl. 28:
7 ¹⁵/₁₆ × 9 ¹/₂ in. (20.2 × 24 cm); pl. 29: 10 ¼ × 12 ⅜
in. (25.8 × 31.3 cm); pl. 30: 6 ½ × 8 ¾ in. (17.3 × 22
cm); pl. 31: 6 ¾ × 8 ⅛ in. (17.1 × 20.6 cm)
Collection Center for Creative Photography,
University of Arizona: Ansel Adams Archive,
84.92.207, 84.92.208, 84.93.11, 84.92.210,
84.92.213
(Plate 29 exhibited at Peabody Essex Museum only)

Plate 32
Bakers Beach, San Francisco, California, 1954
Polaroid, black and white instant print
2 ⁷/₈ × 3 ¹³/₁₆ in. (7.3 × 9.7 cm)
The Metropolitan Museum of Art, New York, Gift
of Virginia Best Adams and Polaroid Corporation,
1986, 1986.1042.33. Copy photography © The
Metropolitan Museum of Art. Image copyright ©
The Metropolitan Museum of Art. Image source:
Art Resource, NY
(Not in exhibition)

Plate 33
Whaler's Cove, Carmel Mission, about 1953
94 ¼ × 119 in. (239.4 × 302.3 cm)
David H. Arrington Collection

Plate 34
Point Sur, Monterey County, California, n.d.
9 ¼ × 7 in. (23.5 × 17.8 cm)
David H. Arrington Collection

Plate 35
Point Lobos, Near Monterey, about 1950
71 × 96 in. (180.3 × 243.8 cm)
David H. Arrington Collection

Plate 36
Makapu Point, Oahu, Hawaii, 1957
6 ½ × 12 ¼ in. (16.4 × 31.1 cm)
Collection Center for Creative Photography,
University of Arizona: Ansel Adams Archive,
84.92.116

Plate 37
Northern California Coast, Near Elk, California,
1964
10 ⅜ × 12 ¾ in. (26.4 × 32.3 cm)
Collection Center for Creative Photography,
University of Arizona: Ansel Adams Archive/
Purchase, 76.83.14

Plate 38
Glacier Bay National Monument, Alaska,
about 1948
8 × 5 $^{11}/_{16}$ in. (20.3 × 14.4 cm)
The Lane Collection
Courtesy, Museum of Fine Arts, Boston

Plate 39
The Atlantic, Schoodic Point, Acadia National Park,
Maine, 1949
Series title: *Portfolio Two: The National Parks &*
Monuments, 1950
7 × 9 ½ in. (17.8 × 24.2 cm)
Collection Center for Creative Photography,
University of Arizona: Ansel Adams Archive,
77.12.14

Plate 40
Seaweed, Sandy Cove, Glacier Bay National
Monument, about 1948
6 $^{3}/_{8}$ × 8 $^{1}/_{4}$ in. (16.2 × 20.9 cm)
Collection Center for Creative Photography,
University of Arizona: Ansel Adams Archive,
84.92.110

Plate 41
Sea Anemones, Shore Detail, Bodega Head,
California, 1969
13 ¼ × 10 in. (33.6 × 25.3 cm)
Collection Center for Creative Photography,
University of Arizona: Ansel Adams Archive,
84.92.204

Plate 42
Rocks and Limpets, Point Lobos, California, 1960
31 ¼ × 39 $^{5}/_{8}$ in. (78.8 × 100.7 cm)
Collection Center for Creative Photography,
University of Arizona: Ansel Adams Archive,
92.3.28

Plate 43
Rock and Sand, Bakers Beach, San Francisco,
California, 1961
Polaroid, black and white instant print
2 $^{13}/_{16}$ × 3 $^{11}/_{16}$ in. (7.1 × 9.3 cm)
Metropolitan Museum of Art, New York, NY; Gift
of Virginia Best Adams and Polaroid Corporation,
1986, 1986.1042.23. Copy photography © The
Metropolitan Museum of Art. Image copyright ©
The Metropolitan Museum of Art. Image source:
Art Resource, NY
(Not in exhibition)

Plate 44
Rocks, Bakers Beach, San Francisco, California,
about 1931
7 $^{5}/_{8}$ × 9 $^{7}/_{8}$ in. (19.3 × 25.3 cm)
Collection Center for Creative Photography,
University of Arizona: Ansel Adams Archive
84.92.52

Plate 45
Barnacles, Cape Cod, 1938
12 ½ × 8 ½ in. (31.2 × 21.7 cm)
Collection Center for Creative Photography,
University of Arizona: Ansel Adams Archive,
84.92.21

Plate 46
Churches, Truro, Cape Cod, Massachusetts, 1941
9 × 12 ¾ in. (22.8 × 32.3 cm)
Collection Center for Creative Photography,
University of Arizona: Ansel Adams Archive,
84.90.160

Plate 47
Chatham, Cape Cod, about 1939
6 $^{3}/_{8}$ × 4 $^{1}/_{2}$ in. (16.1 × 11.4 cm)
Collection Center for Creative Photography,
University of Arizona: Ansel Adams Archive,
84.90.167

Plate 48
Old Wreck, Cape Cod, Massachusetts, about 1936
4 $^{1}/_{2}$ × 6 $^{1}/_{4}$ in. (11.4 × 15.8 cm)
The Lane Collection
Courtesy, Museum of Fine Arts, Boston

Plate 49
Shipwreck Series, Lands End, San Francisco, 1931
7 ½ × 9 ⅜ in. (18.8 × 23.5 cm)
Collection Center for Creative Photography,
University of Arizona: Ansel Adams Archive,
86.5.9

Plate 50
Shipwreck Series, Lands End, San Francisco,
about 1934
9 ¼ × 7 ½ in. (23.3 × 18.8 cm)
Collection Center for Creative Photography,
University of Arizona: Ansel Adams Archive,
86.5.4

Plate 51
Shipwreck Series, Lands End, San Francisco,
about 1934
7 ½ × 9 ⅜ in. (18.8 × 23.5 cm)
Collection Center for Creative Photography,
University of Arizona: Ansel Adams Archive,
86.5.3

Plate 52
Shipwreck Series, Metal and Stone, Lands End,
San Francisco, California, about 1934
9 ⅜ × 7¾ in. (23.5 × 18.5 cm)
Collection Center for Creative Photography,
University of Arizona: Ansel Adams Archive,
86.5.7

Plate 53
Gravel Bars, American River, about 1950
108 ½ × 84 ½ in. (275.6 × 214.6 cm)
David H. Arrington Collection

Plate 54
Teklanika River, Mount McKinley National Park, Alaska, 1948
8 ⅞ × 11 ⅞ in. (22.5 × 30.3 cm)
Collection Center for Creative Photography, University of Arizona: Ansel Adams Archive, 84.92.221

Plate 55
Stream, Sea, and Clouds, Rodeo Lagoon, Marin County, California, 1962
54 ⅝ × 39 ⅞ in. (138.8 × 101 cm)
Collection Center for Creative Photography, University of Arizona: Ansel Adams Archive, 77.68.1

Plate 56
A Grove of Tamarack Pine Near Timber Line, about 1921
6 × 8 in. (15.2 × 20.3 cm)
David H. Arrington Collection

Plate 57
Mirror Lake, California, about 1950
47 ½ × 49 in. (120.7 × 124.5 cm)
David H. Arrington Collection

Plate 58
Early Morning, Merced River, Autumn, Yosemite National Park, California, about 1950
Series title: *Special Edition Photographs of Yosemite*
7 ¼ × 9 ⅜ in. (18.4 × 23.9 cm)
Collection Center for Creative Photography, University of Arizona: Ansel Adams Archive, 77.65.14

Plate 59
Mount Lyell and Mount Maclure, Tuolumne River, Yosemite National Park, about 1936
Series title: *Special Edition Photographs of Yosemite*
7 ½ × 9 ½ in. (19.1 × 24.1 cm)
Collection Center for Creative Photography, University of Arizona: Ansel Adams Archive, 77.65.10

Plate 60
In the Lyell Fork of the Merced River, Yosemite National Park, about 1935
7 ⅜ × 9 ⅛ in. (18.6 × 23.4 cm)
Collection Center for Creative Photography, University of Arizona: Ansel Adams Archive, 84.91.127

Plate 61
Maroon Bells, Near Aspen, Colorado, 1951
15 ¼ × 19 ⅛ in. (38.7 × 48.6 cm)
David H. Arrington Collection

Plate 62
The Tetons and the Snake River, Grand Teton National Park, Wyoming, 1942
15 ⅝ × 19 ⅜ in. (39.5 × 49 cm)
Collection Center for Creative Photography, University of Arizona: Ansel Adams Archive/ Purchase, 76.83.75

Plate 63
Mount McKinley and Wonder Lake, Denali National Park, Alaska, 1947
Series title: *Portfolio One: Twelve Photographic Prints*, 1948
7 ⁷/₁₆ × 9 ⁵/₁₆ in. (18.8 × 23.5 cm)
Collection Center for Creative Photography, University of Arizona: Ansel Adams Archive, 77.11.1

Plate 64
Bad Water, Death Valley National Monument, about 1942
10 ¼ × 13 ⅛ in. (25.9 × 33.2 cm)
Collection Center for Creative Photography, University of Arizona: Ansel Adams Archive/ Purchase, 76.89.54

Plate 65
Shrub and Rapids, Merced River, 1968
10 ³/₈ × 10 ³/₈ in. (26.3 × 26.4 cm)
Collection Center for Creative Photography, University of Arizona: Ansel Adams Archive, 84.91.202

Plate 66
Merced River below Cascade Falls, Yosemite National Park, California, about 1955
12 ¹/₆ × 9 ⅞ in. (30.7 × 25.2 cm)
Collection Center for Creative Photography, University of Arizona: Ansel Adams Archive, 84.91.169

Plate 67
Rapids, Merced River, Yosemite Valley, California, 1952
10 ¼ × 12 in. (25.8 × 30.4 cm)
Collection Center for Creative Photography, University of Arizona: Ansel Adams Archive, 76.577.5

Plate 68
Waterfall, Northern Cascades, Washington, 1960
13 ½ × 10 in. (34.3 × 25.4 cm)
Collection Center for Creative Photography, University of Arizona: Ansel Adams Archive, 84.92.31

Plate 69
Cascade, Happy Isles, Yosemite Valley, about 1940
10 ¼ × 13 ¾ in. (25.8 × 34.7 cm)
Collection Center for Creative Photography,
University of Arizona: Ansel Adams Archive,
84.91.122

Plate 70
Detail of *Cascade Bridge Creek, Northern
Cascades, Washington,* about 1960
7 ⅜ × 9 ⅛ in. (18.6 × 23.2 cm)
Collection Center for Creative Photography,
University of Arizona: Ansel Adams Archive,
84.92.4

Plate 71
Cascade, Yosemite National Park, about 1968
10 ⅛ × 13 ⅛ in. (25.7 × 33.4 cm)
Collection Center for Creative Photography,
University of Arizona: Ansel Adams Archive,
84.91.200

Plate 72
Untitled, about 1940
15 ¼ × 19 ⅜ in. (38.8 × 49.2 cm)
Collection Center for Creative Photography,
University of Arizona: Ansel Adams Archive,
84.91.539

Plate 73
Merced River, Yosemite Valley, n.d.
9 ½ × 11 in. (24.4 × 27.7 cm)
Collection Center for Creative Photography,
University of Arizona: Ansel Adams Archive,
84.91.126

Plate 74
*Waterwheel Falls, Yosemite National Park,
California,* about 1948
7 ¼ × 9 ½ in. (18.2 × 23.8 cm)
Collection Center for Creative Photography,
University of Arizona: Ansel Adams Archive,
84.91.224

Plate 75
Upper Yosemite Fall, Yosemite Valley, 1946
13 ⅞ × 9 ⅞ in. (33.2 × 25.2 cm)
Collection Center for Creative Photography,
University of Arizona: Ansel Adams Archive,
84.91.256

Plate 76
Nevada Fall, Profile, Yosemite Valley, about 1946
Series Title: *Special Edition Photographs of
Yosemite*
9 ½ × 7 ³/₁₆ in. (24 × 18.7 cm)
Collection Center for Creative Photography,
University of Arizona: Ansel Adams Archive,
78.13.19

Plate 77
Upper Yosemite Fall, Yosemite Valley, about 1960
13 ⅜ × 10 ¼ in. (33.9 × 26 cm)
Collection Center for Creative Photography,
University of Arizona: Ansel Adams Archive,
84.91.91

Plate 78
*Base of Upper Yosemite Fall, Yosemite National
Park,* about 1950
18 × 12 ½ in. (45.4 × 32 cm)
Collection Center for Creative Photography,
University of Arizona: Ansel Adams Archive,
84.91.255

Plate 79
Sentinel Falls, n.d.
9 ¼ × 7 in. (23.5 × 17.8 cm)
David H. Arrington Collection

Plate 80
Fern Spring, Dusk, Yosemite Valley, California,
about 1962
19 ¹/₅ × 15 ¹/₁₆ in. (49.5 × 38.3 cm)
Collection Center for Creative Photography,
University of Arizona: Ansel Adams Archive,
84.91.534

Plate 81
Yosemite Falls, Rain, Yosemite Valley, about 1960
10 ⅜ × 9 ⅝ in. (26.4 × 24.4 cm)
The Lane Collection
Courtesy, Museum of Fine Arts, Boston

Plate 82
*Old Faithful Geyser, Yellowstone National Park,
Wyoming,* about 1942
12 ⅝ × 8 ¹⁵/₁₆ in. (32.1 × 22.5 cm)
Collection Center for Creative Photography,
University of Arizona: Ansel Adams Archive,
84.92.83

Plate 83
*Old Faithful Geyser, Yellowstone National Park,
Wyoming,* about 1942
12 ³/₄ × 8 ¹⁵/₁₆ in. (32.3 × 22.8 cm)
Collection Center for Creative Photography,
University of Arizona: Ansel Adams Archive,
84.92.81

Plate 84
Old Faithful Geyser, Yellowstone National Park, Wyoming, 1942
13 ¾ × 9 ¾ in. (34.8 × 24.7 cm)
Collection Center for Creative Photography, University of Arizona: Ansel Adams Archive/ Purchase, 78.152.87

Plate 85
Old Faithful Geyser, Late Evening, Yellowstone National Park, Wyoming, 1942
13 ¾ × 9 ¾ in. (34.9 × 24.7 cm)
Collection Center for Creative Photography, University of Arizona: Ansel Adams Archive, 76.577.22

Plate 86
Yellowstone National Park, Old Faithful, about 1942
12 ¾ × 8 ⅞ in. (32.2 × 22.4 cm)
Collection Center for Creative Photography, University of Arizona: Ansel Adams Archive, 84.92.82

Plate 87
Grand Prismatic Spring, Midway Geyser Basin, about 1942
8 ¾ × 12 ½ in. (22.4 × 32 cm)
Collection Center for Creative Photography, University of Arizona: Ansel Adams Archive, 84.92.187

Plate 88
Thundercloud, Lake Tahoe, California, about 1938
13 ½ × 10 ½ in. (34.4 × 26.7 cm)
Collection Center for Creative Photography, University of Arizona: Ansel Adams Archive, 76.577.26

Plate 89
Reflections at Mono Lake, California, 1948
20 ⅛ × 26 ¾ in. (51.12 × 67.95 cm)
David H. Arrington Collection

Plate 90
The Golden Gate before the Bridge, San Francisco, about 1932
6 × 9 in. (15.24 × 22.9 cm)
David H. Arrington Collection

Plate 91
Sun and Fog, Tomales Bay, California, about 1953
9 ¼ × 13 ¼ in. (23.5 × 33.66 cm)
David H. Arrington Collection

Plate 92
Clouds and Sun, San Francisco, California, 1959
Polaroid, black and white instant print
3 ¹¹/₁₆ × 2 ¹³/₁₆ in. (9.4 × 7.1 cm)
The Metropolitan Museum of Art, New York, Gift of Virginia Best Adams and Polaroid Corporation, 1986 (1986.1042.34). Image copyright © The Metropolitan Museum of Art. Image source: Art Resources, NY
(Not in exhibition)

Plate 93
Sun and Fog, Point Arena, about 1960
38 ½ × 29 ¾ in. (97.8 × 75.6 cm)
Collection Center for Creative Photography, University of Arizona: Ansel Adams Archive, 92.3.10

Plate 94
Sundown, the Pacific, Carmel Highlands, 1946
17 ¼ × 13 ¾ in. (43.8 × 34.8 cm)
Collection Center for Creative Photography, University of Arizona: Ansel Adams Archive, 84.92.512

Plate 95
Grass, Water and Sun, Alaska, 1948
14 ³/₈ × 19 ⁵/₁₆ in. (36.5 × 49.1 cm)
The Lane Collection
Courtesy, Museum of Fine Arts, Boston

Plate 96
Pool, Yellowstone National Park, 1965
19 ½ × 15 ⅛ in. (49.4 × 38.3 cm)
Collection Center for Creative Photography, University of Arizona: Ansel Adams Archive, 84.92.545

Plate 97
Submerged Trees, Slide Lake, Teton Area, about 1965
15 ½ × 18 ½ in. (39.7 × 47.1 cm)
Collection Center for Creative Photography, University of Arizona: Ansel Adams Archive, 84.92.547

Plate 98
Logs and Water, 1930s
7 ½ × 9 ⅜ in. (19.2 × 23.8 cm)
Collection Center for Creative Photography, University of Arizona: Ansel Adams Archive, 84.91.125

Plate 99
Icicles and Snow, Yosemite, about 1940
31 ¾ × 39 ⅞ in. (80.5 × 101 cm)
Collection Center for Creative Photography, University of Arizona: Ansel Adams Archive, 92.3.24

Plate 100
From Wawona Tunnel, Winter, Yosemite, about 1935
6 ¼ × 8 ¾ in. (15.9 × 22.2 cm)
David H. Arrington Collection

Plate 101
Snow Plough, about 1935
6 ½ × 9 ¼ in. (16.5 × 23.5 cm)
David H. Arrington Collection

Plate 102
*Orchard Cliff, Snow, Yosemite National Park,
California,* 1930s
7 × 9 ½ in. (17.9 × 24.1 cm)
Collection Center for Creative Photography,
University of Arizona: Ansel Adams Archive,
84.91.138

Plate 103
Ice and Water Reflections, River, Yosemite Valley,
about 1942
9 ⅜ × 7 ⅝ in. (23.8 × 19.3 cm)
Collection Center for Creative Photography,
University of Arizona: Ansel Adams Archive,
84.91.220

Plate 104
*Ice and Cliffs, Kaweah Gap (Frozen Lake and Cliffs,
Sequoia National Park),* 1932
14 ¼ × 18 ½ in. (36.2 × 47 cm)
David H. Arrington Collection

Plate 105
*Clearing Winter Storm, Yosemite National Park,
California,* about 1937
24 × 31 in. (60.9 × 78.74 cm)
David H. Arrington Collection

List of Figures

Further Reading

Adams, Ansel. *The American Wilderness*. Edited by Andrea G. Stillman. Introduction by William A. Turnage. Boston: Little, Brown, 1990.

———. *Ansel Adams: An Autobiography*. With Mary Street Alinder. Boston: New York Graphic Society, 1985.

———. *Ansel Adams: Yosemite and the Range of Light*. Introduction by Paul Brooks. Boston: New York Graphic Society, 1979.

———. *Conversations with Ansel Adams, 1972, 1974, and 1975*. Interview by Ruth Teiser and Catherine Harroun. Introduction by James L. Enyeart and Richard M. Leonard. Oral History Transcript. Bancroft Library, University of California, Berkeley, 1978.

———. *Letters and Images, 1916–1984*. Edited by Mary Street Alinder and Andrea Gray Stillman. Foreword by Wallace Stegner. Boston: Little, Brown, 1988; Boston: Bulfinch Press, 1990.

———. *Polaroid Land Photography*. With the collaboration of Robert Baker. Boston: New York Graphic Society, 1978.

———. *The Portfolios of Ansel Adams*. Introduction by John Szarkowski. Boston: Little, Brown, 1977.

———. *Sierra Nevada: The John Muir Trail*. Introduction by William A. Turnage. New York: Little, Brown, 2006.

Adams, Ansel, and Nancy Newhall. *This Is the American Earth*. San Francisco: Sierra Club, 1992. Reprint, with a new foreword. First published 1960.

Alinder, Mary Street. *Ansel Adams: A Biography*. New York: Henry Holt, 1996.

Gray, Andrea. *Ansel Adams: An American Place, 1936*. Tucson, AZ: University of Arizona Press, 1982.

Greenough, Sarah. *Alfred Stieglitz: The Key Set*. New York: Abrams, 2002.

Greenough, Sarah, et al. *Modern Art and America: Alfred Stieglitz and His New York Galleries*. Boston: Bulfinch Press, 2001.

Haas, Karen E., and Rebecca A. Senf. *Ansel Adams in the Lane Collection*. Boston: MFA Publications, 2005.

Hammond, Anne. *Ansel Adams: Divine Performance*. New Haven, CT: Yale University Press, 2002.

Herzig, Susan, and Paul Hertzmann, eds. *Dassonville: William E. Dassonville, California Photographer (1879–1957)*. Essay by Peter Palmquist. Nevada City: Carl Mautz Publishing, 1999.

Heyman, Therese Thau, ed. *Seeing Straight: The f.64 Revolution in Photography*. Foreword by Beaumont Newhall. Essays by Mary Street Alinder, Therese Thau Heyman, and Naomi Rosenblum. Seattle: University of Washington Press, 1992.

Hickman, Paul, and Terence Pitts, *George Fiske: Yosemite Photographer*. Preface by Beaumont Newhall. Introduction by James Enyeart. Flagstaff, AZ: Northland Press, 1980.

Hitchcock, Barbara, et al. *Innovation/Imagination: 50 Years of Polaroid Photography*. New York: Abrams, 1999.

Hutchings, James Mason. *In the Heart of the Sierras: The Yosemite Valley, Both Historical and Descriptive*. Oakland, CA: Pacific Press, 1886.

LeConte, Joseph N. *A Summer of Travel in the High Sierra*. Ashland, OR: Lewis Osborne, 1972.

Newhall, Beaumont. *Focus: Memoirs of a Life in Photography*. Boston: Bulfinch Press, 1993.

Newhall, Nancy. *Ansel Adams: The Eloquent Light*. Millerton, NY: Aperture, 1980. First published 1963 by the Sierra Club.

Prodger, Phillip. *Time Stands Still: Muybridge and the Instantaneous Photography Movement*. New York: Oxford University Press, 2003.

Quinn, Karen E., and Theodore E. Stebbins, Jr. *Ansel Adams: The Early Years*. Boston: Museum of Fine Arts, 1991.

Smith, Joel, ed. *More Than One: Photographs in Sequence*. New Haven, CT: Yale University Press, 2008.

Spaulding, Jonathan. *Ansel Adams and the American Landscape: A Biography*. Berkeley: University of California Press, 1995.

Stillman, Andrea G., ed. *Ansel Adams: 400 Photographs*. New York: Little, Brown, 2007.

———, ed. *Ansel Adams in the National Parks*. New York: Little, Brown, 2010.

Stillman, Andrea G., and John P. Schaefer, eds. *Ansel Adams in Color*, rev. ed. New York: Little, Brown, 2009. First published 1993.

Szarkowski, John, *Ansel Adams at 100*. Boston: Little, Brown, 2001.

Tedeschi, Martha, et al. *John Marin's Watercolors: A Medium for Modernism*. Chicago: Chicago Art Institute, 2011.

Watts, Jennifer, et al. *Edward Weston: A Legacy*. London: Merrell, 2003.

Weems, Jason. *Unseen Ansel Adams: Photographs from the Fiat Lux Collection*. San Diego, CA: Thunder Bay Press, 2010.

Wright, Peter, and John Armor. *The Mural Project: Photography by Ansel Adams*. Santa Barbara, CA: Reverie Press, 1989.

Index

Italicized page numbers refer to figure illustrations. Plate numbers—prefixed with "*pl*"—are placed at the ends of entries. Unless indicated otherwise, photograph titles refer to works made by Ansel Adams.

Now the wide vision, now the burst of light,

Now the sweet recognition, now the song

Shaking the depths of sky, rippling the sea . . .

— Ansel Adams, "And Now the Wide Vision," quoted in Anne Hammond,

Ansel Adams: Divine Performance [New Haven, CT: Yale University Press, 2002], p. 19